MECHADEMIA 5

Fanthropologies

Mechademia

An Annual Forum for Anime, Manga, and Fan Arts

FRENCHY LUNNING, EDITOR

Mechademia is a series of books published by the University of Minnesota Press devoted to creative and critical work on anime, manga, and the fan arts. Linked through their specific but complex aesthetic, anime, manga, and the fan arts have influenced a wide array of contemporary and historical cultures through design, art, film, and gaming. This series seeks to examine, discuss, theorize, and reveal this unique style through its historic Japanese origins and its ubiquitous global presence manifested in popular and gallery culture. Each book is organized around a particular narrative aspect of anime and manga; these themes are sufficiently provocative and broad in interpretation to allow for creative and insightful investigations of this global artistic phenomenon.

MECHADEMIA 5

Fanthropologies

Frenchy Lunning, Editor

UNIVERSITY OF MINNESOTA PRESS MINNEAPOLIS • LONDON

http://www.mechademia.org

Spot illustrations by Barbara Guttman

Published by the University of Minnesota Press
111 Third Avenue South, Suite 290
Minneapolis, MN 55401-2520
http://www.upress.umn.edu

ISSN: 1934-2489
ISBN: 978-0-8166-7387-2

Printed in the United States of America on acid-free paper

The University of Minnesota is an equal-opportunity educator and employer.

18 17 16 15 14 13 12 11 10 10 9 8 7 6 5 4 3 2 1

Mechademia Editorial Staff

Contents

Modes of Circulation

Styles of Intervention

Review and Commentary

Introduction

FRENCHY LUNNING

Recently nothing has inspired more interest and attention in studies of Japanese and global popular culture than fans and fan activities, and the word *otaku* has entered both the popular and scholarly lexicons. But like other commonly used terms, we tend to naturalize words like "fan" and "otaku"— to assume we know all that they denote, connote, include, and exclude. In our need to identify and to find community, we lump common (mis)conceptions into a subject we call otaku. But in truth, we otaku are a vast multiplicity of subjects, practices, and texts that have gathered speed and are now fanning out in massive waves of morphing production and exchange. Constantly innovating, creating, performing, and consuming new iterations of this "style," this family of forms, narratives, and characters is sutured together by the conceptual threads of Art Mecho, the term we use to describe the visual and narrative forms that extend from Japanese anime and manga and that have now vaulted onto the global stage to be transformed over and over again in local sites and citations.

As Thomas LaMarre wrote in this volume's call for papers: "Terms like 'fan' and 'otaku' have been mobilized for a wide range of reasons in a wide variety of discourses, from gender studies to inquiries about technology and sociality. We think that the exploration of fan activities and *otaku* phenomena is crucial to understanding the contemporary world of transnational image and information flows, as well as the transnational formation of concepts and discourses. In keeping with our mission to forge links between different communities of knowledge and to challenge the conventional channels for the flow of information, in *Mechademia 5* we propose a challenge to the

received understandings of fans. We would like to challenge quasi-anthropological and pseudo-sociological readings in which the identity of 'fan' or 'otaku' is presumed in advance as a fixed object of knowledge." We have all seen these unproductive readings in condescending journalistic works where the identity of "fan" or "otaku" is assumed: the geeky but newsworthy Other. In contrast, the present volume conceives "fanthropologies" not as a pat anthropology of fans but as an exploration of landscapes and subjects that challenge received frameworks and ideas.

The call asked authors to consider the "social and historical construction of fans or otaku as an object of knowledge" from which new insights have emerged. From the many fine essays submitted, we chose several that rise to that challenge. The zones of activity treated in these essays range from manga and anime fansubs and copyright issues to dolls and Rococo style. They include a remarkable photo essay on the emerging art of cosplay photography, a biographical manga of a doll-fan, and an insightful discussion of Akihabara by a scholar disguised as a tour guide disguised in a cosplay costume. The response to our call for papers was so strong that the editors decided to continue the discussion in a follow-up volume, *Mechademia 6: User Enhanced*, to be published in 2011. *Mechademia 6* will present essays focused on alterations fans bring about through the reception of these performances and processes—the sometimes startling changes in landscapes, bodies, and subjectivities that become part of their fan identities.

Mechademia 5: Fanthropologies is divided into four sections. The first, "Sites of Transposition," focuses on transformative processes applied to texts, textual subjects, fans, and ideas about fans. The essays in the second section, "Patterns of Consumption," range from Ōtsuka Eiji's influential theory of narrative consumption to Kon Satoshi's narratives about consumption. The third section, "Modes of Circulation," discusses fansubs, scanlations, 2channel, and Akihabara's otaku tours. Finally, "Styles of Intervention," the fourth part, examines forms of militance and resistance (aligned variously along political, economic, national, and gender lines) possible in and through fan studies.

An exciting review section in this volume sparkles with cogent and critical discussions of emerging works, complementing these with a reflexive glance back in a special multipart review of *Evangelion 1.01*. *Mechademia 5* concludes with a fascinating dialogue between associate editor Thomas La-Marre and Patrick W. Galbraith in the トレンド or "Trends" section, a wide-ranging discussion that wraps up the volume by reviewing some of the dominant approaches to fan studies up to now and pointing to its possible and provocative futures.

Mechademia is proud to offer this volume, and we dedicate it to the vast, global, and radically diverse community of otaku who are breaking the rules and setting new standards through their innovations in fanfiction, illustration, animation, circulation, and distribution. With the two books of *Mechademia 5* and *Mechademia 6,* we hope to illuminate the discourses and discursive practices that spiral out from anime and manga and proliferate in increasingly dynamic and compelling forms.

Sites of Transposition

MARILYN IVY

• • •

The Art of Cute Little Things: Nara Yoshitomo's Parapolitics

In the beginning was, is, the word: *fan.* What is a fan? I refer to the *Oxford English Dictionary,* which I often do in such moments: it tells us that *fan* comes from *fanatic* (it is surprising how many people don't realize this origin). Whereas the *OED* does list a 1682 precursor ("The Loyal Phans to abuse"), not until the turn of the twentieth century does *fan* emerge as an American transformation of *fanatic,* referring to "a keen and regular supporter of a (professional) sports team" (originally, the *OED* states, baseball). From there it was not a big transformation for *fan* to morph into a "keen follower of a specified hobby or amusement" and thence to indicate "an enthusiast for a particular person or thing."[1]

Then, we might ask, what is a fanatic? The *OED* tells us that as an adjective, *fanatic* meant that which "might result from possession by a deity or demon; frantic, furious"; "Frenzied; mad." Furthermore, the fanatic is "characterized, influenced, or prompted by excessive and mistaken enthusiasm"; she is an "unreasoning enthusiast."[2]

The excessive, the unreasoning, the enthusiastic, and the mistaken: these, then, are some of the semantic dimensions of the fan that haunt its history. In the fan's singular obsession with a mistaken object—one that

somehow inappropriately, and excessively, stands in for healthier, normal object choices—we hear more than a suggestion of the notion of the fetish.[3] The *affect* of the fan—devoted enthusiasm—is here combined with a question mark appended to the *object* of that (inappropriate) enthusiasm. In its indication of the phenomenon of possession, the *OED* reveals how affect and object exchange substance; the body of the fanatic is caught up in a frenzy of identification with the object of his devotion, such that the deity takes over the fanatic's very being. The excessiveness of the fan's enthusiasm is bound to result in a mistaken object of affection; conversely, the very mistakenness of the object is tied to the mistaken enthusiasm of the fan. In either or both cases, the social abnormality of the fan-object relation is staged.

Perhaps nowhere more so than in Japan has the fan figure, with its incarnation in the *otaku,* been pushed to the extremes of mass cultural fascination. The stereotypical otaku figure displays an intense intimacy with mass-mediated fan objects; a highly developed connoisseurship of animated minutiae; a solitary mode of being, yet accompanied by absorptions into virtual sociality (with forms of convening and movement that bespeak new modes of communication); and something akin to fetishism, in which small objects of desire come to stand in for the larger, more totalized sexual relationships that are designated as normal and good.[4] We might think of the otaku figure as embodying the core contradiction of the fan figure in general: big passion, little object (often literalized in the otaku's attraction to and passion for minutely specified elements of aesthetic form—the color of an animated figure's hair, for example, or the cat's ears a character displays: elemental provocations of desire, elements of *moe,* to use the Japanese word).[5]

The otaku-child figure, lost to normal sociality, sexuality, and national–cultural identification, has thus been refunctioned in academic and aesthetic discourses as the most appropriate sign for the strange fate of the Japanese nation-state and its peculiar history: defeated in World War II, bombed atomically (the bomb dropped on Hiroshima was called "Little Boy"), and dominated by the looming, fraternally sinister, yet comforting presence of the United States. To many, the otaku figure has seemed to encapsulate all-too-perfectly the infantilization and impotence of the Japanese nation-state and its mass culture in the wake of Japan's defeat in 1945.[6] But the otaku figure is merely the most publicly available and capitalized-on object of national-cultural anxieties about youth and national futurity. Primarily gendered male, otaku find their mass-cultural counterparts in the objectified persona of *shōjo* (young girl), a word indicating a subject position that is primarily female but can be affectively shared by either gender (shōjo

indicates a psychically open space epitomized by the "adolescent girl" not yet fully appropriated by the socio-sexual order).[7] With their everyday commodity desires for the *kawaii* (cute) and for the tender, whimsical, and romantic affective worlds that embody cuteness, shōjo have become the theoretical counterparts of otaku.

How do the large obsessions of fans and the smallness of ludic objects, cuteness and weirdness, the child and the adult work together in contemporary Japanese art? That is a question I want to explore by looking at the works of Nara Yoshitomo. Nara—acclaimed for his paintings of small, solitary, strange children in various states of anger, abnegation, and abjectness—has become the center of a large international community of fans, many of them young women, who have found in his art and his aesthetic practices expressive means to identify their experiences of advanced capitalist everydayness and the mysteries of psychic maturation. Nara's work explicitly and repetitively thematizes the "child" as an internal formation and as an external object in mass culture and commodity life; his works incorporate a thoroughly disciplined syntax of dreamlike associations, fairytale motifs from European sources, American and Japanese comic-book styles, and naive figurations of young girls and animals (mostly puppies) to create an art that has produced startling effects of identification among many viewers. The resolutely nondigital and handcrafted visual styles of Nara are at the opposite end of the spectrum from the high-gloss digital artworks of Murakami Takashi, Japan's most famous contemporary artist (Nara would be a close second). Yet, as we know, the two artists have collaborated on many works, have had joint exhibitions, shared interviews, and have a long-term working friendship (although it is said that the friendship is no longer viable). There is even a Web site called "Narakami" that sells their products (it assures its readers that Murakami and Nara are "good friends").[8] Murakami has worked to theorize his art and has incorporated Nara's works in his larger theory of Japanese art, which he has termed "Superflat." In engaging "Superflat" visuality and its relationship to the gaze and the figure of the child, we can begin to grasp the fan appeal of Nara's works and their powers of attraction.

> THE EXCESSIVENESS OF THE FAN'S ENTHUSIASM IS BOUND TO RESULT IN A MISTAKEN OBJECT OF AFFECTION; CONVERSELY, THE VERY MISTAKENNESS OF THE OBJECT IS TIED TO THE MISTAKEN ENTHUSIASM OF THE FAN.
> IN EITHER OR BOTH CASES, THE SOCIAL ABNORMALITY OF THE FAN-OBJECT RELATION IS STAGED.

So first, Murakami: he came to international attention with his exhibition entitled "Superflat," held in Japan in 2000 and subsequently staged in the United States in 2001. Murakami's essay "Superflat Manifesto," which opened the catalogue for the exhibitions, presented a distinctive theory of Japanese art. Saturated by the techno-aesthetics of Japanese anime in particular and mass-cultural energies in general, Superflat art is premised on a digitally constituted world, one in which a multiplicity of perspectives and planar surfaces coexist without the privileging of any one perspective or plane.[9]

Superflat connotes much more than the visual, however. For Murakami, it also connotes the resolute flattening of distinctions between popular culture and any form of high culture. And even though Superflat is most closely associated with contemporary postdigital aesthetics, Murakami is invested in theorizing a lineage of Japanese aesthetics, a particular stream of artistic production that has emphasized the movement of the eye across decorative, metamorphosing, playful surfaces. It is an aesthetic that fundamentally overflows and displaces canonical distinctions between high and low art and much else in the name of a singularly imagined Japanese visual and cultural regime. Among those hierarchies that Superflat art displaces—or claims to displace—is the familiar one that includes the adult and the child. It is this Superflat placement of the child that I want to take up here, starting with the very notion of the subject itself and its relationship to vision.

In his important essay entitled "Super Flat Speculation," which functions as a companion essay to Murakami's "Super Flat Manifesto," the philosopher Azuma Hiroki uses the work of Jacques Lacan to theorize the work of the gaze, or the play of gazes, in Superflat aesthetics. As Azuma explains: "I look at you. You look at me. And it is the interaction of our gazes . . . that provides us with the sense that we share the same space, that we occupy a common 'there.'"[10] The creation of this effect is produced through the "use of linear perspective and the interaction of gaze."[11] Azuma then argues that linear perspective—which conjures a sense of reality by having lines of sight converge on a central vanishing point, thus producing a unified sense of space—is a socially constructed perspective that "requires the suppression of the childish sensibility that would see instead an accumulation of independent objects . . . each an image with which to be empathized individually."[12] Again, Azuma: "A child sees something, and in so doing feels desire. But the child has no conception of 'the self looking at something.' Simply put, the child is unaware of the relativity of its own perspective. Lacan understood this state as lacking an *awareness of gaze*." This suppression of the child's unself-conscious, visually polymorphous sensibility, this abandonment of the omnipotent realm of

images, is virtually synonymous with Lacan's notion of castration: "to be castrated is to abandon a direct tie to the image (the direct gratification of desire) and come to recognize one's own gaze. . . . The child may be charmed by images, but the adult is conscious of

> A SOLITARY CHILD IS SUSPENDED WITHIN AN INDETERMINATE, MUTED BACKGROUND; THE CHILD IS ALONE AND LONELY, CONCURRENTLY TENDER AND VIOLENT, ADORABLE AND PERVERSE: THIS IS THE ARCHETYPICAL SCENE IN A NARA PAINTING.

the gaze."[13] The child must abandon the realm of images, of the omnipotence of its desire, to enter into the (adult) realm of the social. Murakami's work embodies this relationship between the child and vision by his incessant motifs of anime-like eyes throughout his art, eyes that are "signs of eyes," in Azuma's formulation.

Nara Yoshitomo's work embodies a different relationship to the child and to the gaze. A solitary child is suspended within an indeterminate, muted background; the child is alone and lonely, concurrently tender and violent, adorable and perverse: this is the archetypical scene in a Nara painting. Nara's work has been compared to that of Balthus; others see it as evoking outsider art, or children's art itself, in its use of simple lines and deformations.[14] Sketches and drawings, the forms that Nara has consistently valorized (even in his highly finished paintings, the emphasis on drawing remains), have commonly been regarded as preparatory to painting as the *summa* of the artistic process; thus, drawings are canonically considered incomplete, in process, developmental, characteristics that are easily mapped onto the figure of the child in process, an entity ever metamorphosing.[15] Texts and pictures sometimes overlap, with a proliferation of works made up of scrawls on envelopes, scribbles on brown paper, and pages torn from notebooks. These remind one of the illicit drawings of a child at school, transgressive and furtive. They are all resolutely undigital. They all evoke an aesthetics of the fragment. In their fragmentation and in their elevation of drawing, again, they evoke the minor, the occasional, the spontaneous, the misfit (thus Nara's many references, implicit and explicit, to punk rock), and the child: theme, style, and medium recapitulate one another (Figure 1).[16] And with exceptions and elaborations— Nara's work is more diverse than is sometimes acknowledged—his signature characters, the ones that seem to exemplify this aesthetic more than others, are the glaring, large-eyed girl children of his iconic portraits, strange permutations of the round-eyed *über*-cute girls of manga and anime renown.

Do Nara's children lack the gaze of Murakami's anime characters? These children do not have the anime eyes that Murakami produces, the signs of

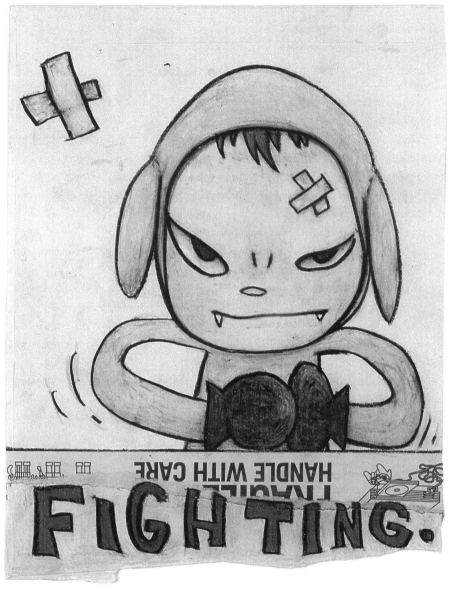

FIGURE 1. Nara Yoshitomo, *Fight It Out*, 2002. Courtesy of Marianne Boesky Gallery, New York.

eyes, as Azuma describes them, within fields of superflattened digital repetition. Yet, the eyes have it in Nara's work. They are a recurrent motif, with a recurrent signature shape: elongated, narrowed, a flattened ellipse (a black half-circle works as an analog of the iris; a smaller olive-colored half-circle operates as the pupil). Here we don't feel so much the pulling of the gaze over

the plane of the work, of the morphing of forms into one another, as the pulling of our gaze toward the eyes of Nara's children. The eyes of these child figures function as repositories of smoldering affect. Most famously, they glare. Sometimes they look sad, other times frustrated. Rarely do they present an unmediated happy face. It is as if Nara reinstates the gaze presumed to be missing in the promiscuous vision of Superflat art, thus providing an uneasy supplement to Murakami's anime-inspired "signs of eyes" (Figure 2).

Following Lacan via Azuma, we might say that Murakami's signature work is in the domain of the imaginary, of a pre-oedipal, unfettered promiscuity of infant vision, while Nara's reinstates the post-oedipal child, the child who has already found itself abandoned within the symbolic order. Nara gives back something that Murakami forecloses. He gives back the lack that lacks in Murakami—and that might signal the ultimately horrific dimension of Murakami's serially repetitive eyes—in the register of loss, figured by the vulnerable yet aggressive children in his work. He locates a range of affects that Murakami does not provide. His characters are epitomes of perverse children, sometimes clutching knives or smoking cigarettes, with oversized heads and narrowed, elongated eyes. Nara's solitary children are somehow outside the social at the same time that they seem to have borne prematurely the burdens of the socio-symbolic order. They upset the developmental temporality that the child must traverse on its road to normalcy (Figure 3).[17]

Their eyes, if not precisely anime-like, do not provide the realist instantiation of the gaze that classic Western portraiture would provide, either (and here the famous example of Hans Holbein's painting *The Ambassadors,* which Lacan discusses—and Azuma takes up—as exemplifying the intersection of gazes constitutive of one-point perspective and the form of subjectivity the results from this perspective). Typically, these child figures don't look directly at the viewer, and when they do look frontally, their eyes don't leave the impression of a reciprocal gaze. Their vision is oblique, fixed on the middle distance; even the objects they often hold fail to fix their gazes. Nara's affective visions course through the figure of the traumatized child (we could say "the castrated subject"), yet the "castrated" space of vision here does not constitute one of perspectivally reciprocal, intersubjective space. Instead, in the obliquity of their regard, the little child figures—glaring out into the distance but not composed to intersect with the gaze of the viewer—seem to reveal a traumatic encounter with the Real; at the same time, their aggression is not directed to any one point of blame or appeal. Their eyes, "looking awry," seem to be fixed on some anamorphic spot, some blot that has caused them to become preternaturally worldly: traumatized children, yet children

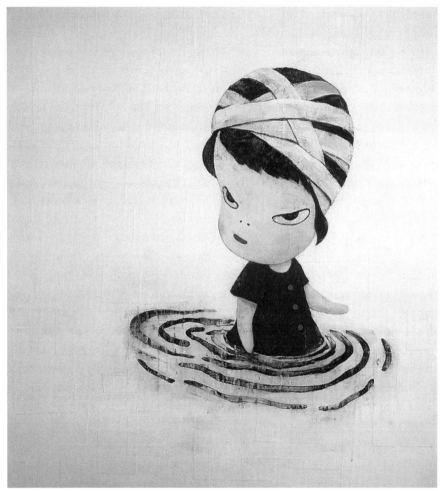

FIGURE 2. Nara Yoshitomo, *In the Deepest Puddle*, 1995. Courtesy of Tomio Koyama Gallery, Tokyo.

nevertheless.[18] Their regard—or lack of it—is directed toward the immensity of the socio-symbolic order itself.

Thus, they often float out of or stand in indeterminate space, a kind of creepy (some would say dreamy) pastel background, featureless and encroaching (in person, one can see the impeccably polished finish of the backgrounds of these often enormous paintings). Sometimes the child stands waist deep in a dark puddle of nothingness that extends in every direction to the edges of the painting. This formless surround of the indeterminate becomes the condition for their semi-emergence as subjects, at the same time that it threatens to engulf them. They smoke cigarettes, hold knives (and paintbrushes), and clearly can wound (and are wounded, repeatedly), yet their tough stances

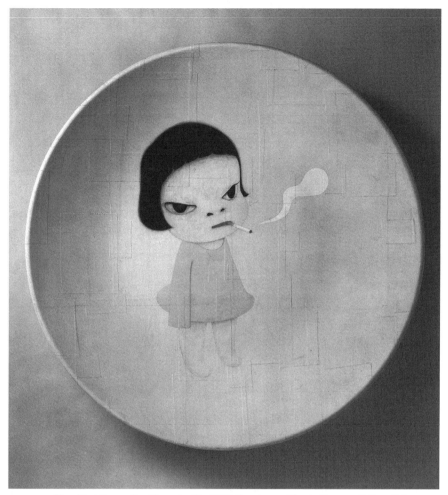

FIGURE 3. Nara Yoshitomo, *Too Young to Die*, 2001. Courtesy of Tomio Koyama Gallery, Tokyo.

and glares rarely attain the status of unalloyed malevolence (although the child in Nara's painting *The Little Judge* comes close) (Figure 4).

We might regard these children as suspended subjects, subjects in formation. To paint a child as a subject is to suspend or stop time at a moment when the body-being is at its most transformative; the child virtually embodies the principle of change and metamorphosis. If paintings of children tend to focus on their innocence and purity, it is precisely to foreground a much-desired transitory perfection and their aesthetic protection from the forces of inevitable growth, and thus the loss of childhood itself. Nara's children are not playing; they are not set within worlds of growth and movement. They are not located within family (certainly not), with friends, with any Other at

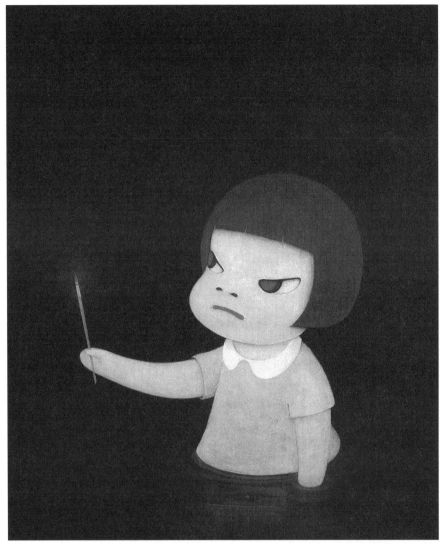

FIGURE 4. Nara Yoshitomo, *The Little Judge*, 2001. Courtesy of Tomio Koyama Gallery, Tokyo.

all. They are resolutely alone, literally conveying the sense of loneliness that Nara constantly references in his writings and interviews.

Nara himself has spoken of the "pure evil" of these children, not without a certain wryness, one must assume. In 2005, my then-seven-year-old daughter accompanied me to Hawaii for the opening of Nara's solo exhibition "Nothing Ever Happens" at The Contemporary Museum in Honolulu. I had been asked to give a lecture on Nara and related themes as part of the exhibition activities, and so my daughter had been introduced to the world of

Nara. Rather than charming or engaging this seven-year-old, Nara's children repelled and annoyed her. Calling them "disgusting children," she produced a surprisingly coherent and impassioned series of reflections on Nara's work, saying that he saw children as evil, that he didn't understand children. She asked me if Nara "hated" children. "Real children aren't like that," she said. "It's kind of insulting to children."

"Don't you think they're cute?" I asked her, leadingly.

"There's nothing cute about them," she insisted.

Rather than lingering on the irony that Nara's child figures completely put off a *real* child (revealing that this art is not produced with children as its intended audience), I want to remark the intensity of the affect that Nara's work evoked in my daughter. When such strong affect is elicited, there's sure to be some kind of (over)identification at work, such that the object becomes the externalized locus of, in this case, negativity. I was not innocent in asking my daughter if she thought his children were cute, because that is the fundamental operative term that is used in assessing Nara's work, both critically and affirmatively. It is perhaps surprising that the minor aesthetic concept of the cute could even provoke such affect in either its positive or negative aspect (so what if it's not cute?). When my daughter denied that there was anything at all cute about Nara's work, she was attempting to fend off the insult to the world of children, her world, that such a perversion of the cute would imply—implying as well that Nara's children were all too cute for comfort.

Here, then, we might want to linger further on the cute—the *kawaii*—itself, as it becomes such a crucial aesthetic term for thinking about Nara's work, and indeed, for much of contemporary art and everyday culture. The origins of *kawaii* had to do with pity or empathy for a small or helpless creature—archetypically, a child or infant. At its inception, then, the notion of the cute is entirely wrapped up in the relationship to the child figure as the epitome of vulnerability and helplessness (and thus *kawaii* is closely linked to the notion of *kawaisō*, or "pitiful").[19] There is no doubt that *kawaii* is gendered feminine, with women and girls linked, as they are in many societies, with children (and, yes, with little animals). From the 1960s on, *kawaii*'s implication of pitifulness and helplessness expanded, under the pressure of mass-cultural proliferations of new categories of taste to what it came to mean in the United States: a positive aesthetic descriptor of things pert, neat, appealing, attractive, and engaging but not heavy, glamorous, massive, or overwhelming. There is always a dimension of vulnerability, smallness, and—indeed—(feminized) childishness attending the *kawaii*.

Yet, of course, "There's nothing cute about them." In a brilliant essay, Sianne Ngai has taken on the cute—as well as the *kawaii,* which in its modern form is close to the English-language notion of cute—in asking how such a commercially elaborated notion came, in an inverse fashion, to influence avant-garde works of art. The differences are, of course, immense: "While the avant-garde is conventionally imagined as sharp and pointy, as hard- or cutting-edge, cute objects have no edge to speak of, usually being soft, round, and deeply associated with the infantile and the feminine."[20] Yet she uncovers unsettling similarities between the resistant ineffectuality of avant-garde art in the midst of capitalized mass culture and the minor aesthetic concept of the cute: the avant-garde text often "thematizes and formally reflects . . . the oscillation between domination and passivity, or cruelty and tenderness, uniquely brought forward by the aesthetic of cuteness."[21] Both the avant-garde work and the cute object as modern phenomena ("cute" really developed as a standard taste concept in mass-cultural society), as articulations with commodity culture, embody an extreme powerlessness that can turn over into its opposite: resistant testimony to the violence of domination. The cute object is, she says, the most "reified or thinglike of things, the most objectified of objects,"[22] and the extremity of that objectification is precisely the fundament of the potential resistance of cuteness.

Commercial cuteness depends on pliability and softness: the cute object "invites physical touching"[23] at the same time that it shows how central anthropomorphism is, such that objects are given faces and, typically, large eyes. For Ngai, the "smaller and less formally articulated or more bloblike the object, the cuter it becomes—in part because smallness and blobbishness suggest greater malleability and thus a greater capacity for being handled."[24] From there, she argues, it's not difficult to see how these "formal" properties of the cute object elicit particular affects. Softness, roundness, squishiness, and simplicity are important, because, as she continues,

> it is crucial to cuteness that its diminutive object has some sort of imposed-upon aspect or mien—that is, that it bears the look of an object not only formed but all too easily *de-*formed under the pressure of the subject's feeling or attitude toward it . . . We can thus start to see how cuteness might provoke ugly or aggressive feelings, as well as the expected tender or maternal ones. For in its exaggerated passivity and vulnerability, the cute object is as often intended to excite a consumer's sadistic desires for mastery and control as much as his or her desire to cuddle.[25]

The movement of a child or a toy out of its domain of cuteness and passivity, of innocence under the control of the parental superego, is one of the most disturbing events imaginable. The cute, in its very vulnerability, inevitably entails the uncanny (*bukimi,* as one standard Japanese word used to translate the "uncanny" indicates). In "The 'Uncanny,'" Freud attempted to account for unpleasant affects and untoward effects in the domain of art, ones that couldn't be included within the classic domains of the beautiful or the sublime. His essay took up one such minor aesthetico-affective experience in literature: that of the "uncanny" (*unheimlich*). What is the uncanny, Freud asked, and how are uncanny effects produced in literature (and secondarily, in life)? The core twist of the work, the memorably important key to understanding the essay, lies in the very term itself: *unheimlich.* Freud shows how the *unheimlich*—the uncanny—emerges etymologically from its exact opposite, from the *heimlich:* the intimate, the homely, the private. Through a process of slippage, a word that designates the most homelike and friendly affect turns into its ugly opposite: the weird, the eerie, the decidedly *not* homey. In a doubling that is characteristic of the entire essay on the uncanny, the most uncanny experience of all is having a word turn into its opposite; a word that means everything homelike and intimate becomes *un*homelike (*unheimlich*), alienated and, well, uncanny. The very notion of the *unheimlich* is itself *unheimlich.*

We are now in a position to see even more clearly what Nara's child paintings are staging. His signature paintings of "evil" children are deformations of the cute; they reproduce many of the conventions—big heads, roundness, softness, squishability, wide eyes—but in a version that has been, precisely, squeezed and compressed by the deformational technique of the artist. The modal requirements of the *kawaii* have been pushed past the limits of vulnerable malleability, disclosing the aggressive dimension always implicit in the cutified aesthetic relationship. These works of Nara stage, in turn, the reciprocal resistance of the cute, its "imposed-upon aspect or mien" that reveals the "pressure of the subject's feeling or attitude toward it."[26] The undecidability of the difference between the *kawaii* and the *bukimi* (Is it cute? Is it creepy?) is *itself* uncanny. But an element of pathos strongly inflects these works: the pathos of the cute object already de-formed by the intersubjective encounter with the subject (artist, viewer). That these works should literally take the form of the child—one might say, they virtually *demand* to take the form of the child—only dramatizes this uncanniness, at the same time it discloses the understanding that nothing is more uncanny than the child herself.

This identity of the *kawaii* and the *bukimi,* the cute and the uncanny, has not been lost on Japanese art critics and observers nor on the devoted fans of Nara (although neither the formal dimensions of the "'uncanny" pertaining to cuteness nor the historical relation of the "cute" to the avant-garde have been adequately theorized). What is particularly difficult to grasp, however, is how that conjunction mobilizes such intense fan affection. With affects ranging from tenderness to breathless praise to passionate attachment and beyond, devotees find in Nara's works an intensity of expression that speaks for them, that speaks a shared relationship to their past, and specifically, to their childhood. The art critic Matsui Midori writes that Nara's paintings "recapitulate the child's telepathic sympathy with the phenomenal world"; later in the same essay, she remarks the "special gaze" of the child in Nara's work, as it "penetrates beyond the world she inhabits."[27] The syntax of dreams, unspoken forms of communication (Nara's use of language awaits a study: its display of comic-book captions, its reliance primarily on English but also on Japanese and German, its slyly fractured use of punctuation), and magical forms of identification all become modes of description for Nara critics and fans. The assessments seem to go beyond critical praise and analysis, and take flight into worlds of description that the writers hope can do justice to Nara's children. One wonders how much these lyrical flights of critique are really focused on Nara's works and how much they are really talking about the figure of the child itself and its ineffability. Yet, at the same time, this critical lyricism is pointing to nothing else but the commodified everyday, that place where "nothing ever happens" (the title of one of Nara's solo exhibitions in 2005), and which Nara (along with contemporaries such as novelist Yoshimoto Banana) pulls into the malleable, open world of childhood imagined from afar.[28]

Nara's art works with the intimacies of the cute and the ghastly, but in ways more intimate than Murakami's explosive fusions and bluntly didactic foregrounding of the unmitigated horror of the *kawaii* in its Japanese incarnation. They produce undeniable effects of fan devotion. Nowhere is this seen more clearly than with his groundbreaking exhibition at the Yokohama Museum of Art in 2001 entitled "I DON'T MIND, IF YOU FORGET ME," which established Nara as a major contemporary artist in Japan. Nara had recently returned to live in Japan after some ten years in Germany, and the exhibition represented a homecoming for him, a return to the land of his childhood. This exhibition explicitly produced the museum as a theater of childhood, and it did so by producing new fans and enticing old ones to participate in what came to be known as Hamapuro (the "Yokohama Project"). The Hamapuro

entailed putting out an open call through the Nara Yoshitomo fan Web site Happy Hour (now defunct) for volunteers each to sew a stuffed doll-toy (what the Japanese call *nuigurumi*) of one of Nara's figures. In a reversal of the commercialized trajectory in which one of Nara's eminently copyable *kyara* ("characters") becomes licensed out to toy companies and made into purchasable plush toys, Nara incorporated his fans in an enterprise that was outside the commodity circuit: make your own hand-sewn Nara plush toy and then donate it for use in the exhibition. Imagined as a way to produce a fan collectivity, as an "action" that would incorporate the energies of fans in the exhibition itself, the Yokohama Project drew on the immense longings and identifications of the Nara fans to share his world. In attempting to move out of the commodity circuit—Nara increasingly uses volunteer labor to erect his museum installations—and to reframe the star–fan relationship as one of gift exchange, Nara works to produce the sensation of a shared emotional and aesthetic community.

What provides the basis for fans' participation in something as elusive as an artist's work? (Nara doesn't have a rock band or baseball team, as of yet). The Yokohama exhibition revealed the outlines of this project. At the entrance of the museum visitors saw—spelled out in huge, hollow, clear acrylic letters— I DON'T MIND, IF YOU FORGET ME (Figure 5). Massed inside those letters? Hundreds of the stuffed Nara-figures made by his fans—there were some 1,500 figures in total—redefined, in the process, what it means to be a "stuffed toy" (Figure 6). Lined up on shelves below these letters were vintage toys, Nara's own collectibles, not all of them *nuigurumi* but all of them childhood toys. In another section of the museum was installed an enormous, room-spanning mirror with the words YOUR CHILDHOOD imprinted across the middle. And there, on the floor in a most promiscuous pile, were hundreds more fan-made stuffed dolls, heaped in profusion. Walking into the room, visitors confronted their own reflections in a mirror entitled YOUR CHILDHOOD, which reflected as well the sea of stuffed toys piled on the floor (Figure 7).

The art critic Sawaragi Noi thinks through the relationship of the *kawaii* to the *bukimi* (he explicitly remarks a relationship of equation between them) in an essay that compares the tried-and-true coupling of Murakami and Nara to the American one of Jeff Koons and Mike Kelley in the 1980s: Koons with his monstrous pink panther balloons and stainless steel rabbits, the shine and gloss of the commodity form and its sheen of glossy technical achievement contrasted with Mike Kelley and his defaced, restitched, stuffed animals, discarded objects unfit for the "adult" space of the museum.[29] Here, the commentary on art—high/low, museum'd and otherwise—is paralleled

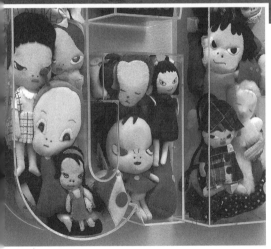

FIGURE 5. Nara Yoshitomo, *I DON'T MIND, IF YOU FORGET ME*, 2001. Installation view at Yokohama Museum of Art, Yokohama. Photo by Yoshitaka Uchida. Courtesy of Tomio Koyama Gallery, Tokyo.

FIGURE 6. Nara Yoshitomo, *I DON'T MIND, IF YOU FORGET ME*, 2001. Detail of installation at Yokohama Museum of Art, Yokohama. Photo by Yoshitaka Uchida. Courtesy of Tomio Koyama Gallery, Tokyo.

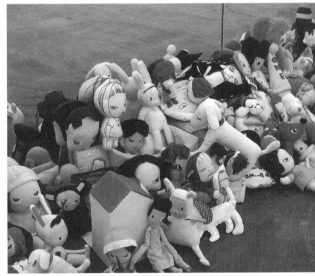

FIGURE 7. Nara Yoshitomo, *I DON'T MIND, IF YOU FORGET ME*, 2001. Detail of installation at Yokohama Museum of Art, Yokohama. Photo by Yoshitaka Uchida. Courtesy of Tomio Koyama Gallery, Tokyo.

with the place of childhood objects and of subcultural refuse. Sawaragi is interested in how not only toys but stuffed toys have functioned in aesthetic theory and practice. In thinking, then, about the place of the *nuigurumi* in contemporary art, Sawaragi deftly refers to them as "transitional objects" (*ikō taishō*). What, indeed, are stuffed animals, plush toys, doing for all those two-year-old kids? They are, in the thinking of the psychoanalyst D. W. Winnicott, objects that help the child move away from the Mother by operating as substitutes for the maternal presence. They are loved fiercely, and, in the strongest instances, they never leave the child, even to the point of the disintegration of the soft object itself (one remembers *The Velveteen Rabbit*). At a certain moment, however, they must be overcome, discarded, expelled from the household and from the physical attachment and love of the child, if the child is to transition into the world of the adult, so object-relations analysts contend. Yet what becomes of the discarded transitional object? What happens when one does not give up the transitional object? Then we might find the perpetual child, the one who transfers transition, who defers transition, from one beloved object to the next. (This deferral of transition could describe a dimension of perversity.) Is this description so different from the obsessive otaku fan, the Nara groupie, or even the modal addictive consumer of late capitalism?

What Nara thematized so forcefully in "I DON'T MIND, IF YOU FORGET ME" was the place of this transitional object, its place as remnant, as refused and as refuse, as leftover and excess. By virtue of this leftover quality, the abandoned *nuigurumi* powerfully embodies and evokes the child as past, and the past *as the child*. What is engaged is the place of the child as *itself* objectified as transitional, commodified in the work of art and imagistically available for purchase in any number of Nara stuffed toys (for adults as well as for children). The child is always and ever *in transition,* and it is only by a process of abandonment that one can provisionally give up the fixated version of childhood to which one clings. In visually fusing YOUR CHILDHOOD with the abandoned *nuigurumi,* visitors were invited to reflect—literally—on an irrevocably past but still potent identification with the child.

For anyone who has been to Japan and visited Buddhist temples, the sight of figures of the bodhisattva Jizō, the protector of pregnant women, children, and the dead, standing over heaps of material objects given in remembrance of deceased loved ones is familiar. Jizō has come to be the patron saint, if you will, of aborted fetuses; women who have had abortions (along with women who have lost a child) often give offerings to Jizō, many of which consist of dolls, toys, stuffed animals, items of clothing: all the material signifiers of

childhood, now given away and alienated as offerings. To see heaps of purposefully abandoned *nuigurumi* is inevitably to evoke the deathly resonances of Jizō offerings.

Nara is from the prefecture of Aomori, where the sacred Mount Osore is known for its yearly summer festival in which blind female spirit mediums call down the dead. Mount Osore is watched over by Jizō, and innumerable small Jizō shrines, almost buried in offerings of children's clothes, toys, and dolls, mark the landscape of the mountaintop. However distantly, this relationship of death, children, and the accumulation of *nuigurumi* must function in the artistic unconscious of Nara Yoshitomo. As such, then, the excess of these dolls, these toys, at the Yokohama exhibition evoked a kind of "horror," according to one critic, a horror connected both to the death of childhood through the abandonment of toys and to the palpable death of actual children evoked by a number of dolls heaped on the floor. The dolls functioned as stand-ins for the dead: dead children, the death of the child's time, the dolls themselves as corpses.[30] As "stranded objects" that can no longer be used to help the child transition into maturity, they evoked a particular melancholy and morbidity.[31]

Yet these stuffed toys were constructed to be exhibited, constructed to be abandoned in this overtly theatrical way. They were not, precisely, the abandoned, dirty "lovie," with button eyes missing and ears ripped off. These were new, handmade dolls—faithfully portraying or evoking Nara's signature figures—that were given up by fans to be exhibited and then used to stage the scenario of the abandoned transitional object. The peculiar nature of these *nuigurumi* is disclosed by the letters from the Hamapuro fans to Nara the artist, many of which were published.[32] The fans referred to each other as "brothers and sisters" (*kyōdai*); what is more, they refer (as did Nara himself) to the dolls (*ningyō*) themselves as brothers and sisters, or alternatively, as their "children" (*ko*). Take this message from Nanao: "First off, I was deeply impressed by how the exhibit was put together . . . Seeing so many brothers and sisters, filled with loving care, I was so happy I could hardly stand it. No matter how many there were and even though there were so many of them, I thought they were all works familiar to me in their innocence. (I had a weird [*fushigi na*] feeling when I saw myself reflected in the mirror.) I thought it was really wonderful that I could participate. When I found my child [*ko*] in the exhibition hall, I thought, 'It really did arrive in good order!' and I started to cry a little."[33] Another one: "When I saw them in photographs, they appeared extremely individualistic taken one by one, but when I actually saw them at the exhibition, they became one work, and it was really moving. I searched

for my sibling [*kyōdai*] with all my heart, and I found one that looked like it was the one. It was great that I could participate in such an awesome [*suteki na*] project." And another: "I was transfixed by forms that exceeded my imagination. Once again it came home to me how amazing Nara-san is. Really, going to look for my sibling was such a joy." Repeatedly, the messages express their appreciation (*kansha*) to Nara, their feelings (*kanjō*), and their happiness at being part of the "project" in which they communed with "brothers and sisters" fictively produced as coparticipants and as intimately produced dolls (which also took on the status of children).

The back jacket of the exhibition catalogue responded to the title I DON'T MIND, IF YOU FORGET ME by proclaiming "Because, You Never Forget Me. I Never Forget You." If we can move through the oddities of these phrases (including the punctuation), we might imagine (as Sawaragi does) that the subject here, the "I" (*boku*) of the enunciation stands in for the abandoned child within, who had to be given up along with the beloved *nuigurumi* as well as childhood itself. The addressee must be the adult viewer, those who through this exhibition can reencounter the lost land of childhood and the lost child there. The child, the child of the past, the lost child, and the thrown-away transitional object fuse here in a movement of prosopopoeia (the movement of personification, which Ngai says is always at stake with the "cute" object and its relation to its owner or viewer: one thinks of dolls and the ventriloquism of their child owners). The dead child and the abandoned doll are given voice in Nara's titles, and what is creepier than the undead (child, doll) speaking? The voices are from beyond the grave or the trash heap, saying, "I don't forget you" ("Because, You Never Forget Me"). In a reversal of the title of the exhibition—"I DON'T MIND, IF YOU FORGET ME"—the rejoinder on the back of the catalogue reminds us that there is an "unforgettable" dimension to the relationship of child and transitional object, adult and inner child. Here is where the therapeutic dimension of Nara's exhibition is encountered: not unlike "inner child" therapies in the United States and elsewhere that would enjoin the adult to use finger paints or to draw with the nondominant hand in order to go back to the state of childhood, to recover the missing "inner child," Nara's work solicits viewers to attend to an inner world of affect that had been repressed in an attempt to transit to adulthood.[34]

Sawaragi has argued that along with this potentially therapeutic dimension of Nara's staging for viewers is perhaps a more persuasive interpretation: that in contemporary Japanese consumer society, *everyone* is in thrall to commodity fetishes in the guise of *kawaii mono* (cute things), mass cultural figures, icons, and Internetted experiences, such that the transitional object

NARA DRAWS ON THIS INCHOATE
LONELINESS OF THE YOUNG IN
RECESSIONARY JAPAN,
REFUNCTIONING LONELINESS AS
THE BASIS FOR COMMUNITY
ITSELF: THE LONELINESS, ONE
MIGHT SAY, OF THE SUBJECT
WHO HAS GIVEN UP THE
TRANSITIONAL OBJECT BUT
FINDS ADULTHOOD LACKING.

is never relinquished; the dependency on the object that keeps the Mother near is merely transferred from one form to another, keeping Japanese (or Japanese consumers) in a state of perpetual childhood. Adulthood is indefinitely postponed, and a dimension of unending fetishism and perversity is fundamentally inscribed into everyday life as it is. On this view, Japanese institutional structures of adult order and symbolic force are profoundly complicit in reproducing this system of childishness. As such, most viewers of Nara's exhibition probably did not experience anything like a therapeutic catharsis through the reminders of childhood traumas of abandonment; they merely, as Sawaragi proffers, turned toward Nara's iconic "characters" in a movement of desire and attraction (*kyara moe*), as his works engage the intimate entanglement of iconic "characters" from mass culture and older forms of portraiture.[35]

Yet it is clear that Nara's fans—fans largely drawn from a certain recognizable stratum of shōjo or post-shōjo girls and women—are subjects who do register some sort of cathartic encounter with childhood in viewing his works, and particularly in a form of community that was enabled by the Yokohama Project. Nara himself muses on this fan relationship in an interview:

> In Japan my fans are people who don't often go to galleries and museums. They just like my pictures, I don't really know why. Most of them are teenagers, some in their twenties, and a few in their thirties. In the beginning I was afraid that they were too young to follow my work, but their reaction to it led me to realize that they understand correctly, and deeply, what is expressed in my paintings. They spend no time on the surface of the work. I can verify this from the overwhelming flood of fan letters that I receive. The publisher of my last book enclosed a small readers' survey card to fill out, and whereas in most cases people don't take the trouble to pick up a pen, we received thousands of replies, many of them quite detailed. It meant that the majority felt personally addressed by my work; in Japan there are hardly any kids who haven't experienced the things I have or shared the same feelings.[36]

While Sawaragi believes that Nara's work follows the movement in postmodern Japanese art from an emphasis on the artist and the work of art

to the lure of the *kyara,* Nara instead seems to mediate between an older sense of the artist and a serial logic of *kyara* proliferation (indeed, Nara denies that there is any seriality in his work whatsoever, although an intensive repetition of motifs and forms is obviously at work). His multiple paintings of virtually identical child figures—each one, however, entailing a crucial aesthetic difference—make homely and unhomely the serialized modalities, however enthralling, of *kyara* production. Indeed, Nara personalizes seriality while keeping it recognizable and leaving it open after the fact to mass-cultural recuperation (just look at his plush toys on the market, wherein his figures become "characterized"). His child paintings operate as generative nodes of filiative identification with his fans: they literally operate as children and siblings for fans, and arguably, for Nara. This sense of filiative identification binds his fans into networked affiliations, often notated in the language of kinship.

Nara draws on this inchoate loneliness of the young in recessionary Japan, refunctioning loneliness as the basis for community itself: the loneliness, one might say, of the subject who has given up the transitional object but finds adulthood lacking. What might seem to be an aestheticization of the (potentially) political—the cutification of the raw sentiments of rebellion and dissatisfaction among capitalist youth—is here changed into a version of the politicization of the aesthetic—or at least what I would call a parapoliticization. Nara never calls for overt, public political action as such. Yet his group endeavors produce a mode of politics "beside" public politics; not simply personal, this parapolitics is based on shared affects and affections and generates forms of association and communality difficult to establish in late capitalist Japan.[37] His mobilization of volunteers for his installations, his ongoing contact with his fans, his published diaries, his blogs and writings, his globe-spanning art projects can all be seen to form a parapolitics based on a zero degree of community: the fact that we've all been children.

Nara does not foreground his location primarily within a national frame. His is a traveling practice, shaped by his ten years of life and art in Germany and his world travels and wanderings, travels that have taken him throughout Europe to Pakistan, Afghanistan, Thailand, Indonesia, Taiwan, Korea, and beyond. His studio artistic practice has been highly solitary, contrasting sharply with Murakami's factory-like atelier. While undoubtedly shaped by a postwar culture of the *kawaii* in Japan—and in conversation with mass-cultural iconicity in the United States and elsewhere—Nara's work takes on the always-available space of childhood as something generalizable, beyond national-cultural enframements. He uses it as the basis for an expressive,

parapolitical practice—one formed around fans and fan objects as fictive kin, the detraumatization of loss by an aesthetic therapeutics, a refunctioning of the *kawaii* as a staging of the relationship between subject and object, a pacifist stance (Nara has long opposed the war in Iraq, for example), and a devoted attention to the child as the embodiment of the critical potential of the *kawaii*.[38]

Nara's exhibition at Marianne Boesky Gallery in New York in February and March 2009 centered on two spire-topped miniature houses fit for hobbits, one shingled green and another with an orange cast (could they possibly have been meant to evoke Manhattan's Twin Towers?) (Figure 8). One had to bend down or kneel to see into the interiors, bodily producing the sense of peering into the secret spaces of children. One of the houses, illuminated from within, contained a painting of a round-eyed, button-nosed girl—still staying true to Nara's themes of young girls, but here reprising the kitsch Keane doll look familiar in the United States (or perhaps a Hümmel figurine). On the floor of this elfin structure, we found a pile of stuffed toys: this time— not the carefully hand-sewn Nara figures of "I DON'T MIND, IF YOU FORGET ME"—but explicitly mass-produced, low-end soft toys (Disney figures, rag dolls, teddy bears, ducks) given to Nara, yet again, by his fans (Figure 9). The other miniature hut evoked nothing so much as a troll's house in the Black Forest (its shingled spire, however, had been lopped off—burned off, if the charred, ragged edge of the roof was any indication). This structure had a tiny desk, outfitted with colored pencils and a completed drawing on its surface. The drawing was of a burning house; on the wall hung another drawing of a girl with Nara's old signature glaring eyes, a house in the background, and the lettered word HEIMWEH ("home pain," "homesickness" in German). It seems that Nara hasn't given up the productive search for home, installing it within increasingly exotic and fairy-tale enclosures, a "home" that is never where it seems to be, in flames at the same time the child burns with the intimate yet foreign kernel of heimweh.

Released in 2007, the documentary *Nara: Nara Yoshitomo to no tabi no kiroku* (officially translated as *Traveling with Yoshitomo Nara*) follows Nara and his entourage throughout the world, revealing the fan passions that accompanied him as he mounted the exhibitions that became part of "A to Z," which again thematizes Nara's repeated attempts to construct a "home" in the midst of never being there. In the documentary, Nara states: "I work with other people a lot now. And unlike before, I don't draw those cynical children. They're still desolate, but they're not as transient. The pictures are a bit deeper now. But it's not an evolution of my paintings as artwork. It's because

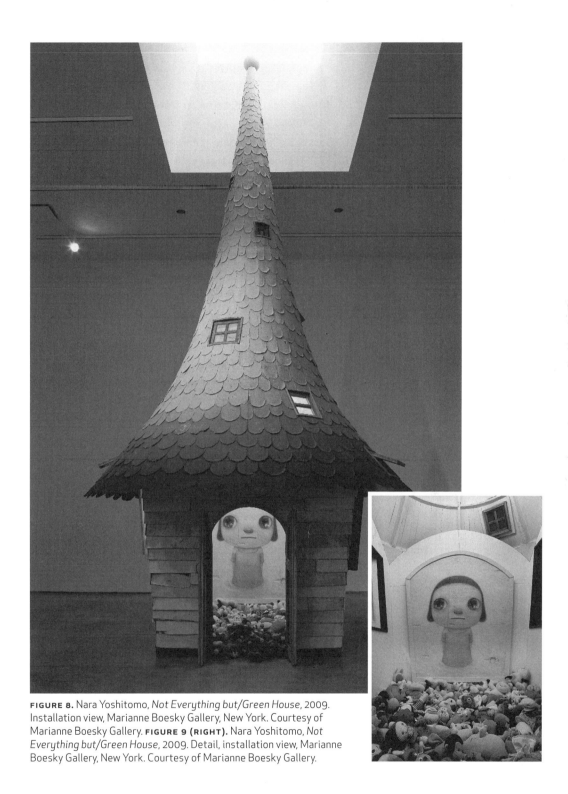

FIGURE 8. Nara Yoshitomo, *Not Everything but/Green House*, 2009. Installation view, Marianne Boesky Gallery, New York. Courtesy of Marianne Boesky Gallery. **FIGURE 9 (RIGHT).** Nara Yoshitomo, *Not Everything but/Green House*, 2009. Detail, installation view, Marianne Boesky Gallery, New York. Courtesy of Marianne Boesky Gallery.

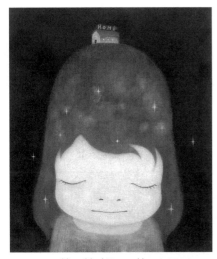

FIGURE 10. Nara Yoshitomo, *Home*, 2009. Courtesy of Tomio Koyama Gallery.

I learned how to interact with other people."[39] Although those "cynical children" still show up in Nara's drawings, more of his paintings now depict children with eyes that are round and filled with stars, or closed in sleep: children who are transient but not as desolate as before (Figure 10). Nara's art of transitional objects has brought together not only lost children in Japan but elsewhere, forming unexpected solidarities based on a grappling with the *kawaii,* the aesthetic marker for the most reified of objects and the most vulnerable of subjects. Nara has animated fan solidarities around a paradoxically activist art centered on cuteness and its latent capacities to signal a shared realization of the vulnerabilities of young subjecthood in commodity culture. Nara's art, perpetually staging the doubleness of the cute child-object/subject and its abandoned home, transforms the anomie of capitalized life through its animation of the parapolitical powers of fans, with their "unreasoned enthusiasms" for, and as, cute little things.

..............

Notes

I would like to thank Nara Yoshitomo for allowing me to reproduce images of his works. In addition, I am grateful to Marianne Boesky Gallery in New York (and Eve Wasserman there) and to Tomio Koyama Gallery in Tokyo (and Tomoko Omori there) for their generous assistance in securing permissions and images. Many thanks, also, to Andrea Arai, Tom LaMarre, Christine Yano, Sam and Anne Morse, and Hoon Song.

1. *Oxford English Dictionary,* s.v. "fan."
2. *Oxford English Dictionary,* s.v. "fanatic."
3. See Sigmund Freud, "Fetishism," (1927) in *The Standard Edition of the Complete Psychological Works of Sigmund Freud* (24 volumes), trans. and ed. James Strachey (London: The Hogarth Press, 1958): 21:147–58.
4. See Thomas LaMarre, "Otaku Movement," *EnterText* 4, no. 1 (Winter 2004/2005): 151–87, for a discussion of distinctive forms of movement, labor, and encounter enabled by otaku. http://arts.brunel.ac.uk/gate/entertext/4_1/lamarre.pdf
5. On the notion of *moe,* see Azuma Hiroki, *Yūbinteki fuantachi* (Postal anxieties) (Tokyo: Asahi Shinbunsha, 1999); also Marc Steinberg, "*Otaku* Consumption, Superflat Art and the Return to Edo," *Japan Forum* 16, no. 3 (2004): 449–71.
6. The otaku figure as exemplifying Japan's predicament and possibilities in a nation-culture infantilized by American defeat and mass-cultural domination was a critical theme in Murakami Takashi's exhibition, "Little Boy: The Arts of Japan's Exploding

Subculture," Japan Society Gallery, New York, April 8–July 24, 2005. For more on the trope of the "little boy" and the place of otaku subculture and the aesthetics of the cute (*kawaii*), see Murakami's essay, "Earth in my Window," in the exhibition catalogue, *Little Boy: The Arts of Japan's Exploding Subculture* (New Haven, Conn.: Yale University Press, 2005), 98–149. See also my review of the catalogue: Marilyn Ivy, "*Little Boy: The Arts of Japan's Exploding Subculture*," *Journal of Japanese Studies* 32, no. 2 (2006): 498–502.

7. There have been innumerable essays in English and Japanese considering the import of the shōjo figure and the allied place of the *kawaii*. Crucial to the theorization of shōjo culture are Ōtsuka Eiji's works, including *Shōjo minzokugaku: Seikimatsu no shinwa o tsumugu "miko no matsuei"* (The ethnography of young girls: "descendants of shamanesses" who spin end-of-the-century myths) (Tokyo: Kōbunsha, 1989). One of the most relevant for any consideration of contemporary Japanese art is Matsui Midori, "Beyond the Pleasure Room to a Chaotic Street: Transformations of Cute Subculture in the Art of the Japanese Nineties," in *Little Boy: The Arts of Japan's Exploding Subculture,* ed. Murakami Takashi (New Haven, Conn.: Yale University Press, 2005), 208–39. John Treat's essays on Yoshimoto Banana are important engagements with shōjo aesthetics and affects in literature and culture. See his "Yoshimoto Banana Writes Home: Shōjo Culture and the Nostalgic Subject," *Journal of Japanese Studies* 19, no. 2 (Summer 1993): 353–87, and "Yoshimoto Banana's Kitchen, or the Cultural Logic of Japanese Consumerism," in *Women, Media, and Consumption in Japan,* ed. Lisa Skov and Brian Moeran, 274–98 (Honolulu: The University of Hawaii Press).

8. The Nara-Kami Shop Web site is http://art.wakaba.net/index.htm.

9. For a discussion of the implications of Superflat visuality, see Thomas LaMarre, "The Multiplanar Image," in *Mechademia 1* (Minneapolis: University of Minnesota Press, 2006), 120–43.

10. Azuma Hiroki, "Superflat Speculation," in *Superflat,* ed. Murakami Takashi (Tokyo: Madra Publishing Company, 2000), 141.

11. Ibid., 141.

12. Ibid., 143.

13. Ibid.

14. See Matsui Midori, "A Gaze from Outside: Merits of the Minor in Yoshitomo Nara's Painting," in *Nara Yoshitomo:* I DON'T MIND, IF YOU FORGET ME (exhibition catalogue) (Yokohama: Tankōsha, 2001), 168–75.

15. See Asano Tarō, "Toward Fragmentation: The Drawing as Form," in *Nara Yoshitomo:* I DON'T MIND, IF YOU FORGET ME (exhibition catalogue) (Yokohama: Tankōsha, 2001), 161–67. Asano discusses Nara's commitment to drawing in conversation with Adorno's elevation of the essay form; he valorizes both in terms of their aesthetics of fragmentation.

16. See Asano, "Toward Fragmentation," again.

17. Thomas LaMarre has questioned this description of Nara's children as post-oedipal rather than non-oedipal, as Azuma and others might argue. While the discourse on otaku sensibility and the novel forms of desire and sociality that otaku embody might indicate a non-oedipalized formation, Nara's children reveal, it seems to me, a continuing reliance on an oedipal paradigm. Their alternately aggressive and seductive relationship to the adult world, their precocious and oft-angry gazes, and their typical reliance on

prostheses of inscription—whether pen, knife, cigarette, or brush—mark these children as firmly within the symbolic order, with all the oedipal accompaniments thereby entailed. Whether one could ever actually be *post*-oedipal remains an intriguing question (perhaps one is either oedipalized or not, period). Nevertheless, Nara's children—too young and cute for the kind of anger and aggression they so complexly express—rely on a conflictual relationship to the authorizations of the symbolic order that can only be imagined as oedipal, post- or otherwise. In contrast, Murakami's art seem to emerge from beyond the kinds of relationships that Nara's works stage.

18. For an intensive explication of the notion of anamorphosis in Lacan's thought and the ways in which "looking awry" makes visible that which can't be seen directly (objectively), see Slavoj Žižek's *Looking Awry: An Introduction to Jacques Lacan through Popular Culture* (Cambridge, Mass.: The MIT Press, 1992).

19. For a lucid discussion of the notion of *kawaii* and its historical transformations, see Shiokawa Kanako, "Cute but Deadly: Women and Violence in Japanese Comics," in *Themes and Issues in Asian Cartooning: Cute, Cheap, Mad, and Sexy,* ed. John A Lent), 93–125 (Bowling Green, Ohio: Bowling Green State University Press, 1999). See also Sharon Kinsella's discussion in "Cuties in Japan," in *Women, Media, and Consumption in Japan,* ed. Lisa Skov and Brian Moeran, 220–54 (Honolulu: The University of Hawaii Press, 1996).

20. Sianne Ngai, "The Cuteness of the Avant-Garde," in *Critical Inquiry* 31, no. 4 (Summer 2005): 814.

21. Ibid., 846.

22. Ibid., 834.

23. Ibid., 815.

24. Ibid., 816.

25. Ibid., 816–17.

26. Ibid., 816.

27. Matsui Midori, "A Gaze from Outside: Merits of the Minor in Yoshitomo Nara's Painting," in *Nara Yoshitomo:* I DON'T MIND, IF YOU FORGET ME (exhibition catalogue) (Yokohama: Nara Yoshitomo Exhibition Committee, 2001), 168–75.

28. This feeling of nothing happening, of the tedium of everyday life in contemporary Japan, is theorized by Miyadai Shinji in his *Seikimatsu no sahō: owarinaki nichijō o ikiru chie* (Fin-de-siècle etiquette: wisdom for living an endless everyday) (Tokyo: Media Fakutorii, 1997).

29. Sawaragi Noi, "Nara Yoshitomo no bukimi = kawaii kyarakutaa sekai," (The uncanniness of Nara Yoshitomo = the world of cute characters) in Sawaragi, *[Bakushinchi] no geijutsu* (The art of "ground zero"), 353–71 (Tokyo: Shōbunsha, 2002).

30. See Takichi Shōichirō, "Subete wa horaa ni shūyaku shite iku ka ni mieta: Aomori/reikai/intaanetto" (From here on in, everything seems to intensify in horror: Aomori, the spirit world, the Internet) in *Bijutsu techō* 53 (December 2001): 29–31. I analyze spirit recallings on Mount Osore and the place of Jizō in my book, *Discourses of the Vanishing: Modernity, Phantasm, Japan* (Chicago: The University of Chicago Press, 1995).

31. Eric Santner uses the notion of transitional objects, derived from Winnicott and others, in his work on postwar Germany. See Santner, *Stranded Objects: Mourning, Memory, and Film in Postwar Germany* (Ithaca, N.Y.: Cornell University Press, 1990).

32. Dozens of comments and notes from fans who had participated in the Hamapuro

were taken from the Happy Hour Web site and printed as "Voices of HamaPuro Brothers & Sisters!!" in *Bijutsu techō* 53 (December 2001): 33–36.

33. Ibid., 33.

34. I have written about the relationship between addiction, missing children, and inner-child therapies in American commodity culture in "Have You Seen Me? Recovering the Inner Child in Late Twentieth-Century America," *Social Text* 37 (Winter 1993): 227–52.

35. Sawaragi, "Nara Yoshitomo no bukimi," 365–67. I would refer the reader back to the registers of childhood that I outlined earlier in this essay; with Sawaragi's argument, we see replicated many of the familiar arguments about the childishness of Japanese society that have been put forth by Western and Japanese critics alike. Sawaragi's writings—along with Azuma Hiroki's, Ōtsuka Eiji's, and others'—have influenced Murakami Takashi's thoughts on the puerility of Japanese society, the society of "little boys" that then became the basis for his "Little Boy" exhibition, with its theorizations of otaku subcultures and the centrality of the *kawaii* for contemporary Japanese art and life.

36. Nara Yoshitomo, "My Superficiality Is Only a Game: A Conversation between Stephan Trescher and Yoshitomo Nara," in Nara, *Lullaby Supermarket,* 103–10 (Nürnberg: Institut für moderne Kunst Nürnberg, 2002).

37. I realize this use of "parapolitics" is quite to the side of standard uses of the term, which range from theoretical analyses that attempt to think about politics that transcend conventional political forms to perhaps its more common usage in referring to covert or illegal political forms and actions, forms that are often repressed. I aim to use the term literally, to indicate a form of unrecognized politics "existing parallel to, or outside, the sphere of mainstream politics." (*OED*, s.v. "parapolitics"). The formation of fan communities around Nara's art—and Nara—works as a form of (para)political action, one that works to produce forms of solidarity resistant to right-wing politics, the justification of war, and neonationalist movements in Japan (and elsewhere).

38. The historian Miriam Silverberg wrote movingly about Nara's pacifist practice and the critical possibilities in his work. See Miriam Silverberg, "War Responsibility Revisited: Auschwitz in Japan," in *Japan Focus*, http://www.japanfocus.org/-Miriam-Silverberg/2470.

39. See *Nara: Nara Yoshitomo to no tabi no kiroku* (Traveling with Yoshitomo Nara) (Tōhoku Shinsha, 2007).

BRIAN RUH

• • •

Transforming U.S. Anime in the 1980s: Localization and Longevity

From the beginning of modern Japanese animation in the United States in the early 1960s, there has been a tension between some of anime's obviously foreign aspects (such as Japanese writing onscreen and a more relaxed attitude toward onscreen violence) and its more easily domesticated characters and plots. American producers were often able to effectively obscure the origins of this imported anime through techniques of selective editing and dubbing. Generally speaking, though, the programs generated through such localization efforts were often very close to the Japanese source material.

Beginning in the late 1970s, American television producers not only adapted anime for U.S. broadcast but began changing the shows around to generate programs that were almost entirely American creations. Such shows took the source animation as a kind of raw material and completely rewrote the stories to make them something unique for presentation to American audiences as well as to television audiences around the world. (U.S. licensors often obtained the non-Asian rights to such shows, and as a consequence the versions distributed to the rest of the Americas and Europe were often redubbed versions of the American alterations rather than translated versions of the Japanese originals.) A program might have the relationships

between characters altered, seemingly unneeded plot information excised to shorten the running time, and be tailored too closely to what the producers thought the audience wanted to see. However, not all attempted Americanizations of anime properties were successful.

At the same time that American television producers were adapting Japanese television shows to meet a growing demand, the Japanese animation industry was undergoing a creative surge of its own. A prime example of this was the film *Nausicaä of the Valley of the Wind* (1984, *Kaze no tani no Naushika*), a landmark in the history of Japanese animation. In director Miyazaki Hayao's adaptation of his own manga, he showed how animation can focus attention on real-world problems such as environmental degradation and the need to coexist with other cultures (and even other species) yet still tell an enthralling tale that still looks fresh nearly twenty-five years later. *Nausicaä of the Valley of the Wind* would go on to win the 1985 *Kinema Junpō* readers' choice award and set the stage for Miyazaki to establish himself as a commercial and creative powerhouse in Japanese cinema as a whole, not just in the world of animation.

However, the American dub and edit of *Nausicaä of the Valley of the Wind*, named *Warriors of the Wind* (1985), has become infamous in fan circles for the liberties it takes with the Japanese original. Although most would probably acknowledge the necessity of dubbing the film into English for the American market, many had a problem with the fact that *Warriors of the Wind* cut more than twenty minutes from the film's final running time. The general consensus is that the film was a "mutilated,"[1] "wretched,"[2] and "horrendously mangled version"[3] of the Japanese original, which was "subjected to a devastating series of cuts,"[4] and that it "interprets the story of *Nausicaä* just about as accurately as *Demolition Man* redid *Brave New World*."[5] Toren Smith, who would go on to the form the translation and localization company Studio Proteus, wrote that he was so "horrified by the butchery the insensitive Hollywood company had perpetrated on this finely crafted film" that he began trying to arrange for the translation and publication of the *Nausicaä* manga in order "to save the comics from the same sad fate as the Nausicaa [*sic*] animation."[6] Such vocal opinions often fail to properly explain the exact reason for their anger, though, particularly in the context of the anime industry at the time. As already mentioned, heavy editing and dubbing of anime was common, yet few have raised the kind of ire that *Warriors of the Wind* evokes.[7] This reaction raises the question of what it is about *Warriors of the Wind* that marks it so seriously as a failed transnational media product.

This question raises an important point about the nature of media globalization. Such attitudes assume that for the localization of a foreign media

product to be "successful" it needs to be transparent. That is, it needs to provide the most direct access possible to the foreign original, and anything else is extraneous and unwarranted. However, access to a foreign media product through translation will necessarily be awkward to a greater or lesser degree. As Abé Mark Nornes writes in *Cinema Babel*, "Subtitles and dubs, even at their finest, hold something in common with the rocky translation of the instruction manual for a cheap VCR from China: they are legible, but inescapably foreign."[8] This quest for translational transparency for some, though, may result in opacity for others. Watching a film or television show that has dialogue

> HEAVY EDITING AND DUBBING OF ANIME WAS COMMON, YET FEW HAVE RAISED THE KIND OF IRE THAT *WARRIORS OF THE WIND* EVOKES.

in a foreign language, depicting foreign customs, and so on may confuse or even alienate a segment of the viewing audience. As Anne Allison points out with regard to the later, live-action *Power Rangers* franchise in the United States, the show replaced the Japanese actors with American teenagers in segments in which they could be seen, with the goal of depicting more ethnic and gender balance.[9] Changing a media product in this way alters how it may be perceived, to make it more acceptable to a domestic audience and hence more profitable to the local producers.

In this essay, I explore how *Warriors of the Wind* has been set apart from other mid-1980s anime imports by its current popular perception as a "failure." I will contrast the film's flaws with two Americanized television franchises that also have their roots in Japanese animation: *Robotech* and *Voltron*. Both television shows took great liberties with their source material and were broadcast over U.S. airwaves at around the same time that *Warriors of the Wind* was released. However, *Robotech* and *Voltron* were successful at the time and have persisted as cultural icons in their own rights, while *Warriors of the Wind* has languished as an example of how not to import Japanese animation.

ROBOTECH *AND* VOLTRON

Although imports of Japanese animation were popular in the United States in the early to mid-1960s, there were arguably no new programs from Japan shown on major broadcast outlets in the United States from the late 1960s until the late 1970s. (Although, it should be mentioned, localized versions of anime shows were very popular across Europe throughout the 1970s.) One of the biggest influences on the course of anime, and the impetus for the second big wave of anime abroad, was the 1977 release of *Star Wars* (dir. George

Lucas). The success of *Star Wars* had ramifications for not only how anime was perceived outside of Japan but also for the anime that was produced within Japan. For example, in the late 1970s, Takachiho Haruka authored science fiction space opera stories about a crime-fighting duo known as the Dirty Pair and an intergalactic troubleshooter known as Crusher Joe. These stories would go on to be animated and become staples of U.S. anime fandom in the late 1980s. Takachiho has said, though, that before *Star Wars,* it was difficult to publish science fiction that was not "proper" (in other words, pulpier space opera stories) in Japan. Although there were science fiction stories with elements of space opera in them before *Star Wars,* such stories were nowhere near as popular as they were after.[10]

The influence of *Star Wars* could be felt throughout the anime industry in Japan. Writing about the 1978 anime television series *Captain Future,* Jonathan Clements and Helen McCarthy assert, "The sci-fi novels of Edmond Hamilton were optioned for anime production in record time when George Lucas mentioned that they were a major inspiration for *Star Wars.*"[11] Star Wars also laid the groundwork for the *Mobile Suit Gundam* (1979–80, *Kidō senshi Gandamu,* dir. Tomino Yoshiyuki) franchise, which has been the bedrock of Japanese anime fandom ever since.[12] In the wake of *Star Wars,* many of the anime that were imported into other countries were closely tied to science fiction. Even television shows that were not originally about intergalactic combat were shaped to fit this developing mold. Of particular note in this regard was the television show *Battle of the Planets* (1978), which may have been one of the first programs to try to ride the coattails of *Star Wars* in the United States. The show was the brainchild of Sandy Frank, who had begun packaging television shows for the U.S. syndication market in the mid-1960s. In their book about the show, Jason Hofus and George Khoury write about how Frank, who developed the idea for the show, first saw footage of the anime program *Science Ninja Team Gatchaman* (1972–74, *Kagaku ninjatai Gatchaman,* dir. Toriumi Hisayuki) in April 1977 at the MIP (Marchè International de Programmes) in Cannes, France.[13] Although Frank was initially interested in the program, the motivation to bring the series over to the United States was the phenomenal success of the first *Star Wars* film, which opened at the end of May 1977.[14]

However, the original *Gatchaman* series originally took place on Earth and did not involve space travel. In order to make the show into something

that would work with the *Star Wars* crowd, Frank authorized new footage to be animated for the show depicting the team flying through outer space as well as a talking robot that "hosted" the show and strongly resembled R2-D2. Hofus and Khoury mention that some of the people credited as "writers" on the show were people who watched the Japanese originals and noted the action that occurred and the length of each speech utterance, which provided a template for the rescripting.[15] It does not seem that the *Battle of the Planets* staff worked on their episode scripts using a translation of the original Japanese scripts. Rather, they made up the story and dialogue based on what they saw (and created) onscreen. Additionally, a new score was created not only to make the show more familiar for a U.S. audience but "to supplement 'dead spots': silence in the original production."[16] From this, it seems that *Battle of the Planets* took *Gatchaman* as its raw material for a new and very different show. This method proved to be successful, though, as the $5 million spent acquiring the rights, commissioning new animation, editing, dubbing, and rescoring *Battle of the Planets* garnered domestic presales of the show of $25 million.[17] From there, *Battle of the Planets* spread to many other non-Asian markets in its Americanized form, bringing further licensing revenues. This successful method of bringing anime to the world market would continue into the 1980s and set the stage for the successes of *Voltron* and *Robotech*.

Voltron was a television series that began airing in the United States in September 1984. Like *Battle of the Planets,* it was a science fiction show that had been pitched to overseas producers at the Cannes market. The show comprised two separate Japanese television shows—*King of Beasts GoLion* (1981–82, *Hyakujūō Goraion*) and *Armored Fleet Dairugger XV* (1982–83, *Kikō kantai Dairagaa XV*)—that had been roughly shaped into a single storyline. It was necessary to bring the two series under a single umbrella since the number of episodes in each individual series did not meet the minimum requirements for American television syndication. Although the two shows originally had no characters in common, they were produced at roughly the same time by the same Japanese studio, giving them a similar look. (However, the two halves of *Voltron* were not popular in equal measure. The *GoLion* episodes attracted far more of a following and is often what people refer to when they say "*Voltron*" today.)

Although *Voltron* was intended as a show for kids, the *GoLion* source material had a lot more adult content. There were frequent battles throughout the show that often resulted in the spilling of blood, which were of course edited out for American broadcast. Although fighting and violence were allowed, any sort of death was taboo in *Voltron*. If any of the bad guys needed to

be shown being shot, they were always described as humanoid robots rather than living beings. Even the death of one of the main protagonists was explained away: rather than dying, he was just severely injured and had to leave the show for a while. Most allusions to the show's Japanese origins, such as occasional onscreen Japanese text, were excised as well. Some Japanese elements remain, such as the protagonists training by practicing judo in a couple of episodes, although this might not have struck a viewer as odd, because of the increasing number of martial arts movies reaching American shores since the 1970s, particularly more kid-oriented fare like *The Karate Kid* (1984, dir. John G. Avildsen).

The story of *Voltron* was very different from that of *GoLion* or *Dairugger XV*. In fact, as with *Battle of the Planets*, the producers of *Voltron* did not try to translate what was being said in Japanese but rather made up their own dialogue as they saw fit to match the edited scenes. The reluctance to kill anyone in *Voltron* also allowed the producers to create some original *Voltron* episodes. For example, after the last episode of *GoLion*, all of the antagonists have been killed, but they are merely injured or incapacitated in *Voltron*. This allowed the producers of *Voltron* to go back to the Japanese animation studio and order twenty additional episodes in order to continue the *GoLion* storyline. Although U.S. companies had been animating many of their programs for decades before *Voltron*, this marked the first time that the popularity of a program not originally made for the American market was successful enough to request that additional episodes be animated from the original Japanese studio.

In spite of its severe edits, *Voltron* has generally not been criticized within the fan community for the liberties it takes with episodes and characters. However, of all the science fiction anime television imported in the 1980s, it was probably *Robotech*, which began airing in March 1985, that caused the greatest controversy among fans regarding the editing of the program. The series is generally considered to be the brainchild of Carl Macek, who served as producer and story editor. His original plan was to license the anime *Superdimensional Fortress Macross* (1982–83, *Chōjikū yōsai Makurosu*) and redub it for American television. However, the original *Macross* contained a mere thirty-six episodes. As with *Voltron*, this meant that there were not enough episodes to qualify for syndication on American television. The producers of *Robotech* ended up grafting on to the end of *Macross* additional story elements culled from two entirely separate mecha anime shows-*Genesis Climber Mospeada* (1983–84, *Kikō sōseiki Mosupiida*) and *Superdimensional Cavalry Southern Cross* (1984, *Chōjikū kidan Sazan Kurosu*)—to bring the episode count to eighty-five. The plot of *Robotech* was rewritten to make the transition between the shows

as comprehensible as possible. As was the case with the anime used in *Voltron,* all three programs had been animated at the same studio, Tatsunoko Productions, at around the same time, resulting in a consistent style that contributed to the appearance of continuity. The program shows how Earth deals with three successive invasions of aliens from outer space. *Robotech* carries the storyline from the crash of an

OF ALL THE SCIENCE FICTION ANIME TELEVISION IMPORTED IN THE 1980S, IT WAS PROBABLY *ROBOTECH,* WHICH BEGAN AIRING IN MARCH 1985, THAT CAUSED THE GREATEST CONTROVERSY AMONG FANS REGARDING THE EDITING OF THE PROGRAM.

unmanned alien space fortress on Earth, to fighting the Zentradi aliens who come in search of the battleship, to fighting off the Robotech Masters, to the onslaught of the Invid, who manage to conquer the Earth. The final chapter in *Robotech* follows a small band of freedom fighters as they make their way to the Invid stronghold of Reflex Point, where they are finally able to drive the invaders from the planet.

Unlike *Voltron,* though, a number of anime fans have decried *Robotech* as a butchery of the original Japanese programs. (Much fan anger was directed personally at Carl Macek as well. In the documentary *Otaku Unite!* [2003, dir. Eric Bresler], Macek recalls that in the 1980s fan anger at his treatment of the shows resulted in death threats against him.[18]) Although the characters were renamed and a number of edits made, much of *Macross* and the other two mecha anime survived the transition to *Robotech* fairly intact. As with *Voltron,* the popularity of the series prompted a number of attempts at continuing the storyline. A feature-length film, called simply *Robotech: The Movie,* was created by editing another anime production by the same director as *Macross—Megazone 23, Part 1* (1984, dir. Ishiguro Noboru)—with selected footage from *Southern Cross.* However, the film received a very limited theatrical test release and then faded away. Another original television project called *Robotech: The Sentinels* was attempted, but this too was unsuccessful. (A handful of episodes were completed and released straight to video.) A version of *Robotech* based on computer graphics (rather than cel animation, or animation that looks like cel animation) called *Robotech 3000* was attempted in the late 1990s, but fan response to its proposed look and storyline were unenthusiastic.[19] Based on the strong sales of *Robotech* on DVD in the 2000s, though, a new film called *Robotech: The Shadow Chronicles* finally got off the ground, and it demonstrates the increasing globalization of the *Robotech* franchise. What originally began as Japanese anime was recently turned into a movie that expands on the storyline, but which was developed

and coordinated in the United States, animated by the Korean company DR Movie (which has contributed animation to many "Japanese" anime titles), scored via "a live audiovisual link from Santa Monica [California] to the City of Prague Philharmonic Orchestra in the Czech Republic."[20] As with *Voltron,* a live-action version of *Robotech* is currently in the works, to be penned by Lawrence Kasdan[21] (who cowrote the screenplays to the *Star Wars* sequels *The Empire Strikes Back* and *Return of the Jedi,* bringing the cycle of influences back full circle).

WARRIORS OF THE WIND

These examples seem to suggest that Japanese animation in the 1980s was ripe for the plucking by American producers. If one chose the Japanese source material wisely, then it would seem that post–*Star Wars* popular culture consumers would be very receptive. Even in the case of *Robotech,* which angered certain segments of the anime-watching population, the producers were able to generate a program that was ultimately a success. However, localizing anime was not always a successful endeavor. *Warriors of the Wind,* released at roughly the same time as *Voltron* and *Robotech,* has not fared nearly so well. Although *Voltron* and *Robotech* have persisted in popular culture to this day, *Warriors of the Wind* has been largely forgotten, other than as the "butchered" first attempt at bringing *Nausicaä of the Valley of the Wind* to a world market. By all rights, *Warriors of the Wind* should have been successful. It was a postapocalyptic anime film that straddled the fantasy/science fiction divide, whose promotional imagery did much to play up its connections to films like *Star Wars* and *Dune* (1984, dir. David Lynch), to the extent that the promotional art depicted characters that did not even appear in the film (Figure 1). Not only was there no ancillary merchandising for the film, today the film is very hard to obtain and can only be viewed on old videotapes. (The Japanese original can be found very easily, though, which serves to bury the memory of *Warriors of the Wind.*) So the question must be asked: Why was *Warriors of the Wind* a failure when other shows not only succeeded at the time but have been able to prolong their cultural lifespans for decades?

To answer this question, we should begin with the localization process; if *Warriors of the Wind* was treated much differently or more harshly than its contemporaries, that might explain its failure. A detailed comparison of *Warriors of the Wind* and the original *Nausicaä of the Valley of the Wind* reveals nineteen separate instances in which footage was removed in order to shorten the

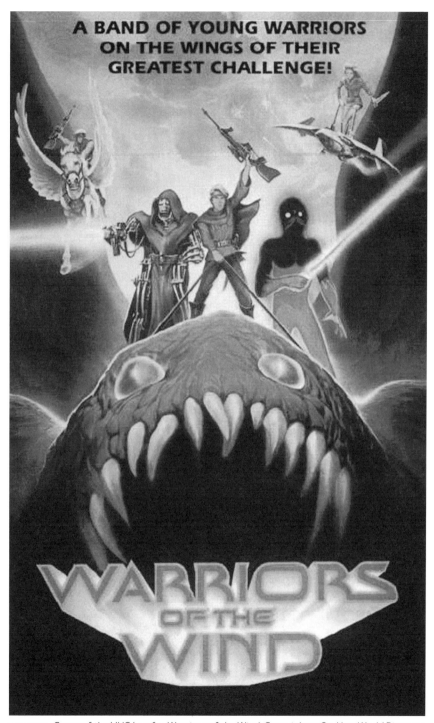

FIGURE 1. Cover of the VHS box for *Warriors of the Wind*. Copyright 1985, New World Pictures.

running time. The occurrence of these cuts is detailed in Figure 2. (The white lines represent cuts in the film as percentages of the overall running time.) All of the cuts are short, varying in time from five seconds to three minutes and seventeen seconds. The graph illustrates that the cuts were spaced relatively evenly throughout the film. However, there were five short cuts (over a quarter of the total) within the first ten minutes of the film, omitting many of the shots Miyazaki used to establish setting and mood.

Voltron and *Robotech* were treated in a similar fashion, as one can see in Figures 3 and 4, which chart the cuts made in the first episode of each series respectively. (The grey segments in Figure 3 indicate cuts that were placed elsewhere in the episode.) Although a similar pattern of editing cannot be extrapolated across the series based on a single episode, the graphs do indicate that cutting footage (and rearranging certain scenes) was a regular occurrence in addition to the changes in storyline mentioned above. If one views the original Japanese episodes on which *Robotech* and *Voltron* were based, it is easy to see the reason for many of the cuts. A number of scenes would not have been suitable for broadcast on U.S. television during morning or early afternoon hours (when most cartoons for children and young adults were aired in the 1980s) due to violence or sexual content. Additional cuts were needed to make each episode conform to the episode length necessary for syndication in the American market.

FIGURE 2. *Nausicaä of the Valley of the Wind.* The graph from left to right represents the running time of the original Japanese film or episode. The black part of the graph represents segments of the film that remained in the edited Americanized version while the white part of the graph represents cuts that were made to the running time.

FIGURE 3. *Voltron* episode 1: "Escape from Slave Castle." The graph from left to right represents the running time of the original Japanese film or episode. The black part of the graph represents segments of the film that remained in the edited Americanized version while the white part of the graph represents cuts that were made to the running time. The gray parts of the graph represent segments that were removed from the Americanized version in their original location but appeared elsewhere in the episode.

FIGURE 4. *Robotech* episode 1: "Boobytrap." The graph from left to right represents the running time of the original Japanese film or episode. The black part of the graph represents segments of the film that remained in the edited Americanized version while the white part of the graph represents cuts that were made to the running time.

This brings up the question of why certain scenes were cut from *Warriors of the Wind*. Since it was a feature-length film intended for theatrical distribution, it did not necessarily need to be edited for content or running time. In its description of *Warriors of the Wind,* the FAQ list on the page of Nausicaä. net, a fan site for aficionados of the film of Miyazaki Hayao and Studio Ghibli, states:

> New World Pictures felt it could only be marketed as a kids' action movie, so they cut out about a quarter of the movie (the parts they felt were "slow moving") and garbled the storyline in the process. Nausicaä was changed to "Princess Zandra." The voice actors and actresses . . . said later that they were never told what the story was about and so the acting was substandard. Miyazaki was horrified when he found out what they had done to his film, and Ghibli asks everyone to forget that this version ever existed. Fortunately, New World Video's rights to *Nausicaä* expired in 1995.[22]

As is often the case with fan lore, there is no evidence given to support some of the claims made. The view that the film was intended for children seems to be widely held although not necessarily supported by the cuts made to the film. The majority of the scenes that were taken out contribute to the overall view of the world in *Nausicaä of the Valley of the Wind* or serve as background for the motivations of the film's titular princess. However, all of the action scenes remained intact, including some that are violent and depict blood. For example, the film's first scene includes a shot of a human skull and a lone doll, indicating that children have probably died as well. Other scenes include killings, dripping blood, and dead bodies, however briefly. Still, the presence of such scenes belies the argument that the film was cut to be marketed as a "kids' action movie," although many cuts do omit segments that might be perceived as "slow moving." Similarly, through my research I cannot confirm the claim that the voice acting was "substandard" because the voice actors were not given relevant details of plot and character. In fact, based on my own subjective criteria, I would judge the overall voice acting in *Warriors of the Wind* to be slightly above average for the time in which it was produced.

Of course, any change to the voicing of a character can change how that character is perceived, even if the same dialogue is spoken. (And the dub script for *Warriors of the Wind* is often very close to the original Japanese dialogue; unlike the case in *Robotech* and *Voltron,* it is obvious that the producers of *Warriors of the Wind* worked from a translation of the script.) Subtleties in characters do tend to get flattened in the film, though. None of the characters

in Miyazaki's *Nausicaä of the Valley of the Wind* could really be called "evil," even though some do horrible things. Rather, such characters are shown to be working for what they think is best, even though they might be misguided. In its selected editing and dubbing, *Warriors of the Wind* simplifies these character relationships. For example, at one point Zandra (Nausicaä in the Japanese) says to Selena (Kushana) that she doesn't believe Selena is evil, to which Selena replies, "Oh, but I am." Later, when advised that it's too soon to revive the ultimate weapon she has planned, Selena scoffs, "It's never too soon to rule the world." Such utterances work against the complexity of the world Miyazaki tried to create in the original *Nausicaä* film, which was never supposed to present two opposing sides in such stark terms. Still, some reviewers picked up on this element and wrote assessments like the following: "Princess Zandra reunites her people after a seven-day global inferno to stop evil"[23] and "The forces of good battle an evil queen to ensure a peaceful and safe future for mankind."[24]

Although few positive reviews of *Warriors of the Wind* can be found, its status as a failure was far from universal. In fact, it played various film festivals in the United States and very little was done to disguise the fact that it came from Japan. *Warriors* premiered at the Los Angeles International Animation Celebration, September 25–29, 1985, and a *Los Angeles Times* article listed it alongside other American premieres of animated films from France, Australia, and Hungary.[25] A write-up from the film's premiere describes it as "incredibly exciting, blending elements of 'Star Wars' and '2001' . . . with riproaring pace and panache."[26] It also played in 1986 at the Asia Society in New York in a "Fantasy/Animation" series alongside *Zu Warriors from the Magic Mountain* (1983, dir. Tsui Hark) and *Uproar in Heaven* (1964, dir. Wan Laiming) as well as at a Japan festival in April 1987 put on by the Japan Information and Culture Center in Washington, D.C. If the film was "objectively" a failure at the time, it is unlikely that the film would have been shown in such venues, particularly those looking to inform a general audience about Japan and Japanese culture.

GLOBALIZATION SUCCESS AND FAILURE

It is still unclear why *Warriors of the Wind* failed to find an American audience while other, less harshly edited shows succeeded. As detailed above, there does not seem to be anything unusual in the way *Warriors of the Wind* was handled. Therefore, the film's failure to secure an audience in the intervening

years seems to rest in how it was received by anime fans and fans of Miyazaki (both at the time and in years since) who cared about the film's artistic integrity. This is a crucial point; and since *Warriors of the Wind* received only limited theatrical distribution, there is a paucity of mainstream critical reviews written at the time from which to draw. Let's consider possible reasons fans may have found *Warriors of the Wind* unsatisfactory.

In his book *Fan Cultures,* Matt Hills suggests that cult texts share three main "family resemblances": auteurism, endlessly deferred narrative, and hyperdiegesis.[27] In short, cult texts are the work of a singular creative individual (or are perceived as being so), there are overriding questions presented to the characters in the text that are never fully resolved, and the events take place in a rich environment "only a fraction of which is ever directly seen or encountered within the text."[28] These three resemblances occur to a greater or lesser degree within any cultic media text. Hills characterizes such texts as needing to demonstrate an endurance of fan enthusiasm "in the absence of 'new' or official material in the originating medium."[29] By analyzing *Voltron, Robotech,* and *Warriors of the Wind* in the context of Hills's concept of resemblances, we can begin to get an idea of why the former two succeeded with American audiences while the latter did not.

> THE FILM'S FAILURE TO SECURE AN AUDIENCE IN THE INTERVENING YEARS SEEMS TO REST IN HOW IT WAS RECEIVED BY ANIME FANS AND FANS OF MIYAZAKI WHO CARED ABOUT THE FILM'S ARTISTIC INTEGRITY.

The "family resemblances" of deferred narrative and hyperdiegesis suggest why *Voltron* and *Robotech* succeeded on American television. Because the two series had to encompass more than one Japanese anime series in order to be syndicated, they necessarily needed to rewrite their storylines to make sense of an expanded textual universe. Although the plots of *Macross* and *GoLion* left few loose ends in their respective storylines, *Robotech* and *Voltron* were written in a manner that forestalls a sense of closure in order to accommodate further episodes from the additional series. This move also, by its very nature, creates the hyperdiegesis Hills points to in cult media. By trying to merge disparate series into a single show, the creators of the Americanized versions tried to patch over obvious seams between the original Japanese components. This had the side effect of giving *Robotech* and *Voltron* a sense of expansiveness that one would not necessarily feel from a single source. Essentially, the edits made to *Voltron* and *Robotech* seem designed to intentionally create fan-oriented objects whereas *Warriors of the Wind* was not. All the component Japanese anime under discussion had distinct beginnings,

middles, and endings that wrapped up the storylines. In contrast, *Voltron* and *Robotech* were put together to have no such neat endings but rather temporary ones, after which additional adventures could take place. (As mentioned, this already happened in an official capacity when twenty additional episodes of *Voltron* were created specifically for the American market; these episodes would not have made sense in a Japanese context since all of the antagonists had already been killed.) *Warriors of the Wind,* however, offers less of an option for continuation than *Nausicaä of the Valley of the Wind* does because the original Japanese ending credits were edited out of the film. In these credits, the audience is shown what happened after the climactic events of the film, hinting at possible relationships and adventures yet to come. Removing these scenes cuts off these impulses and constrains the world of the film.

The concept of auteurism, Matt Hills's final cultic resemblance, points to why *Warriors of the Wind* did not do well with American fans. Viewers of the film, particularly anime fans, may have brought heightened expectations to the viewing experience because the film was directed by Miyazaki Hayao. When *Nausicaä of the Valley of the Wind* was originally released in Japan, Miyazaki was far from the household name he is today, but fans still turned out in droves to see the film. (This is dramatized in the anime film *Otaku no Video* [1991, dir. Mori Takeshi], which is a fictionalized account of Japanese anime fan culture in the 1980s. In the film, Japanese fans are depicted lining up overnight outside a theater waiting to see the premiere screening of *Nausicaä*.) The film was based on a manga written and drawn by Miyazaki, which had been serialized in *Animage* magazine from 1982 to 1994. Therefore, the project was very personal to him, and in fact the comic continued for a decade after the film was made. Although casual viewers and those with little knowledge of the edits made to the film may have been willing to accept *Warriors or the Wind,* fans of Miyazaki probably wanted to see the version of the film as originally intended by its creator. It certainly would not have helped matters that Miyazaki strongly and vocally disagreed with the edits made to his film.[30] In this way, the reaction against *Warriors of the Wind* was probably not due to what it was but rather to what it was not.

Comparing *Warriors of the Wind* to *Voltron* and *Robotech* also illustrates some of the differences between film and television structures and audiences. In the case of the latter two anime, the need to make them suitable for broadcast on U.S. television was the driving force behind many of the modifications that were made: the shows needed to be cut to adhere to standards of length, decency, and the needs of the syndication market. In contrast, since *Warriors of the Wind* was intended for the theatrical and home video

markets, such modifications were not strictly necessary. One could argue that something new was being created in the television shows from the reedited Japanese source material, but, since the film was seen as a unitary object, much less leeway was given to its edits. Additionally, the tendency toward auteurism is often more strongly pronounced with regard to films than television programs (although this is changing). Making changes to a given film seems much more "destructive" to the original text than modifications necessary to prepare a television show for broadcast, even through the latter may in fact make more changes and take more liberties with the text.

In addition to the structural differences between *Robotech/Voltron* and *Warriors of the Wind,* the film bore the blame for the effect its failure had on the subsequent American release of anime films. After *Nausicaä of the Valley of the Wind,* Miyazaki went on to found the animation company Studio Ghibli and create films like *Laputa: Castle in the Sky* (1986, *Tenkū no shiro Rapyuta*), *My Neighbor Totoro* (1988, *Tonari no Totoro*), *Princess Mononoke* (1997, *Mononokehime*), and *Spirited Away* (2001, *Sen to Chihiro no kamikakushi*), for which he won an Academy Award in 2003. Although he continued making films for a Japanese audience, Miyazaki's disappointment over the editing of *Warriors of the Wind* made him wary of any further dealings with U.S. film companies. It would be more than ten years after the release of *Warriors of the Wind* before official versions of any Studio Ghibli films would be released in the United States.

CONCLUSION

Like *Robotech* and *Voltron,* the Americanized version of *Warriors of the Wind* was the form in which the film made its way to other countries around the world. According to the U.S.-based Miyazaki fan site Nausicaa.net, *Warriors of the Wind* made had video releases in the United Kingdom, as well as new dubs based on the *Warriors* edit in France, Germany, Spain, and Argentina.[31] In 1996, Buena Vista Home Entertainment announced a distribution deal with Studio Ghibli to release its films on video and DVD.[32] A frequently recounted story surrounding the production of the American version of *Princess*

Mononoke says that Miyazaki sent a Japanese sword to Harvey Weinstein of Miramax with the simple note "No cuts!" However, Miyazaki says that it was actually his producer who sent the sword, but that he was happy to have prevailed over Weinstein.[33] In the end, following the Buena Vista deal, no Studio Ghibli films were edited in any way without the explicit consent of the studio.

In February 2005, nearly twenty years after *Warriors of the Wind* was released, Buena Vista released the region 1 version of *Nausicaä of the Valley of the Wind,* the first time the uncut film had been made officially available in the United States. (The Japanese region 2 DVD of the film, released November 2003, contained English subtitles, meaning that English-speaking fans with region-free DVD players could watch the film.) The pall of *Warriors of the Wind* still hung over this release, though. In his review of the film, Chris Beveridge of AnimeOnDVD.com prefaced his discussion of the film's content with the following: "*Nausicaa* [sic] is a film that has suffered terribly before in its previous U.S. release. It had been cut by something like half an hour and was done dub only with a good chunk of the storyline rewritten. While if you knew nothing about it otherwise it was something that you could enjoy as a child, once you knew what was really behind it you could never go back and only lament that there was no other way of getting a properly translated copy of the film."[34] Although Beveridge does not mention *Warriors of the Wind* by name in the review, its presence is felt throughout. He mentions the time in the theater when he was "finally able to see it [the film] as meant to be" and concludes the review by saying he is "ecstatic that so many people are finally getting to see it for the first time."

Warriors of the Wind was certainly not the first attempt at Americanizing anime that failed, nor was it the last. The editing of anime series and films in an effort to effectively localize (and, one might argue, sanitize) them remains a contentious issue within anime fan communities and even within scholarly debate. A recent article in a law journal proposes that anime viewers (and other viewers of world TV and film) may have a kind of "moral right" to access unedited versions of their favorite programs.[35] However, as we have explored, editing an anime series does not necessarily reduce its popularity or franchisability, since television series like *Robotech* or *Voltron* would not have been possible without such actions. By expanding the shows beyond the scope of the Japanese originals, the creators were able to create enduring objects. However, editing can have an opposite effect, as demonstrated by *Warriors of the Wind*: it constrains the original text by omitting much of the surrounding world of *Nausicaä of the Valley of the Wind* and works against fans' desired notions of authorial intent.

Notes

1. Noel Megahey, "*Nausicaä of the Valley of the Wind*," *DVD Times* (March 3, 2005), http://www.dvdtimes.co.uk/content.php?contentid=56349 (accessed July 14, 2009).

2. Raphael See, "THEM Anime Reviews 4.0—*Nausicaä of the Valley of Wind*," *THEM Anime Reviews* (2005), http://www.themanime.org/viewreview.php?id=231 (accessed July 14, 2009).

3. "Video List: *Kaze no Tani no Naushika*," *Nausicaa.net,* (2007), http://nausicaa.net/miyazaki/video/nausicaa/ (accessed July 14, 2009).

4. Helen McCarthy, *Hayao Miyazaki: Master of Japanese Animation* (Berkeley, Calif.: Stone Bridge Press, 1999), 78.

5. See "THEM Anime Reviews."

6. Toren Smith, "The New Miyazaki Generation: Spreading Even into English Speaking Countries," *Comic Box* 98 (January 1995): http://www.comicbox.co.jp/e-nau/toren.html (accessed July 14, 2009).

7. The degree to which fan outcry over these edits is genuine or a performance of how a faithful anime fan is supposed to respond is interesting but unfortunately beyond the scope of this article.

8. Abé Mark Nornes, *Cinema Babel: Translating Global Cinema* (Minneapolis: University of Minnesota Press, 2007), 8.

9. Anne Allison, *Millennial Monsters: Japanese Toys and the Global Imagination* (Berkeley and Los Angeles: University of California Press, 2006), 120.

10. *Crusher Joe* DVD liner notes (AnimEigo, 2002), http://www.animeigo.com/Liner/CRUSHERJOE.t (accessed July 14, 2009).

11. Jonathan Clements and Helen McCarthy, *The Anime Encyclopedia: A Guide to Japanese Animation since 1917,* revised and expanded edition (Berkeley, Calif.: Stone Bridge Press, 2006), 86.

12. Curiously, *Gundam* did not become popular in the United States until 2000 with the television broadcast of *Gundam Wing* [1995–96, *Shin kidō senki Gandamu uingu,* dir. Ikeda Masashi].

13. Jason Hofus and George Khoury, *G-Force: Animated—The Official Battle of the Planets Guidebook* (Raleigh, N.C.: TwoMorrows Publishing, 2002), 17.

14. Ibid., 18.

15. Ibid., 24.

16. Ibid., 23.

17. Ibid., 23, 27.

18. *Otaku Unite!*, dir. Eric Bresler, DVD (Central Park Media, 2006).

19. Although, coincidentally, the CG work on this new series was performed by Netter Digital, who worked on the CG *Voltron* series around this same time.

20. Tommy Yune, *The Art of Robotech: The Shadow Chronicles* (Berkeley, Calif.: Stone Bridge Press, 2007), 133.

21. Borys Kit, "Kasdan to Write Screenplay for Big-Screen 'Robotech,'" Reuters/*Hollywood Reporter* (July 16, 2008), http://www.reuters.com/article/filmNews/idUSN1642634020080616 (accessed July 14, 2009).

22. "Video List: *Kaze no Tani no Naushika*."

23. "Cable TV Movies," *Chicago Tribune* (1963–Current file), ProQuest Historical Newspapers *Chicago Tribune* (1849–1986), (August 10, 1986): I38.

24. "Home Box Office," *The Washington Post* (1974–Current file), ProQuest Historical Newspapers *The Washington Post* (1877–1991), (August 3, 1986): TW59.

25. "L.A. Animation Celebration Set for Sept. 25–29 at Wadsworth," *Los Angeles Times* (1886–Current file), ProQuest Historical Newspapers *Los Angeles Times* (1881–1986), (August 23, 1985): F19.

26. Michael Wilmington, "Cartoons for All Tastes," *Los Angeles Times* (1886–Current file), ProQuest Historical Newspapers, *Los Angeles Times* (1881–1986), (September 25, 1985): OC_E2.

27. Matt Hills, *Fan Cultures* (New York: Routledge, 2002), 131.

28. Ibid., 137.

29. Ibid., x.

30. McCarthy, *Hayao Miyazaki,* 42.

31. "Video List: Kaze no Tani no Naushika."

32. "Disney-Tokuma Deal, from Studio Ghibli," Nausicaa.net (2000), http://www.nausicaa.net/miyazaki/disney/dtdeal_ghibli.html (accessed July 14, 2009).

33. Xan Brooks, "A God among Animators," *The Guardian* (September 14, 2005), http://www.guardian.co.uk/film/2005/sep/14/japan.awardsandprizes (accessed July 14, 2009).

34. Chris Beveridge, "Nausicaa of the Valley of the Wind," AnimeOnDVD.com (2005), http://www.animeondvd.com/reviews2/disc_reviews/3645.php (accessed July 14, 2009).

35. Joshua M. Daniels, "'Lost in Translation': Anime, Moral Rights, and Market Failure," *Boston University Law Review* 88, no. 3 (2008): 709–44, http://www.bu.edu/law/central/jd/organizations/journals/bulr/volume88n3/documents/DANIELS.pdf (accessed July 14, 2009).

THOMAS LAMARRE

• • •

Speciesism, Part II: Tezuka Osamu and the Multispecies Ideal

Although the rhetoric of *sengo* or "postwar Japan" encourages the articulation of a resolute break between prewar and postwar Japan, postwar manga and animation do not abandon the speciesism seen in wartime manga and manga films. On the contrary, speciesism, that is, the translation of race relations into species relations, becomes more prevalent in the postwar era. Postwar manga and animation refine, intensify, and redouble the wartime aspiration of "overcoming racism" by summoning and implementing (often in the context of war) a multispecies ideal, which often takes the form of a peaceable kingdom in which different populations (species) coexist productively and prosperously. The continuity with wartime speciesism is particularly evident in the works of Tezuka Osamu, who is usually acknowledged as the pivotal figure in establishing new conventions for manga and television animation in postwar Japan. While this essay begins by exploring the continuity between wartime speciesism and Tezuka's interest in the ideal of a peaceable animal kingdom, it becomes clear that Tezuka remained wary of the multispecies ideal articulated in wartime manga and manga films. Here, however, the goal is not merely to point out sites of continuity or discontinuity between prewar and postwar Japan. Rather than using continuity or discontinuity to define

eras or objects, the aim is to proceed genealogically, to delineate the contours of a power formation associated with, and maybe impossible without, manga and animation.

TEZUKA, THE POSTWAR

Histories of manga usually place a great deal of emphasis on the works of Tezuka Osamu in the formation of manga as we know it today. Commentators commonly draw attention to the introduction of cinematic forms of continuity in Tezuka's manga, which helped to consolidate a stable set of conventions for conveying and sustaining action, perception, and emotion across panels. In this respect, within manga history, the works of Tezuka have come to play a role analogous to theories of the formation of a classical style in cinema in the 1920s. If we add to this the idea of manga as "comics that are easy to draw," we might think of Tezuka's manga in terms of the establishment of an easily imitable system of expression for producing imaged-based narratives.[1] Or, if you prefer to think of the continuity of action, emotion, and perception in manga less in terms of narrative and more in terms of interaction with characters, we might see his manga in terms of a stable and imitable set of conventions for making image-based character arcs or reader–character interfaces. In either case, Tezuka is commonly styled as the god or the father of manga on the basis of his formation of a stable, imitable system of manga expression.

Similarly, histories of anime that focus specifically on anime as a distinctive set of limited animation techniques developed largely in the realm of television production (*terebi anime*) see Tezuka Osamu as the originator of anime, starting with his establishment of Mushi Pro to bring the manga *Tetsuwan Atomu* to the small screen. Here a contrast with full animation, that is, animation that strives for a higher degree of fluidity and mobility in character animation that is associated with cinema and the big screen, becomes important. Commentators stress how Tezuka's work created a new set of conventions for animation, at once stable and readily imitable, which spawned a lineage (or lineages) of anime, distinctive from big-screen animations such as the feature-length films of Disney Studios, the *dōga* (literally "moving pictures") of Tōei Studios, and the *manga eiga* (manga films) of Ghibli Studios.

It is interesting that in manga histories Tezuka is often credited with introducing cinematic modes in order to stabilize manga expression, while in anime histories, he is typically credited with developing an anime system

of expression distinctive from cinema or cinematic animation. Yet we don't need to set these two paths of Tezuka in opposition. It is clear that Tezuka's works mark both a continuation of and a break with cinema—in other words, a transformation in cinema (understood as a stable set of conventions for action, emotion, and perception). Nevertheless, histories of manga and anime have tended to avoid the logic of transformation, insisting instead on a radical break between the prewar and the postwar, which is embodied in the figure of Tezuka.

TEZUKA IS COMMONLY STYLED AS THE GOD OR THE FATHER OF MANGA ON THE BASIS ON HIS FORMATION OF A STABLE, IMITABLE SYSTEM OF MANGA EXPRESSION.

In recent years, especially in manga histories, signs of trouble with this historical paradigm in which Tezuka plays the role of godlike originator have increased, and the apparently stable ground beneath the historical emphasis on Tezuka has begun to shake and buckle, threatening to topple the exalted idol. As new materials from prewar and postwar Japan become more widely available, and as scholarly and popular interest in manga and anime history expands, we encounter a more extensive and less stable field of analysis, which has led to a reconsideration of Tezuka's primacy. Challenges to his ascendency are especially pronounced in the writings of Ōtsuka Eiji and Itō Gō, which I will discuss subsequently. But first I wish to signal that there is more at stake in reexamining the role of Tezuka in the development of manga and anime than broadening the scope of inquiry, correcting the historical record, or acknowledging the contributions of other creators to the formation of a distinctive set of manga and anime conventions.

Manga and anime histories have gravitated to the figure and the works of Tezuka for two reasons. First, Tezuka truly played a crucial role as an innovator and consolidator in both manga and anime production, and it is exceedingly difficult and probably impossible to bypass his contributions. Second, because a broader interest in manga and anime history is relatively recent, and because histories to date have often been rather informal, the histories of manga and animation in Japan have tended to rely on and to reproduce the entrenched paradigms for understanding Japanese history, rather than considering how materials such as manga and animations might allow us to rethink how we approach Japanese history or to invent new historical paradigms.

Among the most entrenched of historical paradigms for organizing Japanese history is that of a radical break between prewar and postwar Japan. Carol Gluck uses the term the "long postwar" to call attention to the

persistence of a seemingly intractable tendency, still in evidence some sixty years after World War II, to organize Japanese history around a rupture with wartime Japan. She writes, for instance, of "the original *sengo* [postwar] consciousness that wished and hoped for—although not necessarily believed in or lived—a history that could begin again at noon, August 15, 1945."[2]

Gluck's essay draws attention to a number of factors that encouraged this sense of a radical break with the wartime and a totally new beginning, factors that came into play immediately after the war under the American Occupation (1945–47). While the American occupiers of Japan, for instance, as well as progressive Japanese historians put history on trial, government leaders in postwar Japan continually announced the new driving out the old. And the sense of a radical historical break brought with it a new set of attitudes toward history. It encouraged the belief that history could begin anew, and, Gluck reminds us, it encouraged the idea that modernity had gone wrong in Japan but that it could be righted. It also invited a forgetting of Japan's imperial past, at least in the domain of official histories.[3]

With the establishment of *sengo* as *the* paradigm for understanding Japanese history, large divisions of history—that is, macrohistorical conceits—became gradually compressed into and distributed across the analysis of all manner of sociohistorical activities and events. Historical inquiry in postwar Japan has thus gravitated toward and selected those figures and events that mesh with the macrohistorical paradigm of *sengo*. The history of manga, for instance, finds a perfect fit with the *sengo* paradigm in the figure of Tezuka Osamu as the originator (or god) of manga, or of anime, or both. What Gluck calls the long postwar is repeated in the establishment of a radical break in manga and anime history by insisting on Tezuka as the origin.[4] The compression of the *sengo* paradigm into manga history has produced, as an analog to the long endless postwar, a long endless Tezuka. As a consequence, to look at Tezuka's manga and anime in light of their continuity with prewar (or wartime) manga and manga films forces an encounter with fundamental questions about Japanese history and modernity.

In his recent writings, for instance, Ōtsuka Eiji challenges the received paradigm of a break between wartime and postwar, precisely because he is concerned with what he sees as the resurgence of nationalism and the persistence of militarism in the contemporary world of manga and anime. He is openly and vehemently critical of recent attempts on the part of the Japanese government to make manga and anime into cultural heritage and to develop public policies for their production. Such concerns have spurred Ōtsuka not only to highlight the relation between wartime and postwar in his analyses of

Tezuka but also to challenge the idea of an unbroken, purely Japanese lineage for manga and anime. He writes:

> I should first point out that it is a mistake to view Tezuka Osamu's manga system of representation as originating entirely in Japan. It is not impossible to see manga in terms of a lineage that goes back to *ukiyoe* of the Edo period or comic animal art of the medieval period, but such a view of history ignores the "invented traditions" prevalent in so many of the introductory books on manga published in the late 1920s and early 1930s. With respect to stylistic innovations at that time, the reception of Disney is exceedingly important.[5]

In sum, Ōtsuka's concerns with the resurgence of nationalism in Japan lead him to emphasize the relation between wartime and postwar, which encourages him at the same time to situate these materials in relation to the history of Japan, both of wartime Japan in its conflicts with the United States and nations in East Asia, and postwar Japan at peace with the United States but complicit with American militarism in East Asia. His emphasis on the reception of (and reaction to) Disney provides a point of entry into this complex set of political responses and exchanges, for Disney signals for him, in a grand fashion, a history of Japanese relations with the United States.

While in this essay I too am concerned with the relation between wartime and postwar manga and animations, my concerns differ from Ōtsuka's in three crucial respects. First, where Ōtsuka relates militarism largely to cultural nationalism, my concern is with imperial desire. Which is to say, while the co-production of national values and military techniques is clearly part of the problem of empire, I see the process of political indoctrination into national values (national propaganda) as secondary to, and as a retrospective effect of, a process of desiring empire evident in popular culture. With reference to Japan's national empire, I see not only a process of excluding, "inferiorizing," and dominating others through the generation of a sense of Japanese solidarity and superiority but also simultaneously a process of including and celebrating others—the realm of pan-Asianism, the Greater East Asian Co-Prosperity Sphere, and multicultural ideals. Too much emphasis has been placed on how so-called common people are passively duped or tricked into backing the nation and too little on how people come to desire empire, actively enough.

Second, because my context is one of engagement with anime and manga under transnational conditions, I am concerned with how the "desiring empire" associated with multiculturalism or multiethnicism, although at one

level specific to Japanese manga and animations, proves amenable to transnational circulation, production, and reception. I do not think it coincidence that the global boom in Japanese manga and anime not only happens with the rise of new information and communications technologies from the late 1980s but also corresponds with the open use of the term "empire" to describe our historical juncture and the desire for multilateral participation in imperial wars.

Third, while I am no more optimistic than Ōtsuka about the current situation, I nonetheless feel that, if we are somehow committed to empire in entertainments and media, however reluctantly or ambivalently, then we fans of manga and anime will need to work through these commitments and this material horizon rather than disavow them. Since this "work" will not begin with corporations, it should begin with fans. After all, who is better situated to appraise the situation?

Such concerns lead me to focus on militarism in relation to national empire and multiculturalism rather than in relation to Japanese nationalism alone. My point of departure is the continuity between wartime manga and postwar manga in the domain of "speciesism," that is, the translation of relations between races into relations between species, which I introduced in the first part of this essay in *Mechademia* 3. I will explore the postwar continuity with the prewar, yet my goal is not merely to demonstrate continuity or, for that matter, discontinuity. I aim to proceed "genealogically." Which is to say, rather than defining an era or an object, I am interested in delineating the contours of a power formation connected to, and maybe unthinkable without, manga and animation.

MULTISPECIESISM

In his diary, Tezuka describes his response to a manga film released in the last year of Japan's Fifteen-Year Asia-Pacific War, *Momotarō, umi no shinpei* (1945, Momotarō's Divine Navy), writing:

> My first impression of the film was that it seemed to have adopted elements
> of culture films, and even though called a war film, it had in fact taken on a
> peaceful form.[6]

Tezuka uses the term "culture film" or *bunka eiga* to explain the peaceful qualities of the animated Momotarō film. The term comes from the title

of Paul Rotha's book, *Documentary Film* (1935), translated into Japanese as *Bunka eiga-ron* (On culture film), leading to an association of documentary film with the German *Kulturfilm*. These were films primarily on science that had achieved some popularity in Japan. As Abé Mark Nornes remarks, the introduction of theories of culture film in Japan coincided with the increased government control over filmmaking, "ranging from intricate censorship mechanisms to nationalizing entire sectors of the industry."[7] The culture film became integral to the government control of cinema, and the 1939 Film Law mandated the screening of nonfiction *bunka eiga*.[8] At the same time, the government also exerted tremendous control over animation production, making manga films central to its series of "national policy films" (*kokusaku eiga*). Thus, when Tezuka refers to *Momotarō, umi no shinpei* as a culture film, he implies that the manga film recalled nonfiction films designed to cultivate appreciation for science and nature rather than to promote war—whence its peaceful form.

There were a series of Momotarō films in the 1930s and 1940s, but Seo Mitsuyo's *Momotarō, umi no shinpei* was in many ways the culmination of Japan's wartime manga films, a visual and technical tour de force. This last wartime Momotarō film also expands on the logic of speciesism implicit in the previous Momotarō films. When Momotarō and his platoons of "Japanese" companion species (the film adds rabbit to the folklore convention of dog, monkey, and pheasant) arrive on an island in the southern seas, a variety of cute little "indigenous" or local animals—tiger cubs, monkeys, elephants, and others—eagerly assist with the construction of an air base. The film is a prime example of the difference between America's wartime speciesism and Japan's. Where American wartime propaganda commonly depicted the Japanese enemy as a dehumanized savage animal to be hunted down and exterminated, Japanese wartime speciesism, geared as it was toward visions of pan-Asian liberation and coprosperity, expanded on the logic of companion species, offering scenarios of species engaged in playful rivalry or cooperative endeavors. Alongside Momotarō with his awe-inspiring ability to produce cooperation among different kinds of animals, there were other heroes in the world of manga and manga film, such as Dankichi or Mabo (Maabō), boys who pursue their adventures in the company of an animal friend or friends, companion species.[9] There were also comical military animal heroes such as Norakuro the Stray Black Dog and Sankichi the Monkey.[10]

This emphasis in Japanese manga and manga films on heroes with animal companions, animal heroes, and animal cooperatives finds counterparts in European, American, and Chinese animation. Yet, taken as a whole, Japanese

> IN EFFECT, *MADAGASCAR*,
> LIKE *JANGURU TAITEI*,
> STRIVES TO IMAGINE THE
> INTERACTION OF SPECIES
> BEYOND THE LOGIC OF
> SOCIAL DARWINISM.

wartime animations take the trope of companion species to its logical limit, which is especially evident in the Momotarō animated films with their emphasis on Japanese animals befriending local animals of other environments. Simply put, Japanese wartime speciesism headed toward "multispeciesism," which we might think of as a specific form of multiculturalism related to the Japanese effort to envision a multiethnic empire.

Like multiculturism, multispeciesism is an abstraction that organizes actual flows and practices, and at the same time is continually discountenanced and thrown into crisis by them. My discussion of the abstraction of multispeciesism is not an endorsement of it as an ideal, nor do I claim that the Japanese empire attained this ideal or generated successful ways of coding its flows of peoples and practical relations to them. In drawing attention to the multispeciesism of prewar Japanese manga and manga films, I aim to call attention to the existence of modern Japanese thinking about what we today call multiculturalism, for three reasons.

First, this is a lineage that was deliberately suppressed after the war, with the approval of a Japanese regime eager to forget the horrors of and ignore responsibility for the Fifteen-Year Asia-Pacific war. With encouragement on the part of the American Occupation, the postwar regime reconstructed Japan as a mono-ethnic nation, by stripping Japan of its imperial holdings, "repatriating" non-Japanese living in Japan, and generally discouraging any recollection of empire and its end (the atomic bombs). It is important then to counter this postwar indifference vis-à-vis Japanese efforts to envision a multicultural empire. Second, and more important in this context, we cannot understand the transnational reception of anime and manga, unfurling into a recognizable boom in the 1990s, without consideration of the genealogy of multiculturalism, evident in wartime multispeciesism. In fact, in my opinion, the current transnational popularity of manga and anime is due in part to multispeciesism. Multispeciesism not only builds multiple species/peoples into its characters and stories but also promises a different way of thinking about multiculturalism (at a time when that abstraction is in deep crisis). Third, while I am less optimistic than Donna Haraway about the forms of desire associated with companion species, I do agree with her that the cyborg is a subspecies of the companion species.[11] Consequently, my emphasis on the politics of multispeciesism is, by extension, a critique of discussions of cyborgs that introduce an insuperable divide between the personal and

political, dwelling on identity formation and technologies of the gendered self without any consideration of the social character of desire.

Now, multispeciesism makes a frequent appearance in Tezuka's manga, in a form reminiscent of wartime manga and manga films, as multispecies cooperatives and peaceable kingdoms based on animals living together in playful rivalry for the sake of coprosperity. It is surely not a stretch to conclude that what Tezuka saw as the "peaceful form" in *Momotarō, umi no shinpei*—that which invited him to see in it an appreciation of science and nature reminiscent of the culture film—was closely related to the film's vision of a multispecies ideal. For instance, in his manga *Janguru taitei* (1951–54, Jungle emperor), later adapted into television animation (1965–67) and shown in North American syndication as *Kimba the White Lion*, Tezuka follows the trials and triumphs of a lion cub who, although captured by human hunters and nearly exiled from Africa, eventually assumes his rightful place as emperor and strives to improve the lot of all animals.[12] Note that Leo is not merely king of a country but *taitei*, or emperor, of a jungle empire. The terms "emperor" and "empire" feel appropriate in the context of *Janguru taitei*, because this political entity comprises many species. Leo is not merely king of the lions but emperor of many species of jungle animal. In other words, Leo's empire is a multispecies cooperative, and the manga and anime offer images of different species engaging in playful rivalry or harmonious cooperation reminiscent of the jungle scenes in *Momotarō, umi no shinpei* (1:164–65). There is a sense of musical harmony and symphonic cooperation (Figure 1).

To achieve cooperation among species, what is to be avoided above all is competition and war among them, and, as is generally the case in Tezuka's works, the manga *Janguru taitei* is haunted by questions about the circumstances under which animals of one species may eat those of another. In this respect, Tezuka anticipates the problematic that courses through recent animations for children in the United States, such as the first *Madagascar* animated film (2005), in which a group of New York zoo animals (lion, zebra, hippo, giraffe), transported to Africa, have to figure out how to survive without eating each other. After all, lions tend to hunt and kill zebras. In effect, Madagascar, like Janguru taitei, strives to imagine the interaction of species beyond the logic of social Darwinism. The key phrase of social Darwinism (survival of the fittest) is sometimes translated bluntly into Japanese as a brutal hierarchal conceit, "the strong eat the weak" (*jakuniku kyōshoku*), which effectively yokes the idea of "nature red in tooth and claw" to that of survival of the fittest. Other recent American animations address this question—how can different species cooperate as friends beyond the frame of

FIGURE 1. In this scene from *Jyanguru taitei*, the various species of the jungle gather in a peaceful circle of harmony.

social Darwinism? In addition to *Madagascar*, there are digital animations made for children and general audiences such as *Ice Age* (2002), in which the saber-tooth tiger gradually befriends a member of a "weaker" prey species, and *Bee Movie* (2007), which explicitly and comically superimposes species interactions and race relations with its rhetoric of species exploitation and civil rights.

Tezuka, however, is ahead of these animations, not merely in chronological terms but also in terms of the depth of his engagement with the problematic of multispeciesism. This depth derives in part from Tezuka's background in biology and medicine: he completed his training as a doctor even as his career as a manga creator began to take off, and in addition to manga designed as biology primers (such as *Manga seibutsu gaku,* 1956), questions about life, nature and species are a constant preoccupation in his works.[13] Yet the depth of his thinking about multispeciesism is not simply a matter of biological knowledge and scientific preoccupations; it also comes of his proximity to the Fifteen-Year Asia-Pacific War. Because Tezuka was born in 1928, the war spanned his childhood years; he was seventeen at the end of the war when he saw *Momotarō, umi no shinpei*. Tezuka cannot help but associate multispeciesism with war, and in particular associate it with interspecies or

race war. Consequently, his is not the feel-good "let-them-eat-sushi" or "prey-becomes-buddy" multispecies ideal of *Madagascar, Ice Age,* or *Bee Movie.*[14] Tezuka continually tries to separate multispeciesism (the ideal of multiethnic empire) from war, yet his manga tend to dwell on failure not success, and the multispecies kingdom is usually destroyed. Likewise those nonhuman creatures who strive for cooperation across species tend to die tragically.

For instance, in one of the sequences in *Aporo no uta* (1970, *Apollo's Song*), a manga in which a young man who delights in killing is gradually taught the value of love through a series of dream experiences, the young man is stranded on an island in the southern seas in the company of a young woman whom he learns to love.[15] The island is a peaceable kingdom in which animals live together without killing or eating one another. When the young man makes the grave mistake of killing a rabbit for food, the animals turn against him and, to teach him a lesson, injure the woman (35:100–101; Figure 2). As he nurses the woman back to health, he learns to respect the peacefulness of this multispecies cooperative. Oddly, as in *Madagascar,* the practical solution to the impasse of not eating other species is for the man to eat fish rather than "meat," a clear sign that multispecies cooperation has definite zoological limits. Yet, when it comes to thinking the relation of war and multispeciesism,

FIGURE 2. In this sequence from *Aporo no uta,* the animals of the peaceable island kingdom stand in accusation around the young man and his female companion, whom the animals have injured in retaliation for the man eating the rabbit's companion. It is as if the human has entered and broken the circle of animal harmony depicted in Figure 1, transforming into it in a theatre of operations.

it is the backstory for the existence of this peaceable kingdom in *Aporo no uta* that merits closer attention.

In a cave, the young man and woman discover the remains of a prior human inhabitant of the island, including his final testament. The remains are those of the head zookeeper of Hanshin Zoo in Kobe, who, during the "terrible and loathsome" (*imawashii*) war, received orders from the army to poison the animals. Unable to kill his animals, the zookeeper took two animals (male and female) of a number of species and transported them by boat to the island—a sort of wartime Noah's Ark (35:147). The animals seemed to understand the situation, and speaking from the heart to them, he succeeded in training them not to prey on one another. Thus, on the island, all distinction between beast (*kedamono*), bird, and human disappeared (35:148).

In this backstory for the island multispecies cooperative, Tezuka tentatively draws a line between war and multispeciesism, making sure that the peaceable kingdom stands in contrast to war and presenting the zookeeper's act as resistance to wartime atrocities inflicted on animals—the zookeeper becomes a "Schindler" for animals. In this respect, Tezuka's gesture is in keeping with the postwar Japanese imaginary wherein the focus on the horrors of war often provided a way to avoid rather than address the ideals associated with the wartime Japanese empire. War appears as an inexplicable drive to destroy, a descent into madness, a force of nature, or act of God—hence "resistance" can take the form of Noah's Ark, saving the species of the earth from destructive impulses of human nature. Because Tezuka indulges this view of war as a quasi-natural, nonhistorical force of destruction, he manages to dissociate the wartime imperial ideals of multispeciesism from the actual war. But then wartime manga and manga films had already begun the process of dissociation of the imperial ideal from the actual war, by displacing the codes of Pan-Asianism and the Co-Prosperity Sphere onto multispeciesism. This prior displacement helps Tezuka ignore, overlook, or "forget" the relation between war and multispeciesism. This is how multispeciesism in Tezuka appears, as in *Momotarō, umi no shinpei,* to take on a "peaceful form," although it is actually a "wartime thing" (*sensō mono*).

At another level, however, it is clear that Tezuka does not and maybe cannot forget the relation between war and multispeciesism. After all, war and peace (multispeciesism) always arrive together in Tezuka's world, as if they were somehow inseparable. While some of his manga end with indications of peace as a resolution to a warlike threat or military interlude, peace—particularly in its multispecies form—appears largely impossible in Tezuka. It is as if the peaceful empire of species were permanently foreclosed, as if to

overcompensate for the inability to separate it definitively from war. When the multispecies ideal makes an appearance, the peaceable animal kingdom is usually doomed. In *Aporo no uta,* for instance, the island turns out to be volcanic, and no sooner does the volcano begin to erupt than a rescue boat appears offshore. The two men who come ashore, however, will not listen to the young man's pleas to take the animals aboard; instead they fire on the animals. The young man and woman flee with the animals, and in the end, the volcano erupts, killing them all. Various forms of violence—war, human violence to animals, and natural forces (the volcano)—merge to assure that multispecies cooperation remains an impossible ideal.

This sequence from *Aporo no uta* is in effect the flipside of *Janguru taitei,* wherein the bid for multispecies empire proves more durable. Yet, looking at Tezuka's works as a whole, I would argue that *Janguru taitei* and *Tetsuwan Atomu* are somewhat exceptional in narrative terms in allowing for more durable interludes of multispeciesism and cooperation between species (both animals and robots). The durability of the imperial ideal might explain in part the popularity and exportability of *Kimba* and *Astro Boy* in the 1960s, as well as the appeal of Tezuka's lion emperor for Disney in the 1990s, in the form of *The Lion King* (1994).[16] On the whole, however, the impossibility of achieving multispeciesism, which comes of Tezuka's inability to dissociate it entirely from wartime empire, results in a tendency to embody a kind of "transspecies" potential in cute little nonhuman characters, whose suffering at the hands of humans repeats the sense of the impossibility of sustaining the multispecies ideal in this world and even in this cosmos (as interplanetary and intergalactic relations do not afford a solution either). Leo and Atom (or Kimba and Astro) are not entirely exceptions in this respect. In particular, the constant suffering of Atom at the hands of evil humans underscores the impossibility of actually building the peaceable kingdom on earth. But let me look at an earlier example of this embodiment of the transspecies potential in manga characters, one that had a tremendous impact on early postwar readers and paved the way for the later characters—Mimio the rabbit.

Mimio the rabbit plays a central role in two manga that appeared in print about the same time: *Rosuto waarudo* (1948, Lost world) and *Chiteikoku kaijin* (1948, Mysterious underground men).[17] In these manga, a human doctor has surgically endowed a rabbit with a human brain, producing Mimio, who walks and talks and thinks like a human. Significantly, however, giving a human brain to a cute little animal does not result in a creature with adult human capacities. The animal endowed with a human brain must be taught, and there are in *Rosuto waarudo* scenes of humans teaching the animals.[18]

These scenes make Mimio and the other talking animals appear rather like school children, unlearned yet potentially receptive to learning. In other words, the animal with the human brain is like a child, and its diminutive stature and cute features, together with its flexibility, receptivity, and manic energy, reinforce the sense that the talking animal is a special case of childhood. I will return to this dimension of the animal character in part 3 of this essay (to appear in a future issue of *Mechademia*), where I will characterize it as not merely as an instance of cute but as neoteny (an evolutionary retention of juvenile features). But first I would like to look at how the talking animal character becomes a test case for multispeciesism in Tezuka.

It is the inability of humans to accept the humanity of the talking rabbit Mimio that generates an aura of pathos around him, which in turn disposes the little rabbit to make greater efforts to win love and recognition from humans, especially from adults. (There is a general equation of human with adult: even though some children mistreat animals, and some adults befriend them, generally it is adults who mistreat the animals, and the manga thus divides adults and children in terms of their ability to accept Mimio.) Ultimately, it is the inability of adult humans to embrace different species, even when they so obviously display human qualities, that anticipates the unhappy end of the talking animal character. As Fujimoto Hiroshi of the Fujio Fujiko manga team indicates in his recollections of first reading *Chiteikoku kaijin,* part of the impact of these manga came of the death of Mimio:

> When we reached the conclusion, we were all taken aback! Mimio dies at the end! We were so involved with the Mimio character and then he gets killed off! We said, "He can't do it!" But he did . . . Tezuka introduced an element of tragedy for the first time to a *manga* for children.[19]

The tragedy of Mimio, however, comes not only from the sensation of losing a beloved friend (a companion animal) but also from the sense of the inevitable failure of multispeciesism in the actual world, the world of adult humans. In other words, the specificity of Tezuka does not lie in the production of cute little critters, even though he did excel at making them and gradually amplified the 1930s modalities of cute that are largely associated with Disney (despite the contributions of a range of cartoonists and characters). Nor does the specificity of Tezuka lie exclusively in his willingness to kill off his cute little nonhumans in order to introduce "reality" into manga in the guise of cruelty, tragedy, or death. Rather the specificity (and the genius, as it were) of Tezuka comes of his skill in embodying multispeciesism in

cute little nonhumans, in an attempt to find a way to think through or work through the legacy of Japan's multiethnic empire in a postwar era characterized by the ubiquity of war rather than the end of war.

In fact, the very design of Mimio recalls wartime multispeciesism as articulated in *Momotarō, umi no shinpei*. While it is possible to see in Mimio the general impact of Disney (rather than, say, a specific Disney rabbit, Oswald) as well as Looney Tunes (Bugs Bunny), the design of Mimio immediately recalls the teams of little rabbit companion soldiers who so eagerly bridge the gap between humans and exotic indigenous animals during the construction of the airstrip in *Momotarō, umi no shinpei* (Figure 3). Just as those rabbits assisted the contact between humans (Momataro) and local animals, so Mimio assists humans in their contact with alien species. With the death of Mimio, it is as if Momotarō's loveable animal companions, rather than triumphantly interacting with, and assisting with the liberation of, the exploited local species, ultimately had to die to prove the virtues of multispeciesism. This resonance between wartime and postwar companion species makes Tezuka's nonhuman cuties something of a paradox: isn't death for the cause of multispeciesism precisely how the Japanese war was articulated? Is this manga an endorsement of wartime multispeciesism, once again to the death, or is it a critical response to it?

Embodying multispeciesism in cute little nonhumans (and making them suffer for it) does change things considerably. On the one hand, wartime multispeciesism has been transformed in Tezuka into a potential that is crossing through or traversing worlds that are structured by interracial and interspecies violence, that is, a cosmos predicated on social Darwinism. The abstraction of multispeciesism has been opened to multispecies flows and becomes a transspecies potential. In Tezuka's manga and animations, the transspecies potential acts as an affective force that hovers over and permeates the cruel Darwinist cosmos, revealing itself in tragic sacrifices that promise salvation rather than alternative ideals. For all its ambivalence, then, Tezuka's gesture does allow for an exposure of and critical response to the relation between multiculturalism and war, provided we acknowledge the continuity of postwar manga with wartime manga and begin to think genealogically.

Thus far I have stressed the Japanese wartime critique of social Darwinism as the genealogical point of continuity/discontinuity that continues to trouble and motivate postwar Japanese manga and animation. From this

> THE ANIMAL WITH THE HUMAN BRAIN IS LIKE A CHILD, AND ITS DIMINUTIVE STATURE AND CUTE FEATURES, TOGETHER WITH ITS FLEXIBILITY, RECEPTIVITY, AND MANIC ENERGY, REINFORCE THE SENSE THAT THE TALKING ANIMAL IS A SPECIAL CASE OF CHILDHOOD.

FIGURE 3. Tezuka's cute little rabbit Mimio in *Rosuto waarudo [above]* recalls the cute little rabbit soldiers who assist Momotaro in *Momotarō umi no shinpei [below]*.

point of view, Tezuka appears not as a godlike creator or moment of total historical rupture but as an innovative transformer of manga and manga films. We also begin to see that postwar Japan is not a "Japan after war" and thus not a "Japan at peace." Postwar Japan becomes a key player within the new military-industrial complex, and the prefix "post-" should refer us to the ubiquity and commercialization of war rather than its demise.

On the other hand, the embodiment of multispeciesism in cute little non-humans finds support in the materiality of manga and animation wherein the force of the technical assemblage tends to channel the dynamism inherent in the mechanical succession of images into animated animal characters. As is often the case in Tezuka manga, *Rosuto waarudo* includes a series of comic asides about Mimio and other talking animals, to the effect that "this is just like a manga" and "only a manga writer would turn animals into humans." Such nondiegetic remarks focus attention on the specificity of manga worlds vis-à-vis the generation of animaloid humans or humanoid animals. This relation between animal characters and the materiality of manga and animation demands greater attention.

In Part 1, I discussed how animation tended to "animalize" the human, while cinematic conventions tended to humanize the animal. Animation tended toward plasmaticity, encouraging violent deformations and radical transformations of character forms, while cinema, especially in nature documentary, tended toward photography conventions that spurred a subjectification of animals. Needless to say, cinema frequently turns to deformations, transformations, mutations, and "animalization," yet when it does, it tends to incorporate animated or "animetic" modes of expression in the form of special effects. This suggests that we might consider the increased use of digital animation in cinema, which some argue has made cinema into a subset of animation, in light of the genealogy of multispeciesism.[20] But that goes beyond the confines of this essay. I will return to the materiality of animation in Part 3, but suffice it to say for now, in Tezuka, it is above all the animal character that harnesses the force of the moving image, which promises to afford a relay between manga, animation, and cinema. As such, tensions become condensed into the animal character, in its oscillation between humanization and animalization, or between animaloid human and humanoid animal.

In sum, Tezuka's trick of embodying multispeciesism in cute little non-humans accomplishes two things: it opens the wartime codes of speciesism into a potential that traverses worlds, liberating its affective force, and it presents innovations in manga and animation techniques at the level of characters, which imply a shift in the relation between reader and viewer and

the image. Part 3 of this essay series will return to questions about how the materiality of animation and technologies of the moving image affect the deployment of animal characters in the works of Tezuka, but here I wish to address some more questions about speciesism in general, in order to situate the implications of Tezuka's dedication to a critique of social Darwinism.

SPECIESISM, POSTWAR REDUX

Translating racial relations into species relations is a gesture so common that we often take it for granted. With the proliferation in recent decades of science fiction films and television series that highlight the encounter between humans and aliens, we have become ever more accustomed to thinking social, political, and cultural difference in terms of difference between species. But what happens when species difference becomes an operative logic that sweeps across and courses through our experiences of cultural, ethnic, social, or political difference?

Let me cite three instances of speciesism that may help us to think about what is at stake in speciesism in general, drawn from the 1960s (roughly) to set the stage for further discussion of Tezuka:

- Pierre Boulle's novel *La planète des singes* (1963, *Planet of the Apes*), in which primates come to dominate the universe, and humankind is a mute subspecies;

- Gene Roddenberry's original *Star Trek* series (1966–69) in which human space explorers, under a directive not to interfere with alien cultures, encounter aliens who test their capacity to obey their prime directive; and

- Numa Shōzō's *Kachikujin Yapū* (Yapoo, the human cattle, completed in 1970) about a future world in which the distant descendents of the Japanese serve as "domesticatible" bodies that the rulers of a white matriarchal galactic empire reengineer into a variety of household objects to serve and pleasure them.

Of these three instances of speciesism, the first two proved internationally popular, subsequently spawned films, and inspired other series. In this respect, although geared toward children or "general" or "family" audiences, due to its international appeal, Tezuka Osamu's *Jyangaru taitei* might appear to be a more obvious fit with *Planet of the Apes* or *Star Trek* than *Kachikujin*

Yapū. Yet I wish to call attention to *Kachikujin Yapū,* for its impact was profound in the Japanese context, and its relentless and unflinching exploration of the dynamics of the desire for subjugation in the context of empire is unparalleled in science fiction.[21]

In these entertainments, speciesism predicates political and personal interactions on "species difference"—a set of seemingly irreducible and insurmountable biological differences. As such, speciesism calls attention to the interaction of populations, under conditions in which one population cannot biologically assimilate or blend with the other. There are two faces to speciesism.

On the one hand, even though the concept of species is subject to intense debate in biology, as such entertainments attest, the traditional definition of species—organisms capable of interbreeding and producing fertile offspring—remains generally in effect in the social imaginary. One consequence of articulating social difference at the biological level of species is that hybridity becomes exceedingly difficult and sometimes impossible, however desirable. By definition, species do not interbreed. In this respect, because it implicitly evokes a limit with respect to interbreeding (who can marry whom and with what results), speciesism also bears echoes of totemism and its organization of kinship relations, such as Lévi-Strauss described them.[22] Yet, where totemism, if considered biologically, constitutes an attempt to regulate interbreeding,[23] speciesism establishes barriers to interbreeding, and when tales of speciesism allow for interbreeding between species, the resultant offspring are commonly treated as torn between different worlds, between different clans and totems, as it were, physiologically, biologically, and psychologically.

In *La planète des singes,* for instance, some apes and humans learn to negotiate, that is, to speak with one another, and even to respect one another. But we do not see any signs of ape–human marriages with hybrid offspring who might ultimately erase the very basis for conflict. And the novel is framed by the disbelief of chimpanzee readers who discover an account of interplanetary travel written by a human: impossible to believe that humans possess the ability to write, let alone pilot spaceships! In the original *Star Trek,* in which the multiethnic and multicultural cast stands as evidence of how future humans have overcome racism, a great deal of attention nonetheless falls on Spock, on his status as hybrid, as half human and half Vulcan. Frequently, Spock appears literally, that is, biologically, torn between two possibilities. This is such an important trope of the series that, in one of the later movies, Spock's human mother remarks to him that he is, after all, *physiologically* half human.

It is as if all the problems associated with racism had merely been displaced onto species difference. Consequently, speciesism feels like an exceedingly inflexible form of racialism,[24] wherein the difference between peoples is articulated as *natural*—that is, biological—difference, at the very moment when cultural or ethnic differences within the human species have allegedly been overcome. *Kachikujin Yapū* confirms this bias whereby speciesism serves to intensify racialism and thus to promote racism: in this story, it is the discursive transformation of the Japanese people into a species (Yapoo) by white scientists and ideologues that provides the rationale for whites to reengineer the bodies of Yapoo to suit their whims.

This tendency of speciesism to call on racial thinking and racist practices serves as a historical reminder that racial divisions were frequently articulated as species divisions, as biological divides. As Robert Young points out, debates about race in the late nineteenth and early twentieth century often centered on the question of whether different races could interbreed.[25] Those who initially argued that races could not interbreed changed their tack when confronted with evidence to the contrary; they then argued that, even if races could interbreed, the offspring would be infertile or degenerate. Equally disturbing, those who accepted the evidence that humans were one species often felt that the "lower races" should be bred with the "higher races" to improve the stock. Japanese novelist Natsume Sōseki cites one such encounter in his journal in 1901: "When talking with Brett this evening, he said that we had to improve the Japanese people. To do so, he said we ought to promote marriage with foreigners."[26]

In sum, on one level, speciesism appears to rely on racialism and racial "sciences," and even to reinforce thoroughly discredited ways of thinking about racial difference. If we recall that the first works of science fiction exploring the invasion of Earth by alien entities drew their inspiration from "yellow peril" discourses,[27] speciesism appears to be little other than a continuation of modern racialism and even racism by other means.

On the other hand, the postwar era was supposed to do away with racism or, at the very least, expose and challenge its presuppositions and operations. Precisely because scores of millions perceived World War II as a race war, the end of the war saw concerted efforts to put an end to racism, especially among the former Allied Forces. In November 1945, for instance, a conference was held in London for the establishment of the United Nations Educational, Scientific and Cultural Organization (UNESCO), and about a year later, in 1946, UNESCO held its first conference in Paris under the direction of biologist Julian Huxley. The preamble of the UNESCO Constitution declares "the great

and terrible war which has now ended was a war made possible by the denial of the democratic principles of the dignity, equality, and mutual respect of men, and by the propagation, in their place, through ignorance and prejudice, of the doctrine of the inequality of men and races."[28] In other words, to end racism was to end war.

Of course, it is not so easy to put an end to racial thinking, and even though the initial statements delivered in 1945 underscore the role of racial prejudice in the war, with the Associate President Léon Blum speaking of the war in terms of "glorifying violence and propagating the inequality of races,"[29] there evidently remained some commitment to, or confusion about, the reality behind the concept of race. For instance, while many speakers expressed their commitment to combating racial inequality, their solution was to promote equality among races. In other words, they accepted the existence of races as such. The British prime minister, for instance, stressed "the world-wide difficulty that we all have to face—the education of backward races."[30]

Part of the confusion came of the fact that the term "races" carried a fluid series of connotations running the gamut from "peoples" or "nations" (cultural or ethnic difference) to "races" in the sense of biological difference. Before long, however, UNESCO indicated its awareness that the very idea of race, with its connotations of inherent biological difference, threatened to ruin its mission of promoting the fundamental equality of humans. By the time of its 1950 statement, "The Race Question," UNESCO had begun to challenge the very idea of race as a dangerous myth: "For all practical social purposes 'race' is not so much a biological phenomenon as a social myth. The myth 'race' has created an enormous amount of human and social damage."[31]

It is in light of such efforts to discredit racism by casting race as myth and pseudo-science that postwar speciesism appears politically backward and socially awkward in its insistence on thinking cultural difference in terms of biological difference. In the wake of progressive antiracism, to dwell on racial differences between humans could only appear reactionary. Progressive anti-racism thus makes it difficult to explore the physical concreteness of racial discrimination. Part of the appeal of thinking race relations at the level of species, then, comes of its emphasis on physical, biological difference. The emphasis on species, on biological difference, imparts a sense of physicality and concreteness to racial discrimination, which threatens to disappear once racism is construed as an extension of myth or fantasy. It is difficult to grasp the actual cruelty and the real experience of racism if racism is cast as a matter of individual or collective ignorance. Consequently, the appeal of speciesism lies in the challenge that it poses both to reactionary racism and

to progressive antiracism, by staging an encounter between the human and the nonhuman as if to say, "Well, you think you're comfortable with difference, but what if you had to live with or work with some disgusting-looking species?"

In sum, in response to antiracist politics that tended to dematerialize racism, speciesism strives to give us a physical, visceral experience of difference. A universe formerly dominated by humans but now ruled by apes gives discrimination a physical charge that, say, a nation formerly governed by French but now ruled by Germans does not. And if Americans are intent on the idea of doing empire but getting it right this time (that is, without race war), what could provide a more concrete test of their sense of mission to coordinate the universe nonracially than a series of alien encounters? These species twists on racial politics present, needless to say, a thoroughly ambivalent gesture vis-à-vis racialism, but the gesture should not be conflated with racism or racial prejudice *tout court*.

> IN RESPONSE TO ANTIRACIST POLITICS THAT TENDED TO DEMATERIALIZE RACISM, SPECIESISM STRIVES TO GIVE US A PHYSICAL, VISCERAL EXPERIENCE OF DIFFERENCE.

At the same time that such instances of postwar speciesism clearly derive from and expand upon racialism (with a systemic mapping of physiological and biological difference onto cultural or ethnic differences, and vice versa), their "rematerialization" of racial difference by translating it into species difference also entails an effort to move beyond the logic of segregation altogether. Speciesism rematerializes racialism in an attempt to transcend segregation. Speciesism strives to imagine, apparently in all innocence, how apparently incommensurable populations might come to an agreement, learn to cooperate, and productively work together. In other words, even as speciesism reinforces "natural" divides between populations (a sort of hyperracialism), it strives to overcome racist segregations by evoking multispecies cooperation. The result is a kind of biopolitical multiculturalism, in the form of multispeciesism.

Multispeciesism is like multiculturalism in that it aims for diversity, yet it insists on distinct boundaries between cultures and makes cultural homogeneity on small scales a precondition for cultural diversity on a large scale. As such, multispeciesism is biopolitical in two ways: (1) it emphasizes biological boundaries, with a predilection for translating cultural and ethnic difference into biological difference, and (2) it thus introduces life into politics, and in effect, it makes life the basis for politics. As such, the crises of multispeciesism typically evoke the struggle for survival, the destruction

of entire worlds, or the threat of extinction of a people, a species, a planet, a world, or a universe. Frequently genocide is recast as species extinction, and racial domination as species domination, which implies a reduction of the human to what Agamben calls "bare life" or "naked life," or analogously, a reduction of sentience to "bare sentience" (a manipulable and exploitable sentience that falls outside the zones of law or religion).[32] In such scenarios it is life itself that is at stake, life that is dominated, exploited, reengineered, and threatened.

The Allied Forces' postwar interest in multispeciesism—a nonhierarchical yet competitive coordination of populations that appear biologically incommensurable—presents a certain resonance with Japan's wartime speciesism as evidenced especially in manga and manga films that echo pan-Asianism and the Co-Prosperity Sphere. This is because multispeciesism in the postwar era likewise targets social Darwinism, at once translating and contesting the teleological social theory based on natural selection wherein "survival of the fittest" (already an unworkable reduction) generates the axiom "those who conquer are biologically fittest," and wherein hegemony becomes predicated on whatever passes for biological fitness. Multispeciesism pits itself against evils associated with social Darwinism, such as race war, genocide, and eugenics, and strives to imagine a nonteleological, nonhierarchical coordination of populations.

Resistance to social Darwinism not only became central to some lineages of biology, evolutionary theory, and philosophy of science and nature early in the twentieth century in Japan, but also played a crucial role in Japanese resistance to Western hegemony and modernity, which was frequently construed as founded in racial prejudice. For instance, the Japanese delegation to the Paris Peace Conference of 1919 demanded not only territorial control over former German colonies in East Asia and the South Pacific but also made a proposal for racial equality, which mandated equal and just treatment for all alien nationals of states without distinction on the basis of race or nationality. The rejection of both demands confirmed the impression among many Japanese that Western modernity and the global imperial struggle were predicated on racial inequality and social Darwinism. Thus the Japanese bid to "overcome modernity," that is, to overcome Western modernity, also included resistance to social Darwinism and racial prejudices that appeared so integral to Western imperialism.[33] This is why Japan's Fifteen-Year Asia-Pacific War could be couched as a war of racial liberation, of freeing peoples and nations of Asia from Western domination, and offering the vision of a new sphere of nonracial—that is, nonhierarchal—"co-prosperity."

Because Japan's defeat discredited such formulations, it is easy today to dismiss pan-Asianism and the Co-Prosperity Sphere as transparently ideological ruses to mask military and economic domination, exploitation, and destruction. It is easy, too, to demonstrate how one of the prime instances of multispecies cooperation in manga films, the sequence in *Momotarō, umi no shinpei* of indigenous animals happily assisting Momotarō and his Japanese animal teams, is predicated on forms of hegemony and hierarchy. Multispeciesism is, in other words, easy to debunk. Yet, if I am not content merely to debunk and dismiss the multispecies ideal, it is because it is still with us, prevalent in family and children's films and in science fiction, evidently not so readily dismissed and not so transparent in its operations. In this respect, it is not a Platonic Ideal that preexists its expression but an ideal that arrives in its reiteration. Or, put another way, multispeciesism is a code or axiom that, by organizing flows, produces an ideal.[34] This ideal becomes more pronounced in the postwar era in response to the racial horrors of the "Great War." The ideal is that enemies, no matter how nonhuman in appearance, are not to be dehumanized or bestialized, that is, reduced to naked life forms, for exploitation or extermination. In addition, the multispecies ideal demands nonhierarchical cooperation.

In sum, in calling attention to multispeciesism, especially its prevalence in the postwar era as a "solution" to racism, I do not aim to debunk or embrace it as an ideal or ideology. What interest me are its side effects. I am interested in what happens when multispeciesism comes into play: because it cannot entirely code the flows that it evokes and addresses, it begins to falter and break down, to release other potentials. When speciesism at once evokes and bars racism, there arises a whole new realm of indefinable and uncontainable desires.

I have already drawn attention to how Tezuka, precisely because he does not feel comfortable with multispeciesism as a solution, inscribes it instead as a transspecies potential in cute little nonhuman characters whose delightful antics and human-inflicted suffering go hand and hand. In *La planète des singes,* some humans and apes begin to treat each other with respect, which suggests a degree of comfort with a multispecies solution. In particular, the human man feels strongly attracted to a female chimpanzee scientist who assists him. Likewise, in the first American film version of the novel, *The Planet of the Apes* (1969), apes and humans start to find each other physically attractive. Even though the film lingers somewhat predictably on the desirability of the white man, even here the multispecies ideal is breaking into a play of surfaces, evoking an eroticism that defies easy relation to biological or social

reproduction. The original *Star Trek* appears quite at ease with its multi-species ideal, yet Spock's hybrid character, frequently in physical torment, becomes the site of inscription of the violence of multispeciesism and a new potential of breaking with it. For instance, while Spock's general celibacy and lack of children feel like a distant echo of old notions of the infertile hybrid (a hyperrational emotionless mule), the consequent bond with Kirk and McCoy takes on an erotic charge that goes beyond the realm of everyday devotions and regulations (which slash fiction is so adept at locating and channeling).

Among these instances of 1960s multispeciesism, *Kachikujin Yapū* takes an unusual tack. Significantly, as in Tezuka, the multispecies ideal is barred but with greater intensity. I would hazard to say that Japanese fictions were less quick to embrace multispeciesism in the 1960s because memories of Japan's wartime multispeciesism lingered. In contrast, as John Dower points out and as I stressed previously, the former Allies, especially the United States and England, had largely articulated speciesism in the form of dehumaniza-tion and bestialization, rather than multispeciesism or companion species.[35] In other words, the Japanese faced difficulties with the multispecies ideal that the Allies did not.

In *Kachikujin Yapū,* racial difference is inscribed in resolutely physiologi-cal and biopolitical terms; populations designated racially as white, black, and yellow are subject to different forms of biological engineering that as-sures strict segregation and hierarchy. Under such conditions, a nonhier-archal coordination of populations is unimaginable. Oddly, however, the contemporary Japanese male protagonist, when transported with his white German fiancée to this future universe, comes gradually to enjoy his physical debasement and subjugation, finding pleasure in the excruciating biological engineering that transforms him into a piece of "furniture" for her pleasure. Thus, in *Kachikujin Yapū,* the entire galactic empire appears as an elaborate but necessary setup for the incitement of male masochism, for the prolifera-tion of perverse pleasures, even as white supremacy stands exposed.

This is where speciesism forces a confrontation with something happen-ing between (or across) species that cannot readily be reinscribed into racial-ism, codes of segregation, or the totemic regulation of populations; where the impulse to force an encounter with radical physiological difference beyond race spurs the proliferation of perverse pleasures. This has become such a common gesture that today we tend to count on speciesism to generate per-verse situations that implicate transspecies potential. We do not bat an eye when faced with such eccentric species interactions as ABe Yoshitoshi's manga and animation *Nia andaa sebun* (NieA_7, 2000) in which aliens arrive on earth

and learn to live among humans; or Yoshitomi Akihito's *Blue Drop* (serialized 2004–2005), which explores the aftermath of a war between humanity and an alien race/species consisting of lesbian women; or *Keroro gunsō* (Sergeant Frog, manga begun in 1999, anime series in 2004) in which members of an army of humanoid frogs, abandoned on earth in the course of an aborted invasion, accommodate themselves to human life, accepting love and violence from their human keepers, while displaying classic *otaku* behavior patterns. As such examples attest, speciesism has today expanded beyond its initial emphasis on racial difference to embrace all manner of cultural difference— racial, national, ethnic, subcultural, generational, and so on. It has become a stupendous translation machine that shuttles every difference it touches into biopolitical difference, introducing life into politics at every turn.

As this massive species translation project has kicked into high gear across the world, it has become more and more difficult to assign a reference to species, to figure out what a particular species stands for. With wartime speciesism, and even with speciesism of the 1960s, it is still possible to read speciesism in terms of reference to actual peoples or cultures or nations, that is, in terms of representation and national allegory; it is still possible to insist that the meaning of speciesism lies in how it represents actual others of the nation or national empire. Yet always inherent in the translation of races or cultures into species is a movement away from referential and representational strategies. Thus speciesism forces us to think beyond the comfortable received framework of representation theory. If we wish to understand what is at stake in this now global translation machine that transforms cultural difference of every variety into biopolitical difference, we need to think not only in terms of allegorical representation (national allegory or racial allegory) but also in terms of biopolitical operations. Thus we return to the problematic of cute little nonhuman species, not merely as allegorical accounts of Japan or the United States but as biopolitical operations. Here, too, Tezuka's nonhuman characters are the benchmark.

BEYOND NATIONAL ALLEGORY AND REPRESENTATION THEORY

In *Chōjin taikei* (which Tezuka titled in English *Birdman Anthology*),[36] serialized in *SF Magazine* from March 1971 to February 1975 and subsequently published in two volumes in his collected works, Tezuka invents a future in which birds suddenly start to evolve, eventually becoming "birdmen" with

an intelligence equal or superior to humans, and entering into a full-scale "war without mercy" to exact revenge on the humans, the species that has treated them cruelly for so long. Composed of a series of stories recounting key events across the centuries in which the birdmen gradually subjugate, exterminate and replace humans as

> SPECIESISM HAS TODAY EXPANDED BEYOND ITS INITIAL EMPHASIS ON RACIAL DIFFERENCE TO EMBRACE ALL MANNER OF CULTURAL DIFFERENCE.

the dominant species on earth, *Chōjin taikei* explores the implications of race war by translating race relations into species relations, first on a global scale and then on a galactic scale.

In the early chapters, Alfred Hitchcock's 1963 film *The Birds* is clearly a point of reference, as the birds begin to turn against humans, learning to light matches and to set fire to human dwellings and then to entire cities. In the third chapter, in which the birds launch an aerial assault on the cities of Japan (94:28–29), the air raids of World War II provide a point of reference, and the imagery of the birds setting fire to Tokyo recalls the 1945 fire bombings of Tokyo (Figure 4), which included one of the most destructive bombing raids in history, killing more than 100,000, injuring tens of thousands, and leaving at least one million homeless.[37] Tezuka himself experienced an air raid as a boy in Osaka during the war, and such images of destruction occur frequently in his manga.[38] Yet rather than humans (Americans) wreaking mass destruction on other humans (Japanese), now it is one species (birds) intent on destroying another (humans). *Chōjin taikei* thus uses species war to expose the dehumanization implicit in the racial politics of World War II, wherein the enemy was construed as a beast to be hunted down and exterminated.

In the wake of these iconic references to the end of World War II and the defeat of Japan, the manga continues to provide historical points of reference for its species war. It is as if *Chōjin taikei* were offering a history of postwar Japan in allegorical form. When the birds defeat Japan, for instance, the manga refers us explicitly and repeatedly to the American Occupation of Japan. While the Japanese government holds debates on how to deal with the conquerors, a professor appears who speaks the birds' language. Via the professor, the birds make an offer to Japan: if the Japanese allow the birds to use Japan as a base for their revolution (which amounts to the elimination of humans), the birds offer in exchange to let the Japanese live in peace. In response to this offer, the Minister of Foreign Affairs remarks, with a combination of irony and diplomacy, "Well, the Japanese have already provided for the establishment of [military] bases on [Japanese soil]." After all, he concludes, Japan has experience conniving with any number of countries (94:32–34).

FIGURE 4. As the birdpeople in Tezuka's *Chōjin taikei* launch their aerial attack on the city of Tokyo, the imagery recalls not only Hitchcock's *Birds* but also the fire bombing of Tokyo by the Americans in World War II.

At this level, the manga is explicitly allegorical, inviting us to read the birds as Americans, and the humans as Japanese. This is national allegory. Subsequent episodes repeat this association of the "bird occupation" of Japan with the American Occupation of Japan. Chapter 8, for instance, tells of a talented human writer who sells his skills to the birds, writing brilliant political speeches for them and thus furthering their cause. As the writer becomes disenchanted with his role and sinks deeper into drink, he remarks, "I've unintentionally been doing PR for them with the humans. It's like skillfully teaching Americanism under the American Occupation" (94:89). Ultimately, when the writer resists, he ends up caged like a bird, under the supervision of birds.

With such references, Tezuka's manga exposes both the militarism of the Pax Americana and Japanese complicity with the American agenda. If the birds are Americans, the humans are the peoples within the American military-industrial theatre of operations—and Tezuka shows how the Japanese have betrayed their "species" to preserve an illusion of peace and prosperity. In the early 1970s, with a sense of the futility of protest against the powerful occupiers, such anti-American resentment is hardly surprising. The defeat of a second wave of widespread popular protest in Japan against the renewal of the Treaty of Mutual Cooperation and Security (Ampo) not only resulted in the continuation of the American military presence in Japan but also effectively subordinated Japanese interests to American interests. More surprising is Tezuka's insistence on the complete failure of negotiation or coordination between species, between humans and birdpeople. The rare instances of mutual sympathy or understanding are invariably fleeting and ineffective, giving way to a brutal struggle to the finish. Multispeciesism proves unthinkable, and the birds ultimately eradicate the humans.

This is also where reading *Chōjin taikei* as national allegory clearly breaks down. There are signs all along that *Chōjin taikei* is not only an allegorical tale of Japan–U.S. relations in the postwar era. It is impossible to make birds neatly coincide with Americans, and humans with Japanese. After all, the birds are also invading the United States, and it is the future of humankind that is at stake. When racialized national relations are translated into species relations, there tends to be an escalation in the scale and stakes of conflict. What can initially be articulated, at least to some extent, in terms of national conflict and international relations cannot ultimately be explained by, or confined to, the national or international. With the translation of race relations into species relations, it becomes impossible to explain race relations historically, as world history or national history. Instead, racial conflict—indeed

race war—turns out to be inevitable, immutable, and eternal. Once the bird-people successfully eradicate humans, for instance, something like racial prejudice arises between different species of bird. Chapter 18, for instance, tells the tale of young lovers, a young birdman and a young birdwoman of different species who fall in love and dream of marriage. When their species object to their marriage they try to flee, but their fellow birdmen track and kill them (95:140–46). Speciesism and racism prove indiscernible, and the translation of race relations into species relations (and vice versa) makes it seem that violent segregation and hierarchies were fated eternally to reappear.

Specific instances of racism and speciesism thus appear mythic rather than historical—part of an eternal cycle of war and hatred of difference. *Chōjin taikei* thus turns from historical difference to mythic difference, and even Christ—or something just like him—makes an appearance among the birdpeople, as Pororo. This is a general tendency in Tezuka's manga: speciesism is conducive to a general transformation of historical events into mythic instances. As a consequence, it becomes impossible to read species referentially or allegorically. Species relations play out in vast mythic cycles. *Chōjin taikei* enacts this conceit in its narrative structure: the chronological scale is vast, and the manga offers vignettes that show us the development of the birdpeople at key moments. Each of the key moments adopts the contours of an iconic, generic or mythic scenario: star-crossed lovers, cowboys and Indians, Jesus and Mary Magdalene, for example. In this respect, *Chōjin taikei* is a harbinger on a reduced scale of the multivolume series deemed Tezuka's magnum opus, *Hi no tori* (*Phoenix*), on which Tezuka worked consistently throughout his career, from the 1960s till his death in 1989. Personal histories play out in accordance with a series of genres, icons, and generic scenarios, but in perpetuity, gradually taking on a mythic and cosmological dimension.

Yet speciesism in Tezuka does not simply result in a transformation of history into myth. His works do not merely mythologize historical conflicts. They often include a demystification or "demythification" of the very mythic cycles that they enact. In *Chōjin taikei,* for instance, it turns out that the evolution of birds into birdpeople has been engineered by the representative of avian species who presides over a sort of intergalactic council that oversees the course of development of diverse worlds. Allegorically speaking, this is an intergalactic version of the United Nations. The avian representative decides, as if neutrally, that the primates on Earth have evolved improperly. Feeling that the birds' turn has thus arrived, the avian representative sends bird feed to Earth that spurs the rapid evolution of intelligence among birds, which allows for their gradual triumph over the humans as the dominant species.

At the end of the manga, however, the council reviews the development of birdpeople on Earth, and another representative accuses the avian representative of having acted on the basis of an undue bias toward birds—in other words, the avian stands accused of species prejudice. Ironically, the accuser, a cockroach person, claims that it is high time to give the cockroaches of Earth their chance to develop and dominate.

If history appears to repeat itself to the point that it verges on mythic repetition, it is because myths about modernization are already at work behind the scenes. *Chōjin taikei* shows us a universe mired in its myths of development and evolution, doomed to repeat bad abstractions throughout eternity. Theories of evolutionary progress and teleological development prove to be nothing more than endlessly escalating form of racism. *Chōjin taikei* thus presents a satire of social Darwinism or the application of theories concerning the evolution of species to the social—the twisted logic wherein natural selection is couched in terms of "survival of the fittest" with the corollary that the victors in war have been "naturally" selected, are "naturally" superior or fitter.

In Tezuka, as in Japanese wartime speciesism, the enemy is social Darwinism or the teleological theories of evolutionary progress associated with Western modernity (and whiteness), yet Tezuka does not envision an overcoming of modernity in the manner of the wartime thinkers who pursued such a critique. In his manga, there is no social or political formation that stands as an alternative to linear and teleological progress, to social Darwinist modernity. Nor do his manga explicitly present an alternative nonlinear, nonteleological theory of evolution. This may come as a surprise, given Tezuka's background in biology and medicine, and in light of the postwar challenge to theories of race and social Darwinism issued by postwar biologists, and given the precedents for alternative ways of thinking evolution in Japanese biology. Yet I tend to think that the legacy of overcoming modernity in Japan (and the discrediting of pan-Asianism and Co-Prosperity) made Tezuka exceedingly wary of offering sociopolitical solutions to social Darwinism. In any event, in keeping with the general trend throughout his work, *Chōjin taikei* does not turn to multispecies cooperation as an ideal solution to the racism implicit in social Darwinism.

Instead of offering a way to overcome modernity, Tezuka shows how attempts at linear, teleological evolution (progress) go nowhere: rather than advance along the line of progress, such attempts result in endless repetition of the same generic tragedies. We can also read his critique of goal-directed linearity and teleology as an allegory for postwar Japan. Many Japanese commentators, both on the right and left, have suggested that postwar Japan is

characterized by a removal from history, or more precisely, from world history, because of Japan's postwar removal from war.[39] In other words, due to the lack of war and the persistent sense of defeat, the postwar in Japan results in an impasse in which events never bring about a sense of historical transformation. There is an endless serialization of the same, an endless postwar. While I think that there is something to be gained by reading *Chōjin taikei* in terms of an allegory of the postwar (especially if it allows us to rethink the postwar in terms of a linearity that short-circuits and turns into an endless loop),[40] reading manga as a representation of Japan leaves us trapped within the endless postwar, replicating rather than challenging representations of Japan. What is more, we will remain unable to explain the transnational movement of postwar manga and anime except in terms of a foreign consumption of representations of Japan or Japanese representations. This is where the materiality of animation and manga demands attention.

..

Notes

1. This is Jacqueline Berndt's turn of phrase (personal communication). The idea of the establishment of a classical film style is especially associated with David Bordwell. For an overview and critique of his conceptualization, see Miriam Hansen, "The Mass Production of the Senses: Classical Cinema as Vernacular Modernism," in *Reinventing Film Studies,* ed. Christine Gledhill and Linda Williams, 332–50 (London: Arnold, 2000).

2. Carol Gluck, "The Past in the Present," in *Postwar Japan as History,* ed. Andrew Gordon (University of California Press, 1993), 66.

3. While Carol Gluck indicates different registers of historical memory and history making, including popular culture, she does not speak specifically about manga or animation. For the most part, when commentators have addressed war memory in Japanese popular culture, the emphasis has fallen on war amnesia. Yet scholarship has largely dealt with canonical literature and film, and thus the sample has been relatively small, with a bias toward what is often called in Japan *junsui bunka* or "pure culture" in contrast to *taishū bunka* or "mass culture." Yet, as Matthew Penney argues, it may not be fair or even accurate to characterize Japanese cultural production in terms of war amnesia. Japanese mass culture or popular culture has consistently addressed the legacy of the war and frequently in critical terms.

4. In a recent exhibit on Yamakawa Sōji held at the Yayoi Bijutsukan in Tokyo (April 3–June 29, 2008), I was surprised by the insistence in the commentary about situating Yamakawa in the history of manga that his image-based narratives, no matter how cinematic in their devices, should be seen only as precursors to the full development of manga narrative by Tezuka. While it may in fact be apt to think of Yamakawa's "manga" more as illustrated stories than actual manga, what is striking is the insistence on preserving Tezuka's place in manga history as the actual origin, in light of which other forms are necessarily incomplete precursors.

5. Ōtsuka Eiji, "Disarming Atom: Tezuka Osamu's Manga at War and Peace," trans. Thomas LaMarre, *Mechademia* 3 (2008): 116.

6. Tezuka Osamu, *Tezuka Osamu taizen* (Tokyo: Magajin Hausu, 1992); cited in Ōtsuka Eiji, "'Bunka eiga' to shite no 'Momotarō umi no shinpei,'" (*Momotaro's Divine Navy* as culture film) in *Shingenjitsu* 4 (Tokyo: Ōta Shuppan, 2007), 115.

7. Abé Mark Nornes, "Pōru Rūta/Paul Rotha and the Politics of Translation," *Screening the Past* 7 (1999), http://www.latrobe.edu.au/screeningthepast/firstrelease/fr0799/MNfr7c.htm (accessed April 14, 2009).

8. Ōtsuka's essay, "'Bunka' eiga to shite no 'Momotarō umi no shinpei,'" cited earlier, explores the background of the film laws and their effect on culture films and animation.

9. Bōken Dankichi or "Adventurous Dankichi" was the boy hero of a manga (serialized in *Shōnen Kurabu*) who traveled to Japanese possessions in the southern seas, spreading the virtues of civilization in the company of his pet mouse, Karikō. Maabō (or Mabo) was a character, launched in a series of animated films by directors Satō Gijirō and Chiba Yōji, who frequently receives assistance from animal friends in resolving his problems. *Maabō no nankai funsenki* (1942, Record of Mabo's tough fight in the south seas) especially recalls *Momotarō umi no shinpei* in that a battalion of animals comes to Mabo's aid in attacking British warships.

10. For more on Norakuro the Stray Black Dog, see my "Speciesism, Part 1" in *Mechademia* 3: 75–95. Osaru no sankichi appeared as a monkey paratrooper in Seo Mitsuyo's animation of the same title.

11. As also noted in part one, in Haraway's essay entitled "Cyborgs to Companion Species: Reconfiguring Kinship in Technoscience," in *Chasing Technoscience: Matrix for Materiality,* ed. Don Ihde and Evan Selinger (Bloomington: Indiana University Press, 2003), Donna Haraway begins with the provocative thesis that "I have come to see cyborgs as junior siblings in the much bigger, queer family of companion species" (58–59).

12. Tezuka Osamu, *Janguru taitei,* in *Tezuka Osamu manga zenshū,* vols. 1–3 (Tokyo: Kōdansha, 1977). Hereafter when citing from this manga and others in this edition of Tezuka's collected works, I will cite volume and page numbers. To refer to the first volume and tenth page of *Aporo no uta* (which is volume 35 of the collected manga), for instance, I will cite thus: (35:10).

13. Tezuka Osamu, *Manga seibutsugaku,* in *Tezuka Osamu manga zenshū,* vol. 279 (Tokyo: Kōdansha, 1984).

14. I am referring here to the solution to the problem of eating well, which in *Madagascar* becomes a matter of eating well without eating one's (animal) friends. The final solution is to eat fish, which are beautifully presented as sushi near the end of the film.

15. Tezuka Osamu, *Aporo no uta,* in *Tezuka Osamu manga zenshū,* vols. 35–37 (Tokyo: Kōdansha, 1977).

16. For an account of the allegations of Disney borrowing from Tezuka's *Janguru taitei* for *The Lion King,* see Fred Patten, "Simba versus Kimba: The Pride of Lions," in *Illusion of Life II: More Essays on Animation,* ed. Alan Cholodenko (Sydney: Power Publications, 2007), 275–312.

17. In his afterword to the edition of *Rosuto waarudo* in his collected works, Tezuka recounts that he began work on it immediately after he had completed his first long science fiction manga *Yūrei otoko* (Ghost man) in his second year of junior high school. At age

twenty, he revised *Rosuto waarudo* and even began a newspaper serialization of it in 1947 (which he never completed). A complete version of the manga appeared in two volumes from Fuji Shobō on December 20, 1948. See Tezuka Osamu, *Rosuto waarudo shikaden,* in *Tezuka Osamu zenshū,* vols. 360–61 (Tokyo: Kōdansha, 1982), and *Chiteikoku kaijin,* in *Tezuka Osamu zenshū,* vol. 253 (Tokyo: Kōdansha, 1982).

18. One early sequence seems to parody the scene in *Momotarō, umi no shinpei* in which the young animals learn the first row of the Japanese kana syllabary (a – i – u – e – o): where the young animals in *Momotarō* show exemplary behavior, the animals in *Rosuto waarudo* are unruly and unrestrained.

19. Fujimoto Hiroshi, quoted in *Chiteikoku kaijin* (Tokyo: Kadokawa Shoten, 1994), 309–10; cited in Itō Gō, "*Manga* History Viewed through Proto-Characteristics," trans. Shimauchi Testurō, in *Tezuka: The Marvel of Manga,* ed. Philip Brophy (Melbourne: National Gallery of Victoria, 2006), 110.

20. Both Lev Manovich, in *The Language of New Media* (Cambridge, Mass.: MIT Press, 2001), and Oshii Mamoru, in *Subete no eiga wa anime ni naru* (All film is becoming anime) (Tokyo: Tokuma Shoten, 2004), make this argument.

21. For recent accounts of *Kachikujin Yapū* in English, see Takayuki Tatsumi, *Full Metal Apache: Transactions between Cyberpunk Japan and Avant-Pop America* (Durham, N.C.: Duke University Press, 2007), and Christine Marran, "Empire through the Eyes of a Yapoo: Male Abjection in the Cult Classic *Beast Yapoo*," in *Mechademia* 4 (2009): 259–73.

22. See Claude Lévi-Strauss, *The Savage Mind* (London: Weidenfeld and Nicoson, 1968). Thanks to Marilyn Ivy for calling this to my attention.

23. Claude Lévi-Strauss speaks to this matter in his essay in *The View from Afar* (New York: Basic Books, 1985), in which he considers the possible genetic advantages of totemic practices.

24. With the understanding that it is impossible to draw a firm distinction, I use the term racialism in contrast to racism, with racialism referring to discourses and practices that presuppose or establish biological differences between races, and racism indicating practices and discourses intent on establishing a hierarchy between races on the basis of biological differences.

25. Robert Young, *Colonial Desire: Hybridity in Theory, Culture, and Race* (London: Routledge, 1995), chapter 2.

26. Natsume Sōseki, *Sōseki zenshū (Collected works of Natsume Sōseki)* (Tokyo: Iwanami Shoten, 1974-76), 13: 43.

27. Tatsumi, in chapter 3 of *Full Metal Apache,* discusses the origins of science fiction in yellow peril literature. In "(Para-)Humanity, Yellow Peril, and the Postcolonial (Arche-) Type," Peter Button talks about the legacy of the parahuman in literature, as related to the yellow peril. *Postcolonial Studies* 9, no. 4 (2006): 421–47.

28. "Conference for the Establishment of the United Nations Educational Scientific and Cultural Organisation," 93. Documents found at http://unesdoc.unesco.org/ulis/ Unesco_1946-1950.shtml (accessed September 2, 2008).

29. Ibid., 27.

30. Ibid., 22.

31. "The Race Question," http://unesdoc.unesco.org/images/0012/001282/128291eo. pdf (accessed August 18, 2009), 8.

32. The definition derives from Giorgio Agamben, *Homo Sacer: Sovereign Power and Bare Life* (Stanford, Calif.: Stanford University Press, 1998).

33. There are many accounts in English of the wartime debates on "overcoming modernity" (*kindai no chōkoku*), but a good place to start is Richard Calichman's recent translation *Overcoming Modernity: Cultural Identity in Wartime Japan* (New York: Columbia University Press, 2008).

34. In this essay I am drawing on the definitions of code and axiom in Gilles Deleuze and Félix Guattari, *Anti-Oedipus: Capitalism and Schizophrenia* (Minneapolis: University of Minnesota Press, 1977). They make a distinction between codes and axioms in that codes properly belong to the State and thus to archaic regimes that persist within capitalism, while axioms are characteristic of capitalism. Nonetheless, codes do not disappear from capitalism; they are at once mobilized and axiomatized. In this essay, with this exception, I refer to speciesism and multispeciesism in terms of codes rather than axioms, because I am not dealing directly with questions of modern capitalism but more with questions of the State. While there is not sufficient space to discuss the matter fully here, I nonetheless have included the term "axiom" as a reminder that these formations of speciesism and the multispecies code are subject to constant deterritorialization and reterritorialization, much as Deleuze and Guattari describe it in the relation between codes and axioms.

35. This is not to say that there were no instances in Japanese wartime cinema of the sort of bestialization of the enemy to which John Dower refers: Akira Kurosawa's *Sanshiro Sugata Part 2* (1945) is one notorious instance, which stands in contrast to *Momotarō umi no shinpei* of the same year.

36. Tezuka Osamu, *Chōjin taikei*, in *Tezuka Osamu zenshū*, vols. 94–95 (Tokyo: Kōdansha, 1980).

37. Mark Selden, "A Forgotten Holocaust: US Bombing Strategy, the Destruction of Japanese Cities, and the American Way of War from World War II to Iraq," *Japan Focus*, May 2, 2007, http://www.japanfocus.org/-Mark-Selden/2414 (accessed April 15, 2009).

38. Tezuka so frequently comments on his experience of an air raid in relation to his depictions of mass destruction in manga that one can find references to it throughout his interviews, in the Tezuka manga biography (produced by Tezuka Productions), and in his essays. For a direct reference in relation to cinema, see the quoted interview with Tezuka in Ōtsuka, "Disarming Atom," 117–18.

39. See Sawaragi Noi's discussion of postwar Japan as a "bad place" in *Nihon—kindai—bijutsu* (Japan—modern—art) (Tokyo: Shinchōsha, 1998). Marilyn Ivy provides a fine account of the right-wing response to the idea of postwar Japan being stuck outside history in a deformed state due to the emphasis on its defeat to ground postwar history, in "In/Comparable Horrors: Total War and the Japanese Thing," in *boundary 2* 32 (2005): 137–49. Finally, I speak to a similar problem in the context of Ootomo Katsuhiro's *Akira* in "Born of Trauma: *Akira* and Capitalist Modes of Destruction," in *War, Trauma, Capital*, special issue of *positions* 16, no. 1 (Spring 2008): 131–56.

40. This is in effect what Sawaragi Noi refers to in his emphasis on postwar Japan as a bad place or bad site. And as his prior work on "simulationism" makes clear, this bad place might be construed as a site where the teleologies of grand narratives fold back on themselves to produce self-referential loops. See the expanded paperback edition of Sawaragi Noi, *Shimyureeshonizumu* (Simulationism), Chikuma bungei bunko 14 (Tokyo: Chikuma Shobō, 2001).

KOICHI IWABUCHI

Undoing Inter-national Fandom in the Age of Brand Nationalism

While studying the "fan" has become well established in media and cultural studies, we need to remember that "fan" is a discursively constructed taxonomy of those who are assumed to share certain cultural attributes. To follow Raymond Williams, we could say: "There are in fact no fans. There are only ways of seeing people as fans."[1] A fundamental feature of the fan might be defined as a passionate devotion to a particular media text or icon, but the term is often used to objectify those people and their activities with an element of judgment, be it negative or positive.

For example, "fan" may negatively connote someone who looks bizarre and unsocial (even a potential criminal), as was the case with *otaku* in Japan. Against such a degrading view, as we know well, serious studies of fan activities and cultures have been developed. Such studies positively reconceptualize those devoted people in terms of their creative consuming and their appropriations of the original texts and icons, activities that blur the assumed boundaries of production and consumption. Thus "fan" could be understood as an imaginative prosumer (producer-consumer) and approreader (appropriator-reader) who does not just passively consume media texts but actively and creatively participates in their cultural signification processes.

> WHAT IS AT STAKE IS NOT THE DEGRADATION OR ROMANTICIZATION OF FANS BUT A DISREGARD FOR THE COMPLICATED PROCESSES OF PEOPLE'S MEDIA CULTURE CONSUMPTION.

However, while it successfully overcomes the earlier degrading view, as least academically, this positive reformulation of "fan" exhausts its critical potential when it automatically and uncritically reproduces what "fan" means, who fans are, and what they do, without contextualized field research and a sophisticated understanding of their activities. (This is actually a widely recognized problem with media cultural studies). After all, as this volume aims to contest, the term "fan," even in its positive senses, can easily become a received taxonomic category that preframes our understanding and our research questions in an objectifying manner. Thus some have cautioned that many studies of fans mechanically adopt a ready-made analytical formula that tends to romanticize their creative activities. Some also argue that studies of fan culture are losing their idiosyncratic merit as the line between fan and audience thins and blurs. More and more people now enjoy indulging themselves with a playful commitment to a particular object of media culture, thanks to the development of digital communication technologies and of marketing strategies aimed at niche tastes.

This is not to say that studies of fans and fan culture are no longer significant. The various ways people ardently engage with particular media texts still merit serious academic investigation. But we need to formulate good critical questions at the outset, rather than just reconfirming the creativity of their activities and the pleasure of identity construction. We need a serious consideration of the sociohistorical contexts in which people passionately consume/appropriate media texts, and of the cultural politics and cultural economy involved in their active consuming practices. We must consider issues such as self-empowerment in terms of marginalized identity politics (gender, sexuality, race, ethnicity, class, nation, and so on), coping with the tyranny of everyday life in the neoliberal world, the manifestation of a more participatory media culture, and the transnational audience/fan alliance against the control of media culture production and distribution by global media culture industries. Through engagement with such contextualized, critical studies of fan cultures and activities, we could avoid reproducing "fan" as a fixed taxonomy and instead show the significance of understanding committed media culture engagements in everyday life.

In relation to these issues, it seems to me that there is another urgent problem that deters us from undertaking critically contextualized studies that go beyond an objectifying understanding of "fan." It concerns the

inter-nationalized understanding of cross-border flows and consumption of media cultures. Here I put the hyphen between the "inter" and "national" to highlight the reworking and strengthening of the national in tandem with the intensification of cross-border media culture flows. What is at stake here is not the degradation or romanticization of fans but a disregard for the complicated processes of people's media culture consumption. As exemplified by the recent discourses of "cool Japan," which euphorically refer to a passionate reception of Japanese media culture outside Japan, superficial and nationalistic observations that people outside Japan are rejoicing in Japanese media culture are automatically made to testify to the rise of Japanese cool culture in the world. This disengages us from crucial questions about the cross-border circulation and consumption of media culture under uneven processes of globalization, questions about whether and how the consumption of Japanese media culture enhances a deeper understanding of the complexity of Japanese society and culture; whether and how it reproduces one-dimensional, stereotypical views of "Japan" as an organic national-cultural entity; and whether and how power relations operate to divide some groups and keep others intact, instead of promoting a dialogic reflection on self-other relations. I would argue that we need to pay more serious attention to these questions when studying fans as well.

The Euro-American media began paying the increased attention to the phenomena that give credence to "cool Japan." Media reports attested to Japan's increasing cultural influence starting several years ago: "During the 1990s, Japan became associated with its economic stagnation. However, what many failed to realize is that Japan has transformed itself into a vibrant culture-exporting country during the 1990s";[2] "Japan's influence on pop culture and consumer trends runs deep";[3] "Japan is reinventing itself—this time as the coolest nation on Earth."[4] Indeed, both domestically and internationally, Japan's media culture is acclaimed as a global cool culture and Japan as a cultural superpower.[5]

At least since the early 1990s, the rise of Japanese media culture in the global audiovisual markets has engendered the emergence of a "soft" nationalism in Japan—that is, a narcissist discourse on the global (crucially including Europe and the United States) spread of Japanese animation, manga, and video games.[6] The upsurge of such a discourse within Japan in the last several years might not be surprising, especially given that the international advent of Japanese media culture looked to be in sharp contrast to the long-standing Japanese economic slump. The diffusion of Japanese media culture in the world seems to inspire a social and personal lift in Japan.

However, this time Japan's positive response to the American discourse on "Cool Japan" is not just limited to a celebratory nationalistic discourse. It is also accompanied by the active development of national strategies to enhance Japan's "soft power." Starting at the turn of the century, the government began announcing this policy orientation, and many committees have been established that discuss the promotion of Japanese media culture: the Head Office for Intellectual Property Strategy (2002), the Committee for Tourism Nation (2003), the Committee for Info-Communication Software (2003), the Research Committee for Contents Business (2005), the J-Brand Initiative (2003), the e-Japan Strategy (2003), the Council for the Promotion of International Exchange (on the strengthening of cultural dispatch) (2006), and so forth.

This development is actually symptomatic of an international trend, especially among industrialized countries, toward the pragmatic uses of media cultures. We have witnessed the rise of what I would call "brand nationalism"—uncritical, practical uses of media culture as resources for the enhancement of political and economic national interests, through the branding of national cultures. While the nationalist strategy of disseminating culture for national interests is never new, the recent development signifies a global change in terms of the collaborative relationship between the state and media cultural industries, and among culture, economy, and politics. "Cool Britannia" might be the best-known policy and practice for this, but East Asia is included, too. Governments such as those of Korea, Singapore, China, Taiwan, and Japan are keen to promote their own cultural products and industries to further their nations' political and economic interests. For states to maximize national interests and beat international competition, culture has come to be regarded as important politically and economically: politically to enhance "soft power" and "cultural diplomacy," and economically for attracting multinational capital and developing service sectors in which creative industries or content businesses play a significant role.

Such a discourse certainly downplays the serious study of people's activities and cultural politics at the site of consumption. Their actual practices and activities with a particular media culture are reduced to quantitative sales figures and survey results regarding the image of Japan, which work as a convenient alibi to prove the global spread of Japanese media culture and its supposed contribution to bolstering the national image. It is anticipated that media culture will improve the image of Japan to such an extent that the historical memory of Japanese colonialism will be eradicated or softened. The need to export Japanese media culture is even more eagerly discussed with the

recent rise of anti-Japanese feeling in China and Korea over historical and territorial issues. After a recent survey revealed that Korean youth who consume Japanese popular culture tend to feel more empathy with

> WE HAVE WITNESSED THE RISE OF WHAT I WOULD CALL "BRAND NATIONALISM"— UNCRITICAL, PRACTICAL USES OF MEDIA CULTURE AS RESOURCES FOR THE ENHANCEMENT OF POLITICAL AND ECONOMIC NATIONAL INTERESTS, THROUGH THE BRANDING OF NATIONAL CULTURES.

Japan, the imperative to step up the export of media culture to Asian markets has become even more pressing. Needless to say, the history and memory of colonialism cannot be erased by the consumption of media cultures. Historical issues necessitate sincere dialogue as well as the broad involvement of all citizens, and it is this involvement that cultural policy should try to promote.

Some may suspect that brand nationalism should not be taken seriously because it is not substantial or especially effective in enhancing the national image or economic profits, despite what the policy makers contend. Since brand nationalism naively disregards the complexity of transnational media culture's circuit of production, distribution, regulation, and consumption, the suspicion is valid. Thus, rigorous research on how Japanese media culture is variously received and consumed around the world would be valuable for showing the intricacies of intercultural image politics and critique the naive expectations of brand nationalism advocates.

However, there is more politically engaged action to undertake, if we take brand nationalism seriously, and there is good reason to do so. As a dominant (inter-)national discourse, brand nationalism has significant public impact in terms of material institutionalization and funding as well as for comprehending the usefulness of (national) media culture, which insistently and pervasively legitimates a neoliberal mode of inter-nationalism. Put bluntly, brand nationalism deters our understanding of and engagement with uneven processes of cultural globalization: these include the high concentration of media ownership in the hands of a few global companies; intellectual property rights; and the transnational, international, and new international division of cultural labor.[7] Also disregarded are the issues concerning the unevenness, domination, and/or appropriation of "foreign" media culture, intercultural (mis)understanding, and dialogue—both self-reflexive dialogue and dialogue with others. Furthermore, as the new connections forged through inter-national media culture tend to exclude "unprofitable" voices, they suppress the hitherto marginalized voices within the nation by stressing the significance of enhancing national brand images in the inter-national

showground. Thus brand nationalism has a detrimental effect on serious engagement with a sociocultural democratization that can do justice to cultural diversity and promote cross-border dialogues (both nationally and transnationally), because it diverts public attention away from imperative issues that cannot be dealt with in an exclusively market and national framework.[8] We cannot afford to mock brand nationalism as unsubstantial policy discourse or to be engaged in academic investigation in a politically detached manner. Undoing brand nationalism will require critical engagement with its ideological closure.

It might be argued that these issues have little to do with the study of fans, who passionately and creatively consume/appropriate Japanese media culture outside Japan. Others may think that cultural issues are not to be politicized. Indeed, this is one strong critique of media and cultural studies. Yet, as we are now entering the age when states are getting deeply involved in the neoliberal circulation of media and popular culture by collaborating with media culture industries, nothing will be politically neutral. Being supposedly politically neutral will mean colluding overtly and covertly with the uncritical pragmatic uses of media culture for creative industries and cultural diplomacy.

It might also be argued that the most interesting counterpractices and dialogic connections are formed at the grassroots level, so we'd better focus our attention there, rather than being bothered by the dominant international trend. Indeed, it is important to examine and draw attention to such practices and connections, which often go unnoticed by the mainstream. At the same time, however, the significance of such practices and connections cannot be fully understood unless we critically attend to the structuring process of decentering and recentering transnational cultural power relations, relations that eventually constrain our consumption practices in everyday life.[9] The decentering process of globalization makes it impossible to single out the absolute symbolic center that belongs to a particular country or region. However, this does not mean that global cultural power has disappeared; it has been dispersed to the site of local consumption, but at the same time it has been made even more solid. Crucially, the unevenness in transnational cultural flows is intensified by the various kinds of alliances among transnational media industries in developed countries, including non-Western regions. As states strengthen their alliances with (multinational) corporations to enhance national interests, the (re)production of cultural asymmetry and unevenness has become even more institutionalized in the inter-national arena.

In relation to this, we also need to seriously attend to the strengthening of a nation-centered framework, which, in the name of inter-national cultural exchange and understanding, reproduces mutual cultural othering and suppresses the complexity, unevenness, and diversity actually existing within Japan. We have witnessed the development of cultural inter-nationalism, which is facilitated by the trend that "the national" functions as one of the most marketable and significant local units. Through (actual and virtual) participation in the inter-national media culture fiesta, culture has become more and more unquestioningly associated with the national, and transnational encounters are comprehended in terms of mutually exclusive inter-national ones. "Banal nationalism"[10] is actually further institutionalized and promoted by an increase in various kinds of inter-national events and spectacles such as media culture, sports, tourism, and art, all of which encourage a particular kind of encounter with people, goods, and images from many different parts of the world.[11] While we must yet analyze people's complex participation in this inter-national fiesta, I would suggest that strong forces are operating structurally to make people "methodological (inter)nationalists." Methodological nationalism has been seriously criticized in social science because it unambiguously and uncritically regards the nation as the unit of analysis, thus disregarding the diversity and differences within national society, and the transnational connections that cannot be dissociated from it. With the penetration of inter-national media cultural spectacles and the associated policy discourse on the pragmatic uses of media culture for national interests, this national way of thinking and feeling has become internalized and pervasive. It might not be aggressive but it is never innocent, as it essentializes national cultures and their membership, and discourages us from engaging properly with issues that cannot be dealt with in the national framework.

Japan's recent embrace of Korean media cultures is suggestive of the complexity of understanding fans in an inter-national framework. While the masculine mass media insensitively and unreasonably mocks middle-aged women fans who are addicted to Korean love stories and male stars, the passionate way Korean TV dramas are consumed intriguingly suggests the possibilities and the limits of fan activities. On the one hand, it has deeply enhanced cultural understanding and exchange with Korea. The consumption of Korean TV dramas has led to vigorous posttext activities such as learning the Korean language, visiting Korea, and even studying the history of Japanese colonialism. This shows a dialogic possibility that Korean TV dramas enhance by urging (mostly middle-aged) female audiences to engage in active

posttext encounters with Korea—self-critical encounters that change their perceptions of Korea and its colonial history. However, it is questionable whether and how these inter-national dialogic consumption activities have intersected with multicultural and postcolonial issues within Japan. How have the media flows from Korea influenced, both constructively and unconstructively, the social positioning and recognition of resident Koreans in Japan, most of whom are the descendants of people expatriated under Japanese colonial rule? I have discussed this elsewhere by examining audience responses to the first prime-time popular Japanese TV drama to deal with sociohistorical issues surrounding resident Koreans.[12] While the social recognition of resident Koreans has improved greatly as the Korean Wave betters the image of Korea, the historically embedded experiences of resident Koreans have tended to be ignored. Instead, they are effortlessly associated with the culture and people of South Korea in a way that subsumes postcolonial and multicultural issues under the rubric of inter-national relations. Studies of fans of Korean TV dramas in Japan show more than just the mass media's objectification of fans; they show the dialogic possibility of fans' creative and active engagement with media texts but also the way nationally marginalized voices are subsumed under inter-national relations.

Thus, studies of fans should attend to how the persisting dominance of the neoliberal and (inter-)national framework has limited the development of transnational dialogues. If we take various people's active engagement with media cultures seriously, we should strive to make sense of the complexity of uneven processes of transnational cultural circulation, and the cultural imagination's reinscription of exclusive national boundaries that inhibit transgressive dialogue and a denationalized cultural understanding.

Certainly many studies have seriously engaged the complications of media culture globalization, but, as critical cultural researchers, we could do much more to go beyond and undo the research perspective of "inter-national fandom," which neglects much (the unevenness and complexity of transnational cultural connections, the operation of political and economic power relations in the realm of culture, and the strengthening of methodological nationalism) through its inter-national framework for analyzing transnational cultural flows. In the last decade or so, we have indeed seen much intriguing work that discusses how "cool Japan" cultures are received in different parts of the world; yet other work (work that just introduces and describes pleasurable fan activities such as cosplay and creative rereading/appropriation of original media texts for personal fulfillment in the name of identity formation) still tends to neglect critical questions about the structural forces of

cultural globalization and about what fans' creative media practices fail to achieve in terms of promoting self–other dialogue.

We have also witnessed a drastic increase in courses teaching Japanese media and popular culture, but often these courses do not critically question the power relations that operate in globalization processes and within Japanese society. Such a curriculum might end up creating another depoliticized, contained image of Japan. This suggests a need to work together to develop well-formulated public pedagogy to enhance mutual understanding and dialogue by using media and popular culture texts more creatively. Recently the pioneering scholar of fan culture Henry Jenkins pointed out the significance of the "pop cosmopolitanism" that results from using media culture texts in the classroom.[13] But we cannot be optimistic that such perceptions will automatically develop through (creative) media consumption. There has to be a more determined, well-designed pedagogical program to capitalize on the dialogic potential in the uses of media culture.

In sum, the best tool to undo brand nationalism (with its thoughtless disregard for the complexity of people's media practices and its deterrence of cross-border dialogues) is a critical consideration of media culture consumption, contextualized within a wider sociohistorical process of uneven globalization and considered in light of its uses for the advancement of a public pedagogy that contributes toward cross-border dialogues. And this is also the best tool to contest the taxonomic containment of the fan in media and cultural studies. After all, we researchers do not just construct a particular way of seeing the fan but also a particular way of studying fan cultures. We should be a bit more ambitious, taking the current situation as a good opportunity to develop the critical study of fan cultures and their activities, and to be more actively involved in critical public pedagogy.

..

Notes

1. Raymond Willams famously states, "There are in fact no masses; there are only ways of seeing people as masses." *Culture and Society* (London: Chatto & Windus, 1958), 289.

2. Cited by the Director of Japan Information Center Kazuhiro Koshikawa's speech at the City University of New York Graduate Center, December 12, 2003, http://www.ny.us. emb-japan.go.jp/en/c/vol_11-5/title_01.html.

3. Christopher Palmeri and Nanette Byrnes, "Is Japanese Style Taking Over the World?" *Business Week,* July 26, 2004.

4. Anthony Faiola, "Japan's Empire of Cool," *Washington Post,* December 27, 2003.

5. As was the case with the Western Orientalist gaze in the construction of Japanese national identity, the above-mentioned American observations are still crucial for the

confirmation of the "cool Japan" phenomena within Japan. As with traditional culture such as *ukiyoe,* Western appreciation has power to determine the international quality of Japanese culture. The fact that Japanese popular culture has been much more actively and massively received in East Asia has never spurred the same kind of euphoria in Japan. In this sense, "cool Japan" discourse still testifies to Japan's appreciation of the Western Orientalist gaze and its complicit uses of that gaze to enhance national pride both domestically and internationally. Cool Japan, thus, is basically a Western phenomenon. See Koichi Iwabuchi, "Complicit Exoticism: Japan and Its Other," *Continuum* 8, no. 2 (1994): 49–82.

6. Koichi Iwabuchi, "Soft Nationalism and Narcissism: Japanese Popular Culture Goes Global," *Asian Studies Review* 26, no. 4 (2002): 447–69.

7. Toby Miller, Nitin Govil, John McMurria, Richard Maxwell, and Ting Wang, *Global Hollywood 2* (London: British Film Institute, 2005).

8. Iwabuchi Kōichi, *Bunka no taiwaryoku* (Culture and its dialogic potentials) (Tokyo: Nihon Keizai Shinbun Shuppansha, 2007).

9. Koichi Iwabuchi, *Recentering Globalization: Popular Culture and Japanese Transnationalism* (Durham, N.C.: Duke University Press, 2002).

10. Michael Billig, *Banal Nationalism* (London: Sage, 1995).

11. John Urry, *Global Complexity* (London: Polity, 2003), 107.

12. Koichi Iwabuchi, "When Korean Wave Meets Resident Koreans in Japan," in *East Asian Pop Culture: Approaching the Korean Wave,* ed. Chua Beng-Huat and Koichi Iwabuchi, 243–64 (Hong Kong: Hong Kong University Press, 2008).

13. Henry Jenkins, "Pop Cosmopolitanism: Mapping Cultural Flows in an Age of Media Convergence," in *Globalization: Culture and Education in the New Millennium,* ed. Marcelo M. Suárez-Orozco and Desiree B. Qin-Hilliard, 114–40 (Berkeley and Los Angeles: University of California Press, 2004).

Patterns of Consumption

ŌTSUKA EIJI

Translated and with an Introduction by Marc Steinberg

• • •

World and Variation: The Reproduction and Consumption of Narrative

TRANSLATOR'S INTRODUCTION: ŌTSUKA EIJI AND NARRATIVE CONSUMPTION

It would not be an overstatement to suggest that Ōtsuka Eiji is one of the most important writers on anime and manga subcultures in Japan. He has also been one of the most important writers on fan cultures. If the intersection of subcultures and fan cultures is so marked in Japan, it is at least in part because the term *subukaruchaa* in Japan has a different valence than the English term "subculture" as deployed in Anglo-American cultural studies, where it carries the sense of an oppositional culture (as Anne McKnight rightly remarks in her essay in this volume). In Japan it has more the sense of a micromarket segment or even a particular fan culture—hence Japanese criticism uses the formulation "otaku subculture" or "anime/manga subculture" where English-language criticism might more readily use "fandom." The highly varied nature of Ōtsuka's writings stems in part from this particular valence of the term "subculture" in Japan and in part from his own intellectual proclivities, leading him to move from semiotic readings of manga[1] to discussions of media politics,[2] from the cultural ethnography of the shōjo[3] to

the analysis of fan or otaku modes of consumption,[4] and to his rethinking of contemporary Japanese literature.[5]

Moreover, though clearly interested in textual readings of manga in particular, Ōtsuka has also had a long-standing investment in ethnographic modes of analysis. The fascination with ethnography and ethnographic modes of analysis Ōtsuka developed during his undergraduate studies was reignited during his later work as a freelance editor for "lolicon" (*rorikon*) and science fiction comics and videogame magazines. During this time he began to see his editorial work as a kind of "fieldwork" geared toward the development of an "urban ethnography."[6] It was in this vein that Ōtsuka published his first of many critical works of the late 1980s. The essay presented here, "World and Variation: The Reproduction and Consumption of Narrative" ("Sekai to shukō: monogatari no fukusei to shōhi"), is taken from one such work of urban ethnography published in 1989, *Monogatari shōhiron* (A theory of narrative consumption).[7]

In fact it was this critical ethnographic work that led Ōtsuka to develop a strong sense of the consumption patterns of youth and the potential for the further development of what in Japan has been called the "media mix" (analogous to what in North America has been called "transmedia storytelling"). At the time, the concept of the media mix—designating the synergetic combination of multiple media types to promote consumption across commodity forms—was strongly informed by the model of the "blockbuster film–novel–soundtrack" trinity developed by Kadokawa Haruki, then president of Kadokawa Shoten (Kadokawa Books).[8] Yet as the initial success of this model wore off and the massive investment required for the production and promotion of Haruki's films destabilized Kadokawa Shoten, the vice president of the company—Haruki's younger brother Tsuguhiko—developed a different media mix strategy based around targeting niche markets, with a strong interest in the emerging video game market. Ōtsuka's work as an editor for such niche, otaku-oriented magazines and his expressed sense of the potential for a media mix different from that which was promoted by Haruki led him to be hired into what at the time was a subdivision of Kadokawa Shoten.[9] It was here that, working as an editor for Kadokawa, Ōtsuka developed his "theory of narrative consumption."

It was also here that Ōtsuka first put his narrative consumption theory into practice as the writer of the manga–novel–computer game–etc. media mix, *Madara* (1987).[10] He would follow the success of this work with other manga and novels or "light novels" such as the *MPD Psycho* (1997–present, *Tajū jinkaku tantei saiko* or Multipersonality detective psycho) series and

Kurosagi Corpse Delivery Service (2000–present, *Kurosagi shitai takuhaibin*). This "creative" work or narrative "practice" (as Ōtsuka refers to this work) in turn affected his critical interests. Indeed, Ōtsuka has since been involved in both the writing and the theorization of the light novel—a "new" form of novel that includes numerous illustrations in the style of anime or manga, which many argue defines the broad genre. Ōtsuka's early involvement in the genre also led him to write several how-to books purportedly serving as guides for aspiring light novel writers.[11] In fact these books are as much theories of the light novel (and its relation to the modern Japanese novel) as guides on how to write the books. As such, Ōtsuka occupies the rare position of critic, fiction writer, and how-to-guide author—with each of his facets influencing the others. The essay translated here is of unique interest, as I will suggest, in part because it offers both the result of a particular form of "urban ethnography" of children's media consumption and a foretaste of the niche-oriented media mix narratives Ōtsuka would later develop. But the importance of "World and Variation" also arises from its privileged place in the work of Ōtsuka's younger interlocutor Azuma Hiroki.

Azuma, whose work was introduced in *Mechademia 2: Networks of Desire*, is another of the most important theorists of otaku and media cultures in contemporary Japan.[12] He is also profoundly indebted to Ōtsuka insofar as the latter provides a kind of theoretical framework in dialogue with which Azuma develops his own theories of contemporary otaku consumption, the light novel, and the video game. Indeed, we might say that Azuma's two books on otaku and the postmodern are responses to two different works of Ōtsuka. Azuma's first otaku book, *Dōbutsuka suru posutomodan: Otaku kara mita Nihon shakai* (The animalizing postmodern: Otaku and postmodern Japanese society), while heavily indebted to Jean-François Lyotard's suggestion that the postmodern is characterized by the decline of grand narratives, is written in close dialogue with Ōtsuka's suggestion in the essay translated here that consumption is informed by the fragmentary and piece-by-piece attempt to approach a certain totality (which Ōtsuka himself terms "grand narrative") otherwise hidden from view. That these fragments are narrative fragments and this totality a kind of "worldview" developed by and in particular narratives is the reason for the title of the book from which the essay comes, *Monogatari shōhiron* (A theory of narrative consumption). Azuma's second volume, *Geemu teki riarizumu no tanjō: Dōbutsuka suru posutomodan 2* (The birth of game-ic realism: The animalizing postmodern 2)[13] is similarly in dialogue with Ōtsuka's work on the light novel, particularly with the latter's *Kyarakutaa shōsetsu no tsukurikata* (How to make character novels), wherein

Ōtsuka develops the concept of manga/anime realism and suggests that this concept cannot be extended to video games. Azuma's objection to the second part of this statement (i.e., Ōtsuka's suggestion that the concept of manga/anime realism cannot be extended to a consideration of video games) provides the starting point of the second volume of *Dōbutsuka suru posutomodan*, just as his dialogue with Ōtsuka's *Monogatari shōhiron* was the starting point for his first volume.

While it is my sense that Azuma could not have written his two volumes of *Dōbutsuka suru posutomodan* without the productive dialogue with Ōtsuka's work, it was undoubtedly Azuma's engagement with Ōtsuka's *Monogatari shōhiron* that gave the book—and particularly its core essay translated here—a second life. First republished in *Shōsetsu torippaa* (Novel tripper) in its spring 2001 issue alongside a long conversation between Azuma and Ōtsuka as well as an essay by Azuma, the essay had been out of print since its initial 1989 publication and, hence, as the editors of *Shōsetsu torippaa* note, "difficult to read."[14] The book from which "World and Variation" comes was in fact expanded and republished in paperback by Kadokawa in October 2001 as *Teihon monogatari shōhiron* (A theory of narrative consumption: Standard edition), so it is very much thanks to Azuma's engagement with it in the early 2000s that the essay gained what we can now call its canonical status within manga and anime criticism. As such, this essay is key to evaluating Azuma's work on otaku postmodernity and his transformation of Ōtsuka's theory of narrative consumption, and key also to evaluating work—such as that of Itō Gō—that appeared in their wake. This is the first reason for its importance and for its translation here.

The second reason lies in its fascinating analysis of a particular historical phenomenon: the consumption of "Bikkuriman Chocolates"—candies that came with sticker premiums or freebies bearing the image of and information about a number of different characters. This analysis alone positions this text as a valuable document in the history of the material culture of Japanese children—one that both differentiates the Bikkuriman phenomenon from earlier premium booms (such as Tetsuwan Atomu stickers and Kamen Rider cards) and permits a greater understanding of more recent sticker or card booms. It also suggests, by example, the importance of paying close attention to the relationship between the premium and the candy, and the mode of consumption of candies and their premiums in analyses of children's material culture.

Third, this essay extends the analysis of this phenomenon into a theoretically sophisticated account of "contemporary" consumption more generally. Of course, how contemporary this account will seem to readers depends on

the degree to which they agree with Azuma's argument that this form of consumption has been superseded by a mode of consumption based around the relation between "*moe* element" and database, rather than narrative fragment and totality.[15] While there is certainly much of interest in Azuma's account of consumption today, this author for one believes that Ōtsuka's account has as much explanatory value today as it did when it was initially published in 1989. Indeed, even as he (disparagingly?) characterizes the work as "late 1980s marketing theory" whose "largest readership was among advertising agencies," Ōtsuka himself, in the "Afterword" to the 2001 republication, admits a certain contemporaneity to the work, noting the continuing presence of "narrative consumption" in both television commercials and the media mix strategies used by Kadokawa Shoten.[16] Given the increasing global diffusion of the media mix model—with writers such as Henry Jenkins suggesting its importance for recent Hollywood franchises such as *The Matrix*—this essay offers an important and sophisticated account of how this transmedia storytelling works.[17] Moreover, while there may have been (and continues to be) a sense in which Ōtsuka's work functioned as a kind of handbook to marketing practitioners, it provides a clear sense not only of how this marketing mechanism operates but also of what the critical potentials of inciting the desire for "totality" might be. Indeed, there is a sense in which Ōtsuka's so-called marketing theory functions not unlike the Marxist criticism of writers like Walter Benjamin, insofar as it provides a quasi-utopian analysis of a particular social system (i.e. the society of consumption in which sign value and narrative replace use value) that points to a liberatory and indeed subversive transformation that will develop from within the system itself.

Finally, the attention this essay pays to fan production and consumption—and its implicit suggestion that narrative consumption and the Comic Market (or Komike) host the kernels of an active model of consumption—dovetails with contemporaneous theoretical and ethnographic work in Anglo-American cultural studies that similarly emphasizes the importance of understanding consumers as active creators rather than passive receptors of media forms.[18] As such, this essay can be read in relation to a larger academic trend toward the rethinking of the position of the consumer in the 1980s and 1990s, and offers a glimpse of how these changes were conceptualized by one of the more interesting Japanese critics to emerge at that time.

For the interest of this work in its own right and for its importance in orienting the English-language reader in contemporary debates around anime, manga, the otaku, and contemporary consumption in Japan, I am thrilled to present a translation of what has come to be one of the most important texts

in Ōtsuka's oeuvre, and indeed one of the more influential texts in anime/manga studies in Japan. There are certain aspects of this essay that bear witness to its age—for example the reference to Baudrillard and his theorization of the society of mass consumption in terms of the consumption of pure signs, a theory that was all the rage in 1980s Japan.[19] And I cannot pretend that this work is beyond fault or without its share of theoretical inconsistencies, which I leave the reader free to evaluate. Yet at the same time my sense is that this essay has aged remarkably well. Like so much of Ōtsuka's work, this essay displays a slightly casual or off-hand manner and yet it also sparkles with insight and even flashes of intuitive genius that have allowed it to outlive its time and its object of study, as well as its more recent critiques. It is my hope that this translation will enable current fans and theorists of manga, anime, and media mix culture to better critically grasp the power of narrative consumption in contemporary Japan and beyond, and perhaps even to incorporate Ōtsuka's insights into their own creative and critical practices.

WORLD AND VARIATION: THE REPRODUCTION AND CONSUMPTION OF NARRATIVE

Jean Baudrillard's assertion that within today's consumer society what people consume are not physical "things" that have a use value but rather "*things*" as signs has clearly become the felt reality for those of us who live in late 1980s Japan.[20] We are all too conscious of this state of affairs where the *things* in front of our eyes exist only as signs and where it's impossible for them to have any other kind of value.[21] Indeed, we even have the sense that it would be strange to expect any kind of use value from *things*.

We might say that Bikkuriman Chocolates (Bikkuriman Chokorēto), an explosively popular hit among children through the years 1987 and 1988, is a representative commodity in this regard.[22] It was all too clear that the children consumers and the candy-making producer were both in complete agreement that Bikkuriman Chocolates' "chocolate" had absolutely no value as a food product. When buying Bikkuriman Chocolates, children took out the "Bikkuriman sticker" and threw the chocolate away without hesitation. Despite having the word "chocolate" in its name and despite this being at least formally the main product (*hontai*), the chocolates of the Bikkuriman Chocolates commodity were completely unnecessary.[23]

Granted all candy makers strove to differentiate their products. Yet even as candy makers released things that seemed to deviate from their original use

value as food, like outrageously spicy snacks, "cute" candies garnished with the shapes of animals, and so on, all the same these candy makers fiercely defended the premise that these snacks would in the end wind up in the mouths of their consumers. Super-spicy foods could only be felt to be spicy once they were eaten, and cute candies could only remain commodities so long as their consumers—even as they exclaimed, "Oh they're too cute, I can't eat them"— ate them. Even those candies in the "premium-included" (*omaketsuki*) format never denied the use value (nutrition) of their main product: the candy. We find the best expression of this in the classic copy phrase of the original premium-included candy, Glico: "Three hundred meters in one tablet."[24] On the other hand, in the case of Bikkuriman Chocolates, the product took the form of "chocolate" for the sole reason that its producer was a candy maker and of necessity sold the products by riding on the food distribution line. The main product of the commodity was the sticker; the chocolate was only there to play the role of a medium (i.e., a container for the sticker).

Well then, if Bikkuriman Chocolates dispensed with the use value of chocolate, what on earth was the object of consumption of these *things*? Since children were feverishly collecting the sticker premiums, common sense would lead us to think that the answer would be the stickers. To be sure, that answer would be correct if we were talking about the case of the Kamen Rider Snacks [Kamen Raidaa Sunakku or Masked Rider Snacks]— when, from 1971 through 1974, children similarly threw the snacks away and collected only the card premiums, a phenomenon that was treated as a social problem and eventually led to the forced stoppage of production. With Kamen Rider Snacks the device introduced in order to differentiate this snack from others ended up negating the commodity's original use value (as a food product) while this device (the sticker) alone took off and became the main product of the commodity.[25]

However, the systems of consumption of Kamen Rider Snacks and Bikkuriman Chocolates are decisively different. In the case of Kamen Rider Snacks, characters from manga writer Ishinomori Shintarō's live-action special effects (*tokusatsu*) drama *Kamen Rider* adorned its packages. This phenomenon of adding value to a product by riding on the coattails of characters from television and manga popular with children is the most classic method of differentiating one product from another, and in no way or form is it unusual. However, in the case of Bikkuriman Chocolates, there was no original television series or comic—and therein lies its decisive difference from Kamen Rider Snacks. To be sure, there are anime and comic versions of Bikkuriman, but these are secondary commodities produced after Bikkuriman

Chocolates became a hit product. In other words, there was no original work that Bikkuriman Chocolates could ride on the coattails of—as Kamen Rider Snacks had done. It is here that we find the singularity of the Bikkuriman commodity.

What, then, was the motivation that led children to go crazy over Bikkuriman and scoop up its chocolates? The following are the devices built into Bikkuriman (this repeats what I have written elsewhere):

1. Every sticker contained the drawing of one character. On the reverse side of the sticker there was a short bit of information called "Rumors of the Devil World," describing the character drawn on the front of the sticker.

2. With one sticker alone this information amounted to little more than noise. But once the child had collected a number of them and put them together, the child began to vaguely see a "small narrative" emerging—the rivalry between characters A and B, the betrayal of D by C, and so on.

3. This unexpected appearance of narrative functioned as a trigger to accelerate children's collection.

4. Moreover, with the accumulation of these small narratives, a "grand narrative" reminiscent of a mythological epic appeared.

5. Child consumers were attracted by this grand narrative, and tried to gain further access to it through the continued purchase of chocolates.

Since I will go into the specifics of the content of Bikkuriman's grand narrative later in this book I will not explain it here,[26] but suffice to say it is an expansive mythological chronicle reminiscent of Deguchi Onisaburō's *Reikai monogatari* (Tales of the spirit world) and the Indian epic poem *Mahābhārata*. In order to gain hold of the system of this grand narrative, child consumers purchased stickers, which were the differential fragments of information. Therefore, what the candy maker was "selling" to children was neither the chocolates nor the stickers, but rather the grand narrative itself.

By comparison, Kamen Rider Snacks were merely selling stickers—based on a character from a popular TV program—that rode on the main product of the candy snacks.[27]

This strange form of consumption can in fact be seen particularly clearly in the commodities of comics and anime or even toys that have children as

their objects. Be they comics or toys, these commodities are not themselves consumed. Rather, what is consumed first and foremost, and that which first gives these individual commodities their very value, is the grand narrative or order (*chitsujo*) that they hold in partial form and as their background.[28] Moreover, it is by convincing consumers that through the repetition of this very act of con-

CHILD CONSUMERS PURCHASED STICKERS, WHICH WERE THE DIFFERENTIAL FRAGMENTS OF INFORMATION. THEREFORE, WHAT THE CANDY MAKER WAS "SELLING" TO CHILDREN WAS NEITHER THE CHOCOLATES NOR THE STICKERS, BUT RATHER THE GRAND NARRATIVE ITSELF.

sumption they grow closer to the totality of the grand narrative that the sales of countless quantities of the same kind of commodity become possible (in the case of the Bikkuriman stickers there were 772 in total). *Mobile Suit Gundam* (1979–present, *Kidō senshi Gandamu*), *Saint Seiya* (1986–89, *Seinto Seiya*), *Sylvanian Families* (1987, *Shirubania famirii*), Onyanko Kurabu[29]—all of these commodities followed this mechanism by setting up their grand narrative or order in the background in advance and by tying the sales of concrete *things* to consumers' awareness of this grand narrative.

But what is this grand narrative or order that supports commodities from the background?

In the field of animation it is what is known as the "worldview." For example, if we were to compare this to *Mobile Suit Gundam,* one episode or one series of the anime would be a fragmentary commodity, corresponding to the sticker. Within a *Gundam* episode or series, the official narrative will be told through a main character such as Amuro or Char.[30] The general viewing audience will only watch for this "official narrative." However what the anime producers are making is not only this single narrative episode. Within a single episode there are countless detailed "settings" prepared yet not directly represented within this episode, including, in the case of *Gundam,* the era in which the main characters live, the place, the relations between countries, their history, their manners of living, the personal histories of the respective characters, the nature of their interpersonal relations, and even, in the case of the robots, the concordance between the functions matching their design and the science of the era. The greater the number of settings prepared, the greater the sense among audience members that the drama of each episode is real. The ideal is that each one of these individual settings will as a totality form a greater order, a united whole. This accumulation of settings into a single totality is what people in the animation field are accustomed to calling the "worldview." So, when seen from the perspective of the totality called

the worldview, the official drama of a concrete single episode or single series of an anime program becomes merely the extraction of a series of events that occurred during a specified period around a single individual arbitrarily chosen to be the central character from within this large world. Theoretically speaking, this also means that countless other dramas could exist if someone else were made the central character.

This will perhaps be easiest to understand if it is compared to a computer game. The totality of the data programmed into one video game would correspond to the worldview. The term "program" can be defined as the order, understood as the totality of all the possibilities that can be recalled from within the world that exists enclosed within a particular video game. By contrast to this, each individual drama corresponds to one game play. Each individual "play" using the same video game will offer up a different development depending on the player and the game. One episode of *Gundam* corresponds to one game play; the possibility exists that a different narrative will appear, depending on the player.

The general consumers we have been discussing thus far have been satisfied with the consumption of the drama developed within one game play. The grand narrative (or worldview) found in the background has been, much like the video game program, an essentially invisible existence and not an attribute seen by the eyes of the game's consumers. However, the anime otaku (*mania*), using information outside that found in the drama of each individual episode as a clue, has tried to dig out the worldview hidden in the background.[31] When we look at special issue *mooks*

> **WHAT IS BEING CONSUMED IS NOT AN INDIVIDUAL DRAMA OR THING BUT THE SYSTEM ITSELF THAT WAS SUPPOSEDLY CONCEALED IN THE BACKGROUND.**

based around a specific anime, we find a wealth of data on its setting that doesn't appear on the surface of the work but that comes via the inference of otaku based on the television broadcast of the images as well as on supplements necessary to their own way of reconstituting the worldview.[32] Similarly, the creation of video game strategy guides and game-world maps also bears witness to the behavior of a consumer intent on revealing the hidden program. Early video game otaku put their utmost into discovering programming errors referred to as "bugs" or "cheats" (*urawaza*). For example, one of the cheats in *Super Mario Brothers* involved turning the main character Mario around. This cheat or rupture in the program could only be inferred once the player had grasped the fact that in the proper program, Mario was always supposed to be facing sideways. Early anime otaku also feverishly sought the points of

contradiction internal to the drama. Yet this interest in programming errors necessarily led them toward an interest in the totality of the program.

While all was fine and well when this interest in the program itself was limited to particular otaku, we are now in a situation where this interest is becoming the common sense of all consumers of anime, comics, and toys. It is here that we can glimpse the new phase today's consumer society is entering. What is being consumed is not an individual drama or *thing* but the system itself that was supposedly concealed in the background. However since it's quite impossible to sell the system (i.e., the grand narrative) itself, consumers are *tricked* into consuming a single cross-section of the system in the form of one episode of the drama, or a single fragment of the system in the form of a *thing*. I would like to call this state of affairs "narrative consumption."

Probably everyone has a vague sense of this state of affairs in which this thing called a commodity is consumed in relation to "narrative." However, as we have seen, two kinds of narrative coexist within today's stage of consumption, and consumption takes place in reciprocal relation to both of these. By two kinds of narrative I refer to, on the one hand, the "small narrative" as the concrete commodity or single episode of a drama, and the "worldview," "program," or "system" that in this work I've been calling the "grand narrative." What we have been consuming until now has only been the former, the small narrative. However, as the Bikkuriman phenomenon has made clear, the new consumer is in the process of incorporating the grand narrative as an object of consumption. That said, since it is almost impossible to make the grand narrative itself into a concrete commodity, what is being consumed is the grand narrative in its differential and fragmented "small narrative" commodity form. The difference in the form of consumption between Kamen Rider Snacks and Bikkuriman Chocolates lies in this very point.

However, the commodity that takes such a "narrative consumption" as its premise has an extremely dangerous side to it. That is to say, if, at the end of the accumulated consumption of small narratives, consumers get their hands on the grand narrative (i.e. the totality of the program), they will then be able to freely produce their own small narratives with their own hands. Let's think of the following case as an example. If someone were to reproduce a single one of the 772 Bikkuriman stickers starting with "SuperZeus"[33] without the permission of the copyright-holding candy maker, this would be a crime. A sticker produced in this manner would be a "counterfeit." There have already been countless incidents like this. However, if this same person were to create a 773rd character not found among the 772 stickers, yet consistent with them and following the Bikkuriman worldview, and if this person were

to sell this character as a sticker, what would happen then? This would not be a reproduction of any of the existing 772 existing stickers. Consequently, in this sense it would not be a counterfeit. Moreover, seeing as this 773rd sticker would be consistent with the 772 others, it would have the same value as the 772 originals. Within this phase of narrative consumption, cases such as this one arise wherein we are no longer capable of distinguishing whether a given commodity is "real" or "counterfeit."

In fact, this state of affairs is not merely hypothetical but has already become our reality. The genre of work called *Tsubasa dōjinshi* is a case in point.[34] There was once a soccer manga called *Captain Tsubasa* (1981–88, *Kyaputen Tsubasa*), which was serialized by Takahashi Yōichi in the magazine *Shōnen Jump*. Originally made for boys, it became a great hit and was turned into an anime series and a video game. The book release of the manga sold more than a million copies.

However, at some point girls in their late teens began writing and self-publishing *dōjinshi* that used the main character from *Captain Tsubasa,* and this phenomenon expanded across the country in the blink of an eye. Hundreds, even thousands of these *Tsubasa dōjinshi* have been produced, and famous *dōjinshi* can sell upward of ten thousand copies per volume. These girls have used the *Tsubasa* characters and their human relations to create and sell their respective *Captain Tsubasa*s.

It would be incorrect to call these girls' works "parodies." A parodic work is one that depends on the existence of a strong original work toward which it then holds an ironic, mocking, or parodic stance. However, these girls extracted the *Tsubasa* "program" from Takahashi Yōichi's *Captain Tsubasa* and wrote their respective *Tsubasas* by following the order of this program in their own individual, creative ways. For these girls, the original work was merely the raw material from which to extract the *Tsubasa* program. Once the program was in the hands of these girls, the original work itself became merely one possible drama that appeared from within the larger framework of the program. Moreover, since these girls stressed the relations between boys within *Tsubasa* when extracting the program and then exaggerated these relationships further, the *Tsubasa dōjinshi*'s characters became entirely different from those of the original work. This is a state of affairs that is subtly different from what is called plagiarism or piracy. The program called *Tsubasa* was itself hidden in the original writer's work. But it was countless amateur writers who extracted this as a program and then, following this, wrote *dōjinshi* versions of *Tsubasa*. The concrete examples of *dōjinshi* "works" were at the very least not instances of plagiarism. Seemingly taking advantage of this ambiguous

situation, several publishing houses based around the commercial publication of *dōjinshi* versions of *Tsubasa* appeared and subsequently got into trouble with Shūeisha, the copyright holder of the "original work."

Putting debates around copyright law aside, what is quite interesting about the Tsubasa dōjinshi is that this is not at all an unusual state of affairs, when put in the light of the history of Japanese narrative creation. In Kabuki and Japanese puppet theatre (*ningyō jōruri*) we can clearly detect a similar sensibility in which the competence or originality of an author is judged by examining the appearance of various small narratives from a shared grand narrative. Within the terminology of Kabuki there is the concept of "world" that has almost the exact same meaning as the term "worldview" within the anime industry. Here I will quote from the "world" entry in Hattori Yukio et al.'s *Kabuki jiten* (Kabuki dictionary):

> *Sekai* (world): Terminology specific to Kabuki and puppet theatre (*ningyō jōruri*). A concept that refers to the historical era or events that constitute the background of the work. In fact this concept includes everything from the names of the characters that appear in the work to the basic personality traits of these characters, the nature of their relations, the basic storyline, the basic aspects and developments that should be dramatized, and so on. While this "world" is mostly founded on the commonly known popular history of Japan, oral traditions, and so on, it also contains generic content developed through the repeated dramatic adaptations and performances in the form of preceding Kabuki and Japanese puppet theatre as well as medieval performing arts, and thus it does not necessarily refer to any established sourcebook or original text. Therefore, each individual "world" is not a permanent or unchanging thing; some new "worlds" emerge and others fall into disuse and remain in name alone as a result of the formation of genres as well as the fashions of the time. The authors thus create their works by dramatizing newly invented "variations" that are based on a particular world, which is commonly known to the actors and their audiences, or by mixing multiple "worlds."[35]

As we can see here, the term "world" has the same meaning as "worldview" or "grand narrative," and each individual small narrative corresponds to the term "variation." There even existed among Kabuki authors something like a crib called the *Sekai kōmoku* (World catalogue). Thus in Kabuki the talent of an author was judged by the particular excellence of their ability to cut out a variation from this world and perfect a single theatrical work (Figure 1).

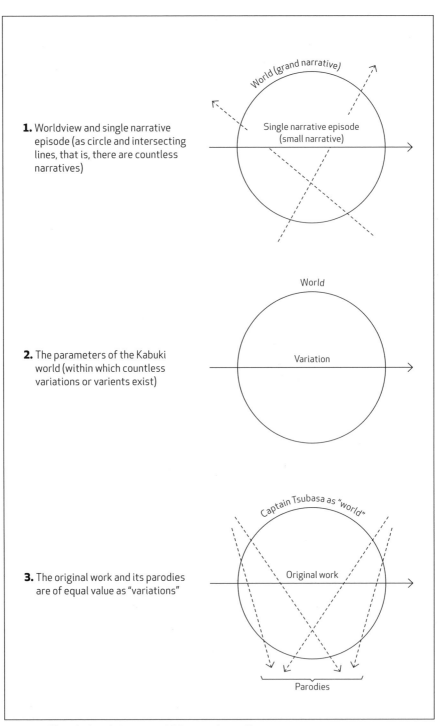

1. Worldview and single narrative episode (as circle and intersecting lines, that is, there are countless narratives)

World (grand narrative)

Single narrative episode (small narrative)

2. The parameters of the Kabuki world (within which countless variations or varients exist)

World

Variation

3. The original work and its parodies are of equal value as "variations"

Captain Tsubasa as "world"

Original work

Parodies

FIGURE 1. The relations between worldviews and narratives.

The works of *Tsubasa dōjinshi* prescribed the world of *Captain Tsubasa* on which different girls brought their own creativity to bear in making their own variations. Understood within the framework of the world/variation axis, the only effective standard of judgment for the countless *Tsubasa* works—including Takahashi Yōichi's main branch of *Tsubasa* works—becomes not which of these is the original work (a question that becomes meaningless) but rather the relative merit of each variation.

In this way, at the same time as narrative consumption motivates the excessive consumption of the kind shown by the desperate child consumers of Bikkuriman stickers, it also bears within it the possibility of a new stage wherein consumers themselves begin to create commodities and consume them on their own terms. At this future point in time, the commodity producers [*okurite*; literally "senders"] will become excluded from the system of consumption and will no longer be able to manage the commodities they themselves had originally produced. For this reason, the final stage of narrative consumption points to a state of affairs wherein making a commodity and consuming it merge into one. There will no longer be manufacturers.[36] There will merely be countless consumers who make commodities with their own hands and consume them with their own hands. Let us be clear here: this would mark the closing scene of the consumer society that saw the endless play of *things* as signs.

...

Notes

1. See, for instance, Ōtsuka's *Sengo manga no hyōgen kūkan* (The expressive space of postwar manga) (Kyoto: Hōsōkan, 1994) and *Atomu no meidai: Tezuka Osamu to sengo manga no shudai* (The Atomu thesis: Tezuka Osamu and the main theme of postwar manga) (Tokyo: Tokuma Shoten, 2003). *Mechademia* 3 includes a recent essay by Ōtuska that gives an excellent sense of the political dimensions of his manga criticism and has some overlap with *Atomu no meidai*. See "Disarming Atom: Tezuka Osamu's Manga at War and Peace," trans. Thomas LaMarre, *Mechademia* 3 (2008): 111–25.

2. See in particular the articles collected in Ōtsuka Eiji, *Sengo minshu shugi no rihabiriteeshon* (The rehabilitation of postwar democracy) (Tokyo: Kadokawa Bunko, 2005 [2001]).

3. Ōtsuka Eiji, *Shōjo minzokugaku* (An ethnography of the shōjo) (Tokyo: Kōbunsha, 1989); Ōtsuka, *Tasogaredoki ni mitsuketa mono: "Ribon" no furoku to sono jidai* (Things found at twilight: "Ribon" premiums and their age) (Tokyo: Ōta Shuppan, 1991).

4. Ōtsuka Eiji, *"Otaku" no seishinshi: 1980 nendairon* (A history of the "otaku" mind: On the 1980s) (Tokyo: Asahi Bunko, 2007 [2004]).

5. *Sabukaruchuaa bungakuron* (A theory of subculture literature) (Tokyo: Asahi Bunko, 2007 [2004]).

6. Ōtsuka Eiji, *Shisutemu to gishiki* (System and ritual) (Tokyo: Chikuma Bunko, 1992 [1988]), 333.

7. Ōtsuka Eiji, "Sekai to shukō: Monogatari no fukusei to shōhi" (World and variation: The reproduction and consumption of narrative), translated from the 2001 republished edition, *Teihon monogatari shōhiron* (A theory of narrative consumption: Standard edition) (Tokyo: Kadokawa, 2001 [1989]). *Monogatari shōhiron* can alternatively be translated as "a theory of narrative consumption" or as "on narrative consumption." While the latter translation has been the preferred one, considering Ōtsuka's remarks about the work in his 2001 "Afterword" and elsewhere, in which he describes the book as a work of theory (*riron*)—even if merely "marketing theory"—I opted to include "theory" in the title. Two other "urban ethnography" books by Ōtsuka from the same period are *Shisutemu to gishiki* (1988) and *Shōjo minzokugaku* (1989), cited earlier.

8. The best account of Kadokawa Haruki's media strategy is to be found in Yamakita Shinji's *Kadokawa Haruki no kōzai: Shuppankai, eigakai o yurugaseta otoko* (The merits and demerits of Kadokawa Haruki: The man who shook up the publishing world and the film world) (Tokyo: Tōkyō Keizai, 1993).

9. Ōtsuka Eiji, "Boku to Miyazaki Tsutomu no '80 nendai, #17: Komikku to media mikkusu" (Miyazaki Tsutomu and my 1980s, #17: Comics and the media mix), *Shokun!* (April 1999): 264–69. For an account of the differences between Kadokawa Haruki and Tsuguhiko's media mixes that agrees with Ōtsuka's assessment, see Shinoda Hiroyuki's "'Daisōran' hete Kadokawa Shoten: Shin taisei no 'zento'" (Kadokawa Shoten has gotten through the "great unrest": An "outlook" on the new system), *Tsukuru* (May 1993): 70–82.

10. Ōtsuka, "Boku to Miyazaki Tsutomu no '80 nendai, #17" (Miyazaki Tsutomu and my 1980s, #17), 269; Ōtsuka Eiji and Azuma Hiroki, "Hihyō to otaku to posutomodan," (Criticism, otaku, and postmodernity), *Shōsetsu torippaa* (Spring 2001): 7.

11. See in particular Ōtsuka Eiji, *Kyarakutaa shōsetsu no tsukurikata* (How to make character novels) (Tokyo: Kōdansha, 2003).

12. Azuma Hiroki, "The Animalization of Otaku Culture," trans. Yuriko Furuhata and Marc Steinberg, with an introduction by Thomas LaMarre, *Mechademia* 2 (2007): 175–87. As LaMarre indicates in his introduction, this essay introduces the basic ideas of Azuma's book *Dōbutsukasuru posutomodan: Otaku kara mita Nihon shakai* (Animalizing Postmodern: Otaku and postmodern Japanese society) (Tokyo: Kōdansha, 2001); translated by Jonathan E. Abel and Shion Kono as *Otaku: Japan's Database Animals* (Minneapolis: University of Minnesota Press, 2009). In the text I've given a slightly more literal translation of Azuma's title than Abel and Kono's, to highlight the links between Azuma's two otaku books and theories of the postmodern.

13. Azuma Hiroki, *Geemuteki riarizumu no tanjō: Dōbutsukasuru posutomodan 2* (The Birth of Game-ic Realism: The Animalizing Postmodern 2) (Tokyo: Kōdansha, 2007).

14. Ōtsuka Eiji and Azuma Hiroki, "Hihyō to otaku to posutomodan," (Criticism, otaku, and postmodernity). *Shōsetsu torippaa* (Spring 2001): 2–33. This dialogue has been recently republished (with some unfortunate edits) in a collection of dialogues between Ōtsuka and Azuma, *Riaru no yukue: Otaku [おたく]/otaku [オタク] wa dō ikiru ka* (The whereabouts of the Real: How do Otaku/otaku live?) (Tokyo: Kōdansha, 2008). For the editors' remarks, see "Henshūsha kōki," ("Editors' postscript"). *Shōsetsu torippaa* (Spring 2001): 240.

15. Once again I refer the reader to Azuma's *Otaku: Japan's Database Animals* and the translation of a brief essay that recapitulates some of its arguments, "The Animalization of Otaku Culture," in *Mechademia* 2.

16. Ōtsuka, *Teihon monogatari shōhiron,* 323, 326. In Ōtsuka's discussion with Azuma first published in *Shōsetsu torippaa,* he similarly suggests that *Monogatari shōhiron* was "marketing theory written in order to make inroads into Kadokawa Shoten and Dentsū," the latter being Japan's largest advertising agency. He also positions Azuma's work as mere marketing theory. Ōtsuka and Azuma, "Hihyō to otaku to posutomodan," 15, and Ōtsuka and Azuma, *Riaru no yukue,* 37.

17. For Jenkins's account of transmedia storytelling, see his description of the *Matrix* franchise in *Convergence Culture: Where Old and New Media Collide* (New York: New York University Press, 2006).

18. This approach is perhaps best represented by the work of John Fiske in, for example, *Television Culture* (London: Methuen, 1987).

19. Ōtsuka himself notes that it was this "shameless" use of the then popular semiotic approach that led him to resist republishing this book until 2001. Ōtsuka, *Teihon monogatari shōhiron*, 319.

20. I am rendering Ōtsuka's opposition between 物 (*mono*, "things") and モノ (*mono*, in italics as "*things*"), which in this context refers to things as material objects (物) versus things as pure signs (モノ). Ōtsuka does not give a citation for the Baudrillard work to which he refers, but Baudrillard's "sign value" theory of consumption (wherein the value of a thing comes from its place in a system of signs rather than from some inherent "use" found in the material object) is found in his *The Consumer Society: Myths and Structures,* trans. Chris Turner (London: Sage, 1998), and *The System of Objects,* trans. James Benedict (London: Verso, 1996). Both of these Baudrillard texts were highly influential at the time of Ōtsuka's writing, and Ōtsuka himself explicitly refers to them in other works, for instance "Shōhi shakairon saikō" (1994, Rethinking society of consumption theory) republished in Ōtsuka Eiji, *Sengo minshu shugi no rihabiriteeshon* (The rehabilitation of postwar democracy) (Tokyo: Kadokawa Bunko, 2005 [2001]), 288–309. This and all other notes are by the translator.

21. Aside, of course, from their purely relational "sign value."

22. Bikkuriman Chokoreeto might be literally translated as "Surprise Man Chocolates."

23. While *hontai* usually means "main body," given the context I am translating it as "main product." For the term *shōhin* I am reserving the term "commodity."

24. As Glico's "running man" mascot indicates, its ad copy means that you could run three hundred meters after eating one tablet or grain of Glico's caramel. Glico included its first premium in the 1920s. I am translating *omake* as "premiums"; other translations could be "giveaways" or "freebies." For more on premiums and candy, see the collection of essays, *Kodomo no Shōwa shi: Omake to furoku daizuhan* (A Children's history of the Showa period: An illustrated book of *omake* and *furoku*) (Tokyo: Heibonsha, 1999).

25. Presumably in this sentence where Ōtsuka writes "sticker" he means "card," since the Kamen Rider Snacks revolved around the collection of cards, not stickers. Incidentally a very similar inversion occurred in the first case of a sticker premium in Japan, Meiji Seika's Tetsuwan Atomu–based sticker campaign of 1963–66.

26. That is, *Monogatari shōhiron,* to which this piece serves as an introductory essay.

27. In fact, what Kamen Rider Snacks were selling weren't stickers but cards, as Ōtsuka properly notes in the earlier part of this essay.

28. *Chitsujo,* here translated as "order," refers not to the "order of events" as a temporal succession but rather the "law and order" sense of the term.

29. *Seinto Seiya* (written *Seitoshi Seiya* in the kanji) is a manga and anime series; Sylvanian Family is a line of plush toys; and Onyaku Kurabu (literally "Kitten Club") is an all-girls idol group from the 1980s.

30. Amuro and Char are two of the main characters appearing across multiple *Gundam* series.

31. While Ōtsuka uses the term *"anime mania"*—which we might translate as anime fanatic or maniac—rather than "anime otaku," I employ the latter term since this is the one most in use today and corresponds with the term mania in use at the time of Ōtsuka's writing, in the late 1980s.

32. A "mook" is a cross between a magazine and book. Mooks are usually information-heavy books based around a particular subject.

33. The first Bikkuriman sticker character.

34. *Dōjinshi* are fan-written and fan-distributed works, mainly manga, novels, or video games, based on an existing manga or anime series.

35. Ikegami Fumio, "Sekai," in *Kabuki jiten* (Kabuki dictionary), ed. Hattori Yukio, Tomita Tetsunosuke, and Hirosue Tamotsu (Tokyo: Heibonsha, 1983).

36. Ōtsuka is distinguishing here between individual producers who make (*tsukuru* or *tsukuridasu*) their own products and companies or manufacturers (*seisansha*) that mass manufacture their products.

ANNE McKNIGHT

Frenchness and Transformation in Japanese Subculture, 1972–2004

The 2004 film *Shimotsuma monogatari* (Shimotsuma story; translated in English as *Kamikaze Girls*) opens with a voiceover.[1] It longingly describes an era long derided, when not neglected, for its vulgarity and excess: the rococo court life of eighteenth-century Versailles (Figure 1). The 2002 novel, on which *Shimotsuma monogatari* is based, embraces the rococo, using the very terms French philosopher Denis Diderot had employed two centuries earlier. Then, Diderot had spurned the paintings of François Boucher by saying they feature only "elegance, cloying sweetness, fantastic gallantry, coquetry, virtuosity, change, brilliance, made-up skin tones, and lewdness."[2] Anticlassical and pro-rococo to the core, *Shimotsuma monogatari* tells the story of two girls: Momoko, a hyperindividualist rococo-phile, and Ichigo, a biker girl who travels with a pack, who form an unlikely friendship in a less-than-idyllic countryside in millennial Japan. In this article, I want to trace the path of the baroque and rococo aesthetics in postwar Japanese subculture. I do so by using the film and novel versions of *Shimotsuma monogatari* interchangeably, with some additional passages of the novel that offer art-historical meditations on the resemblances between subcultures. My goal is to suggest how and why the 1970s emergence of shōjo manga (girls' comics) as well as the millennial

street fashion of gothic Lolitas featured in *Shimotsuma monogatari*, reprise the logic of the rococo, the hallmark of the seventeenth–to-eighteenth-century "consumer revolution" that provided women an entry into the marketplace during the transition from a feudal to a bourgeois regime. How does a baroque or rococo aesthetic provide an exemplary interface for entering the market of adulthood in the 1970s and in the millennial world?

The two characters in *Shimotsuma monogatari* meet through an eBay-like online market. Despite their polarized identities, they discover they both long to get out of the provinces, inhabited by real cows and a hapless bourgeoisie of superstore bargain hunters. In a nod to the most hallowed tropes of the "coming-of-age" novel, independence and social mobility, they move to the metropole and find their fortune by marketing artisanal items of rococo embroidery to an upscale boutique, where Momoko falls in love with the storeowner, and Ichigo becomes a star model. The tropes of "self-discovery" and adult subjectivity found through love are typical of shōjo manga and the young adult genre known as light novels, including Takemoto's *Shimotsuma monogatari*. What is less typical is that every sort of relationship in the novel and film—except the bonds of the biker gang and Momoko's care for her elderly grandmother—is entirely enabled and resolved through the market, from the cementing of the girls' friendship to the discovery of true love through the handmade bonnet.

FIGURE 1. A scene from the introductory reverie of *Shimotsuma monogatari* (2004, *Kamikaze Girls*), with Nakashima Tetsuya, Kyoko Fukada, Anna Tsuchiya, and Nobara Takemoto.

Shimotsuma monogatari's move from country to city, connected to the coming-of-age narrative in the context of feminine solidarity cemented through the market, is staggeringly different than the rococo we see in the first subculture to popularize Frenchness in association with independence and autonomy, the manga *Rose of Versailles* (*Berusaiyu no bara*).[3] The rococo first appeared in this wildly popular manga, serialized in eighty-two chapters between 1972 and 1973 in the weekly girls' magazine *Margaret*. The "rose" is a metaphor referring to the strangeness of fourteen-year-old Marie Antoinette when she is sent from the Hapsburg court in 1769 to marry the young dauphin, the future Louis XIV, and prevent war from breaking out between France and Austria. The manga series tracks Marie's rise and fall at court against the backdrop of the French Revolution. Ikeda adds a second, fictional character, Oscar, to dramatize an emergent politics of solidarity that catalyzes as the Revolution looms. As a narrative, *Rose of Versailles* dramatizes the ideology of postwar social realism in the nationalist version advocated by the JCP (Japanese Communist Party). That is to say, despite, or alongside, *Rose of Versailles*'s dynamic and exuberant formal articulation and its pioneering "bubble" language of character consciousness, the manga is structured by a historicist narrative: the demise of the court and the emergence of the "people." In the manga, the very term of "self" cannot be thought outside of the issues that Ikeda dwells on: class consciousness, asymmetrical class relations between women, companionate marriage born of natural rights and naturally sexed bodies, a citizen's duty, and a subjectivity grounded in the material conditions of labor.

Ikeda adds a new character, Oscar de Jarjeyes, to introduce the question of how to represent female entrance into the new bourgeois world in a postwar Japanese climate in which it is hard to muster support for an aristocracy. This second focus, moreover, adds an awakening critical consciousness. Oscar's narrative of transformation is set in relief against Marie Antoinette's intransigent commitment to frivolity. Oscar is born to a father whose family has served as military guards to the Bourbons for many generations. Her father is so nonplussed to have another daughter that he has her crossdress as a boy and trains her as an aspiring servant of the court. The manga juxtaposes the life of Marie with that of Oscar, whose guard duties throw her into the streets of Paris and increasingly close to the tumult and suffering of its residents, far from court luxury. After a trial at court, Oscar throws away her title to join the "people." Her newfound solidarity is sparked by a new love for a commoner she grew up with, after the man she loves devotes himself to Marie Antoinette with a romantic intensity she admires but a

commitment to the court that she cannot imitate. The emphasis on companionate love, moreover, relativizes the narrative of maternal suffering that is often used to humanize Marie and bring the aristocratic family into a republican national family mold. Oscar's narrative of solidarity is a fundamentally different mode.

Rose of Versailles was the first of Ikeda's manga series to depict world-historical revolutions and protagonists; subsequent manga covered the Bolshevik Revolution (1975–81, *Orufeusu no mado*) and Napoleon's empire building (1986–95, *Eikō no Naporeon*). *Rose of Versailles*'s chief distinction from the rococo world of *Shimotsuma monogatari* is that the politics of taste and cultures of exchange play some role in its story, too, but the *manga* is fundamentally interested in narrating the populist nature of the French Revolution through the experience of both noble and commoner girls. It is tempting to praise the historicist baroque of Ikeda at the expense of the conspicuously less heroic *Shimotsuma monogatari*. But first, let us establish the formal logic that allows us to compare the transformations of baroque and rococo across decades, centuries, and media.

BAROQUE TECTONICS

Ikeda's work stands out in the historical conditions of the 1970s because it connects a historicism that emphasizes the foundational nature of forms drawn from the baroque with the exuberance characteristic of the rococo. Her work, and shōjo manga in general, ran against the grain of the understanding of a fatigued, "posthistorical" Left that weighed heavily in the late 1960s and early 1970s. This melancholy, for instance, is signaled in the baleful title of a 2005 documentary film directed by Izuchi Kishū that interviews former leaders and thinkers of the 1960s student movement: *Left Alone.*[4] Suga Hidemi, in his overview of New Left political movements after 1956, refers, moreover, to the cluster of intellectuals such as Haniya Yutaka, who announced "the melancholy of the permanent revolutionary."[5] Like many writers, especially leftists of that time, Ikeda was interested in revolution and postrevolutionary climates. But unlike many writers, Ikeda was a member of the JCP.[6] This was an affiliation rare enough for a woman in the post-1956 era but still more rare to see in wildly successful mass culture auteurs of the high-growth economy. Although it is hard to document Ikeda's membership in the JCP, it is clear that she is far less interested in etiologies of failure than most male intellectuals and writers of the time.

> THE EMPHASIS ON THE
> SPECTACULAR, A DELIGHT
> IN SENSORY EXPERIENCES,
> AND THE SERIAL NARRATIVE
> OF A STORY "WORLD" ARE
> ALL FORMAL ELEMENTS
> THAT ARE SIGNIFICANT IN
> THE STORY-ORIENTED
> JAPANESE SUBCULTURE OF
> THE LAST THIRTY YEARS.

While it is difficult to account for why Ikeda did not voice the same despair as male intellectuals after 1970, I would like to look at her interface of the rococo and seriality of the baroque system in a different set of formal terms: the logic allowed by an appeal to "Frenchness" as a site of universal popular rights. New media scholar Angela Ndalianis has adapted a framework of art-historical writing to understand some key properties of contemporary cinema of the last thirty years. Her rather formalistic approach to defining a neo-baroque aesthetic is helpful here for two reasons: it applies equally to other sections of the "culture industry" besides film, and it provides a point of entry for analyzing the baroque and rococo aesthetics that are so evident in these texts but house notoriously tangled webs of genres, artifacts, tastes, and approaches.

Both *Rose of Versailles* and *Shimotsuma monogatari* draw on key events and characters of the era just prior to the French Revolution. The court, with its hermetic world of artifice and ritual, offers tropes for examining how a feminine subject becomes self-sufficient and free. It does so through an interface of rococo aesthetics that becomes serialized in the mode of what new-media scholars call the neo-baroque. The baroque aesthetic is generally associated with the seventeenth century and by 1755 was understood as "decorative" and "playfully free," before it succumbed to the later characterization of "unusual, vulgar, exuberant, and beyond the norm."[7] Heinrich Wöfflin revived the term in two works, his 1888 *Renaissance und Barock* (Renaissance and Baroque) and his 1915 *Kunstgeschichtliche Grundbegriffe (Founding principles of art history)*. The 1888 work focused chiefly on the development of architecture in Rome but was the first to apply the term "baroque" in both a broad and a narrow sense, referring to the literature of seventeenth-century Europe. The 1915 work further spelled out precise distinctions from Renaissance style.[8]

Though the baroque remained fluid in definition of formal features, period and scope, what remains a constant in Wöfflin and elsewhere is that the baroque is described in opposition to, yet emerging from, other styles: *not* classical, *not* Renaissance, *not* closed, *not* static. For better or worse, it is seen to present newness, openness, and rupture. The metonymizing of history in these terms brings the baroque to close to the formal logic of contemporary cultural production. In Ndalianis's formulation, formal elements characteristic of the baroque include seriality, multiple centers that disregard

framing and centralizing perspective, virtuosity, and the work's dynamism. Ndalianis writes that baroque "implied an art or music of extravagance, impetuousness, or virtuosity, all of which were concerned with stirring the affections and senses of the individual."[9] She points out that the extremely popular nature of the baroque owes to its appeal to mass spectacle in church architecture and art of the Counterreformation. Spectators are engaged as active, consuming subjects whose participation in the space is required. Participation in a neo-baroque world may not ultimately be underwritten by a transcendental, as a church is, but the intertextual nature of this baroque adapts neatly to the neoliberal formulation of millennial culture and its tendencies to "outsource" meaning making to the spectator. Neo-baroque works' open yet demanding relation to an audience solicits an active engagement. When an audience's "affections and senses" as actively consuming subjects are stirred, their consumption demands that they themselves produce the conventions and formal properties of the works and the intertextual connections that form a world.

By looking at the *locus classicus* of baroque style, the palace and gardens of Versailles, we can see key formal elements of the baroque that are taken and transformed in later subcultural works. A photo of the "bassin d'Apollo" (Figure 2) conveys four chief qualities of the baroque that Ndalianis sees operating similarly in neo-baroque works. In these qualities, we might note a tectonic tendency that is not present in the forms of either *Rose of Versailles* or *Shimotsuma monogatari*. First is the structure of a mythic "world." The temporally unvarying, modular nature of each part of the world is illustrated here in the statue of Apollo rising to carry the sun into its heaven. The status symbolizes, and metonymizes, how Louis XIV would call the world into being and enable it for each and all of his days by writing himself into a larger classic mythic scheme. Second is the lacing of this particular episode of the world into a larger story network spatially dispersed throughout the gardens as the path of the sun. The serial, expandable nature of each of these episodes is the baroque element that Ndalianis puts most weight on in the concept of the neo-baroque: highly structured, yet open ended. Third is the way that sensation and movement saturate the work in the dynamic figure of Apollo and his horses, and in the sensation of transition from one state (water) to another (air). Fourth is the active engagement of a visitor who is stirred by the movement and sensory elements, compelled to assemble the dispersed, serial elements of the garden "world" into a larger intertextual network.

The emphasis on the spectacular, a delight in sensory experiences, and the serial narrative of a story "world" are all formal elements that are

FIGURE 2. View of "Le Bassin d'Apollon et le Tapis Vert" (The Basin of Apollo and the Green Carpet), Versailles. Photograph courtesy of Arthur and Elizabeth Schlesinger Library on the History of Women in America.

significant in the story-oriented Japanese subculture of the last thirty years. What is different is the "world" in which a spectator/reader participates. Before going farther, I would like to summarize briefly why subculture could be brought into the fold of the neo-Baroque because of the very concrete "world" in which the concept emerged: United States–Japan relations after the 1947 Constitution and the 1970 reratification of the United States–Japan Security Treaty. I would like to highlight one ideological and historical reason for the setting of this story: the historicist foundation that licenses the aesthetic and formal language of the mingled baroque and rococo as Ikeda puts it forth. As it transitioned from baroque to revolutionary worlds, France was the historical origin of one discussion of rights that provides an alternative to, and supersedes, the version of "rights" at play in the American-imposed Constitution of postwar Japan. When rights are considered to be universal, and not imposed by a foreign occupier, the new incorporation of women into full citizenship cannot be bracketed as an imposed import: it is instead framed as an actively consumed potential that requires tailoring and customization by its receivers. Ikeda's choice of France as a setting for populist love and revolution provided a way to sidestep the chief source of fatigue, the failure of the Japanese critique of dependency on the United States when the United States–Japan Security Treaty was reratified in 1970. In particular, the plot

of *Rose of Versailles* dramatized how "rights" were an invention of a popular, anti-imperial, spontaneous uprising, not the imposition of a foreign occupying power, as in the case of women's voting and other rights in Japan under the American Occupation. In the next section, I hope to show that as the trope of "rights" emerges from the baroque, it allows a kind of historicism to be articulated that challenges received notions about the new entrants into this world: girls as they are represented in comics.

BAROQUE CITIZENSHIP: SUBCULTURE, GIRLS, AND INTERIORITY

In contrast to Anglo-American accounts, in many Japanese critics' minds, subculture is specifically tied to the 1945–52 Occupation and its legacies. In Anglo-American critical circles, the rubric of subculture comes primarily from two directions. The first approach from which Japan subculture is distinct comes from the Chicago school of ethnographic sociology of the 1920s. Its key concept, one that persists in cultural studies today, is that of deviance. The key questions revolved around understanding why people do not assimilate to a normalizing force such as Americanization.[10] The understanding of subculture as an oppositional or deviant identity was reprised in studies of Thatcherite Britain that worked to understand why dropping out of a labor market or other class-based crucibles of ideology occurred or, alternatively, how style could be conceived as opposition to cultural and class hegemony, using semiotics to borrow and rework objects and things into a "new ensemble" in the larger "struggle for possession of the sign," celebrating the individual status of revolt.[11] Writers like Stuart Hall, Dick Hebdige, and Rachel Powell were provoked by Howard Becker's breakaway sociological study *Outsiders* and collaborated to formulate ideas like resistance through ritual and style in dress and music that saw politics as a place where signs and their readings registered both pleasures and conflicts.

Subculture is most often conceived differently in Japan, in the context of a reflexive relation to cultural nationalism in the postwar geopolitical scheme of the Occupation. The main difference is that, while Anglo-American thought sees subculture as defined by a nonnormative or marginal position and likely approaches study through sociology and urban ethnography, subculture in Japan is defined as a community formed around the conventions of representations in one medium of information culture (manga, anime, heavy metal fans, and so on).

The idea of subculture was debated in the 1970s through literature, not new media, when the writer Murakami Ryū won the prestigious Akutagawa prize for his novel *Almost Transparent Blue* (*Kagirinaku tōmei ni chikai burū*) in 1977. The novel was widely perceived as vulgar and derivative, even by the committee that awarded the prize. Furthermore, the setting of underground youth culture on the outskirts of a U.S. Army base provoked the influential critic Etō Jun to blast Murakami's novel for its decadence and for the base's presence in the work, which he felt should exclude the work from the field of "pure literature."[12] In 1976, Etō had criticized the "nonsense" quality of *Almost Transparent Blue* because it registered "no literary impression." Etō attributed the lack of "literariness" and dependence on the ready-made elements of youth culture clichés to a fatal dependence on American culture, an attitude that 'reflects' that dependence by representing only "a partial cultural phenomenon, not a society's total culture."[13] Etō retired from book reviewing in 1978 in disgust at the lack of "literariness" in writing that "reflected" subculture while itself having no "expression."[14]

Although subculture would come to signify a more-or-less objective reference to partial cultures, New Left and New Academic writers continued to deride subculture as partial and as unworthy of intellectual engagement. A signature writer of New Academic, Asada Akira, criticized Ōtsuka's treatment of the Aum subway gassing incidents as unworthy, saying that they were a "stunted" phenomenon that should not be taken seriously as "either religion/spirituality or thought."[15] Asada is convinced of the trivial and aberrant nature of subculture and marks a decisive difference between academic- and industry-oriented analyses of subculture.

Asada's dismissive view is opposed to that of writer and editor Ōtsuka Eiji, a manga editor and critic who has written most prolifically on subculture as forms of representation. Ōtsuka takes subculture seriously, not because of intellectual intentionality but because it presents the problems of a generation, sociological problems that should be "historicized." Since at least the time of the Asada/Ōtsuka dispute, "subculture" has come to refer to communities of fans and readers who are numerically minor, and has become attached to media apart from literature, such as comics, games, independent music, and other small-scale media belonging to both do-it-yourself and mass culture. Far from deviant, conventions of media-dependent subculture suggest a norm, an intelligible identity in the context of highly differentiated identities and the high-growth economy. Although the normalizing valence of Japanese subculture differs from the American focus on assimilationism and the British focus on deviance and resistance, two

primary models of subculture cite different reasons for the concept's importance in postwar Japan.

The first model is suggested by Ōtsuka, whose academic training was in ethnology and who places subculture in a framework of chronological history within Japanese cultural production. For Ōtsuka, Etō's critique and retirement from book reviewing present key moments of subculture. Ōtsuka objects to the way Etō dismisses subculture because it does not fit into history and is artificial. Like many critics, Ōtsuka associates subculture with partial media formations, rather than total social formations, and sees subculture in the birth of new media that were first popularly consumed in the 1970s context of information culture (*jōhō bunka*). He finds that subculture narratives are postmodern and that their "small-h historical" narratives follow on the "end of history" as multiple narratives converge to become ahistorical in the early 1990s, when the economic bubble collapsed and the Shōwa emperor died, thus rupturing the ideological continuity that had underwritten modernity, imperialism, and mass culture since the 1920s. This model is concerned overall with issues of national sovereignty in the postwar context of the Occupation and its legacies. It is closer to *Rose of Versailles* because it focuses on representation, citizenship, and popular sovereignty.

The second model derives from the late 1950s with the emergence of youth-culture groups such as the "*taiyōzoku*" (sun tribe) that named the romantically nihilistic gang of decadent youth who redefined beach culture in the 1957 novel and 1959 film *Taiyō no kisetsu* (Season of the sun). This is probably one model for Etō's charge that Murakami's 1977 novel was "derivative." As Ueno Toshiya explains, the term *zoku* is an anthropological term that typically designates a tribe. Mabuchi Kōsuke would give this a slightly broader meaning of socioeconomic class and would locate it in the immediate postwar-era aristocracy that had to pawn its belongings to stay afloat.[16] But both agree that by the late 1950s, *zoku* referred to a tightly-knit social formation that plays by its own brash or "creatively destructive rules."[17] Although the rhetoric of tribes may seem primitivist or anthropological, *zoku* is unrelated to temporal formations of development; it merely indicates affinity and differentiation. Where the first model sees the nation-state as the primary a priori of cultural production, the *zoku* model begins with a genre conscious of its global relation to other movements; it may be more appropriate to be talking about cultural production within a globalized context of differential identities. This model is closer to *Shimotsuma monogatari* because it is less concerned with the origins of historicist subjectivity and more interested in how objects facilitate social mobility and how forms of exchange and markets underwrite identity.

Like Etō, Ōtsuka is often troubled by a loss of history and historically inflected subjectivity that follows on this loss of the historical—by which he typically means historicist—consciousness. One particular area of concern is contemporary history's debt to the Occupation. A second, related area of concern, one that is most pertinent to shōjo manga and its highly formalistic relation to the baroque, is the loss of history he sees in shōjo manga, an aporia that he argues defangs the potentially radical nature of the 1947 Constitution. Ōtsuka considers Article 24 to be the most "radical" element of the Constitution because it mandates equal rights (and, presumably responsibilities) to men and women in selecting marriage partners and mandates that "laws shall be enacted from the standpoint of individual dignity and the essential equality of the sexes." Needless to say, companionate marriage is one of the tropes most beloved of shōjo manga. That he grants Article 24 priority over Article 9—the "peace article" that fueled the New Left and grassroots peace movements—is distinctive. He faults, however, the interpretation of Article 24 for placing too much emphasis on the modern "self."

To Ōtsuka, to "historicize" means to understand how engaged subjectivity and self-reflexivity are crucial components of Japanese cultural production, no matter how "high" or "low" the source. The crux of Ōtsuka's critique is that too many critics place too much emphasis on interiority and the "self" at the expense of history. Indeed, his main critique of shōjo manga has been applied to the baroque itself, particularly in its German context. The art historian Georg Dehio, for instance, equates it with the "basic German mood" of German art through the ages because the "Baroque strives for expression, even at the expense of form."[18] The five volumes of *Rose of Versailles* are resplendent with expressive suffering. Indeed, emotions are crucial to the critical reception of shōjo manga and are often seen to eclipse qualities of social life and history due to the interest in private life. Figure 3 shows the kind of scene that shōjo manga critics often emphasize. Here, layering and multiple narratives combine to amplify and deepen subjectivity, particularly in lyrical moments that express interior life, as we see Maria Theresa's anguish over dispatching her daughter to the Bourbon court.

Ōtsuka sees shōjo manga's tendency to dwell on this very kind of subjective depth as a failure to "historicize." This critique is typical of harsh postwar literary critiques of prewar fiction that derided fiction, particularly works that focused on the "self" for its lack of resistance to fascist mobilization.[19] What is new in the critique of "insufficient socialization" is Ōtsuka's shift to focus on the vivid and private interior lives of young female protagonists and to "historicize" representations of their inner worlds. He attributes this new

FIGURE 3. A pensive moment from the first volume of *Rose of Versailles* (1972). Marie Theresa vexes over her decision. "I wonder if I did the right thing . . . that innocent, tomboyish, playful Marie . . ." She alternates between hoping that Marie's arrival will cement peace, and a foreboding that Marie is destined to be unhappy. "She may rise to be queen . . . In the mind of that spoiled, sweet, everyday girl, surely this can bring nothing but unhappiness." Finally she gives up, crying, "Ah, I can't bear this unsettledness," and the scene closes uneasily: "For some reason, I feel an ill omen . . ." The candle in the side panel gives an additional durational moodiness to the sequence of panels that flip-flop between Marie Theresa's memories of Marie, and the external presentation of her thinking; its constancy exacerbates the contrasting nature of Marie's motion and her mother's stasis, Marie's beseeching open eyes and her mother's covered frown. Image courtesy of Ikeda Productions.

subject in manga to the "24-year group" (24-nen gumi), a cluster of female manga artists all born in Shōwa 24 (1949), which includes Ikeda. Ōtsuka's critique of shōjo manga abbreviates his broader critique that feminist writers have toed the same fatally ahistorical line as fiction writers in their failure to show how the "self" is modulated by social and historical conditions.

Is this a fair critique? Are shōjo manga really antihistorical? In my view, no. Part of Ōtsuka's critique may lie in the very successful nature of shōjo manga. If the baroque eighteenth-century aesthetic let people assemble elements of the myth of Louis XIV into a coherent and immersive mythic world, the question here is how the audience becomes capable of traversing multiple texts to give coherence to a specific work. Given that *Rose of Versailles* has been remediated not into critique of myth but into formats as wide in scope as coloring

> THE ENTRANCE OF WOMEN INTO A MARKET OF PRODUCERS AND CONSUMERS APPEARS TO BE INTEGRAL TO THE BAROQUE NATURE OF NEO-BAROQUE SERIALITY, AS WELL AS TO THE ROCOCO AESTHETIC OF THE PLAYFUL DECORATION OF PRIVATE LIFE.

books, the Takarazuka Revue's *theatrical productions*, a wildly popular anime series, and a myriad of commemorative volumes, the apparently ahistorical nature of the commodity form could seem nettling to Ōtsuka. Indeed, it may be hard to see what could in fact be revolutionary about *Rose of Versailles* without knowledge of three crucial facts external to the characters and the world of the eighteenth-century Bourbon court. These contexts may let us to see things Ōtsuka does not, while maintaining his basic line of inquiry.

First, Ikeda's manga are different from other "24-year group" manga because they challenged the very parameters of privacy. No interiority is exempt from being evaluated in terms of its significance in the world-historical frame of revolution. And second, the timing of Ikeda's story of the royal family's demise is striking because, at its time of publication in 1972–73, it depends on a world-historical situation of the sort that leftist commentators typically say was exhausted. This period of leftist fatigue was, in fact, when female writers were entering the comic market as producers and consumers, as in the seismic shift of the *ancien régime*.

Sharon Kinsella reminds us that the manga markets of the 1970s provided an unexpected new gateway into the medium for women via new networks for the production and distribution of amateur manga such the massive Comiket convention. Yonezawa Yoshihiro, then president of Comiket, explains:

All the independent comics and meeting places of the 1960s were disappearing by 1973 to 1974, and then *COM* magazine folded. It was a regression, from being able to publish all kinds of stuff in mainstream magazines to being able to publish only unusual stuff in *dōjinshi* underground magazines. But what else can you do, but start again from the underground?[20]

The new network of this "consumer revolution" subsequently benefited from technical changes in media industries, such as the greater availability of circulated goods on DVD and other platforms, as well as the capacity for multiple audiovisual modes in the same object. The entrance of women into a market of producers and consumers appears to be integral to the baroque nature of neo-baroque seriality, as well as to the rococo aesthetic of the playful decoration of private life.

Finally, Ikeda's manga was modeled on the literary style of Austrian writer Stefan Zweig's biography of Marie Antoinette. Zweig's profound interest in historiographies of chance make the text of *Rose of Versailles* discursive in ways most shōjo manga are not. While Ikeda did "create" the manga, it is worth noting that many of these humanizing characteristics, which give a less-than-melancholy interpretation of revolution, draw on Stefan Zweig's 1933 book to provide both structure and information and to anchor the interior life of the characters in their own saga. Figure 3, for example, depicts a situation taken directly from Zweig's narrative.

In Zweig's biography, Marie Antoinette's life is thoroughly unremarkable for its first thirty-eight years. His biography attempts neither to vilify her as the "*louve autrichienne*" reviled by revolutionary sans-culottes, nor to "deck her with a halo" to "flatter the dynasty" of prerevolutionary Bourbons.[21] He depicts her, rather, as an "average woman," who would neither have been known, nor known herself, had it not been for a chance encounter with an "unparalleled . . . display of historical tensions" spurred by the early days of the French Revolution.[22] Zweig's interest in Marie Antoinette is significant because it departs from many nineteenth- and twentieth-century attempts to see the queen as a "representative" woman because of her role as a mother, linking the historical narrative between court and middle-class family: rather, she is representative for her very mediocrity until her accidental encounter with fate.[23]

Let's look at one more example (Figure 4) from *Rose of Versailles* to see how this story is told in what Thierry Groensteen calls the "the relational play of a plurality of interdependent images," which is to say, the formal relations of a system of images on the page.[24] Figure 4 is the first page of the *Rose of*

❧ Episode 1

FIGURE 4. Introductory scene-setting from chapter 1 of *Rose of Versailles* (1972). The two panels set the scene for the stories that unfold in the following volumes. The upper panel introduces the story's timeline, and sets up suspenseful expectation about the three characters, each born in a noble setting in the three countries of Sweden, France, and Austria. The lower panel sings the praises of Felsen, who is later dispatched to the court at Versailles and will commence a passionate romance with Marie Antoinette. He cuts quite a figure at court, with his good looks and masculine bearing, setting the heart of all the court ladies racing. The following pages relate the backstories of the other two main characters, Oscar François de Jarjeyes, born near Versailles, and Marie Antoinette Joseph Jeanne de Lorraine Autriche, born at the Hapsburg court. Image courtesy of Ikeda Productions.

Versailles series. The juxtaposition of fates that aligns Marie Antoinette, Oscar, and a Swedish nobleman is narrated in a strong discursive voice that is much more directive and present as a commentary than it is in the vast majority of shōjo manga. The "voiceover" draws heavily on sequencing, phrasing, and the use of present tense typical of Zweig's historiographical writings. The effect is to create a sense of suspenseful unfolding. It tells us that the story takes place "In 1755 . . . " and that emerging from this point in time are three stories: "In this year, in three separate European countries, were born three people who would have a fateful meeting at Versailles." The dashing count and future paramour of Marie Antoinette, Count Hans Axel von Fersen, is first introduced, a narrative order that accommodates the usual reading direction of top to bottom, right to left. "In the northern land of Sweden, Hans Axel von Fersen is born to a distinguished line, eldest son of a councilor." After establishing the setting and illustrating his fortune, the narration proceeds to comment on Fersen's physical beauty in a text box pinned over his chest.

Here, it is worth noting that Fersen, whose visage graces the opening page, was, until the late nineteenth century, only a bit player in historiography of the revolution. One of Zweig's innovations as a biographer was to introduce new historical evidence about the queen's lover and friend:

> [D]uring the latter half of the nineteenth century a romantic tale began
> to gain currency. In a Swedish castle there had been preserved under seal
> numerous packets of Marie Antoinette's private letters. At first little cre-
> dence was given to this improbable report. Then there appeared a printed
> edition of the private correspondence, and, although the letters had been
> barbarously pruned of intimate details, the book was enough, at one stroke,
> to thrust the previously unknown Scandinavian noble into the most distin-
> guished place among the friends of Marie Antoinette. These letters modify
> our whole outlook upon the character of a woman hitherto regarded as
> light-minded. They show a spiritual drama splendid and perilous, an idyll
> partly in the shadow of the king's court and partly in that cast by the
> menacing guillotine, one of those soul-stirring romances which perhaps
> can only be penned by history herself.[25]

Zweig's portrait of himself as a mere scribe of "history herself" should make us rethink Ōtsuka's charge of shōjo manga's failure to "historicize." As we turn to the millennial example of baroque and rococo, *Shimotsuma mono-gatari,* it is useful to remember one further historicist narrative that makes

the eighteenth-century story correspond to the interests of the twentieth/twenty-first-century one: namely, that Marie Antoinette as queen of mediocrity is a savvy model for a producer or consumer of shōjo manga. Historically, she is an epoch-shifting queen due to her status as an exemplary participant in the market, just as the shōjo of Taishō modernism was in the forefront of the interwar consumer revolution. The "chance" nature of Marie Antoinette's historical mediocrity is hastened because she was the first queen to leave the palace and patronize the highly regulated and exclusively masculine *marchande de mode* system.[26] If we think of her significance as linked to the patron's entrance into the market, subject to those laws of chance, the connections to postwar Japan and to the millennial baroque become clearer. *Rose of Versailles* dramatizes the Revolution as a shift from feudal to populist sovereignty, whereas *Shimotsuma monogatari* uses the rococo to correspond to a shift from feudal to capitalist relations in eighteenth-century French historicist narrative. In the case of *Rose of Versailles,* self-expression means universalizing the tectonic structures of marriage put in place by Article 24, whereas in *Shimotsuma monogatari,* the miniature, decorative mode of the rococo attaches its characters to an unexpectedly far-reaching network as both producers and consumers.

THE NEO-BAROQUE AND MILLENNIAL FRENCHNESS

While in real historical time the rococo aesthetic fell out of favor near the end of the *ancien régime,* it has undergone something of a revival in postwar Japanese subculture. After the millennium, *Shimotsuma monogatari* idealizes the world of the rococo era by drawing on specific aesthetic elements that were lively, ornamental, and unheroic in contrast to the looming and systematic nature of Louis XIV's baroque world of allegory. Momoko's gothic Lolita street fashion inverts and sometimes reprises elements of the eighteenth-century rococo aesthetic of the Petit Trianon.

Shimotsuma monogatari begins with a dense art-historical explication of Momoko's favored style, culminating in Diderot's condemnation of the rococo. The biker girl, Ichigo, first appears wearing "black extra-extra long knickerbockers with a bizarre aloha shirt she had purchased from me, which had Versace symbols scattered all over it, and over that, her kamikaze coat."[27] The novel's narrator explains the aesthetic principles that underpin the seemingly odd alliance between the two girls: they share a fondness for "extravagant addition." Momoko explains:

Whenever I really want to get into the rococo spirit and give everything I have to being a Lolita, I force myself into a tight corset and make my waist smaller. So might a Yankii's *sarashi* and a Lolita's corset serve the same purpose? Ugh, what an awful thought. But if you look at Yankii bikes and clothes, you can see their aesthetic is all about extravagant addition, which is actually the same as the Lolita aesthetic >sigh< What am I saying?[28]

But this extravagance seems to differ from the consumerism that typically dominates discussions of Japan in and after the high-growth economy. Another axiom of the rococo court that Momoko reprises holds that "for one who lives with the rococo spirit, productive activity such as labor is to be avoided at all costs."[29] Yet the happy ending in which the story culminates is all about being able to turn the frivolous, aristocratic hobby of embroidery into a vocation, to transform hobby into work. In the manifesto-like first sequences of the film, ladies in the digitized pastoral scene (Figure 1) Momoko narrates spend the day strolling through undulating landscapes from one exquisite interior space to the next. They fuss over needlepoint, wince while their corsets are laced, and vanish into the bedroom with abandon.

But the happy ending of *Shimotsuma monogatari* depends more on labor than its absence. It is about finding a place in the world through production. Momoko discovers that mice have eaten holes in one of her bonnets, a "flaw" she covers up with embroidered stitches. But where the cult of the pastoral had meant absence of labor in the court of Versailles, the longing for class mobility sends Momoko straight to work as she buys and sells online merchandise, designs new kinds of garments with her craft skills, and binds herself to supposedly antithetical subcultures. On her next visit to a high-end gothic Lolita boutique, the fascinated clerk introduces her to the store's owner/designer, a foppish figure who makes Momoko swoon, and then asks her to work on commission making frocks and bonnets for the shop.[30] Her independence ends up being both self-sufficient and commodifiable.

As we saw, the bourgeois revolution of *Rose of Versailles* makes its character into a hero and a passionate citizen through the interfaces of love, labor, class-consciousness, and companionate marriage. *Shimotsuma monogatari* makes her into an equally ardent worker, but the terms of subculture through which she becomes an active subject have changed. Where *Rose of Versailles* transcended the bilateral scheme of U.S.–Japan relations by asserting a universal claim on rights, popular sovereignty in *Shimotsuma monogatari* is linked to a transnational awareness of how elements of a market differ from each other. The rococo interface traverses the networks of baroque spectacle

and seriality, while feminizing the crossover of media forms to make work compatible with play. If play was a space of liberation for thinkers of the twentieth century, millennial girls confront us with the sober reality of shōjo manga and the neoliberal state writ large. *Shimotsuma monogatari* updates the three little words that inspired *Rose of Versailles,* the romantic whisper of "I love you," to connect subculture to subjective agency through a more sobering three-word imperative: do it yourself.

Notes

1. *Shimotsuma monogatari,* dir. Nakashima Tetsuya (2004); translated as *Kamikaze Girls,* DVD (VIZ Media, 2006).

2. Novala Takemoto, *Kamikaze Girls,* trans. Akemi Wegmüller (San Francisco: VIZ Media, 2002), 7.

3. Ikeda Riyoko, *Berusaiyu no bara* (Rose of Versailles) (Tokyo: Shūeisha, 2002–3). A relation to Frenchness is not unheard of in contemporary pop culture, though the shōjo baroque differs markedly from the Enlightenment schemes of knowledge found in cultures of collecting in millennial Japan. The Pokémon series, for instance, has a backstory about its interactive play world that recalls the Enlightenment project of the Encyclopedists. It has a founding scholar, the eighteenth-century French Count Tajirin, who was the first to study, order, and classify the thirty types of Pokémon that he found. Japanese scholars have advanced the science of Pokémonology by discovering, classifying, and tracking the evolution of new forms of Pokémon life. See Anne Allison, *Millennial Monsters: Japanese Toys and the Global Imagination* (Berkeley and Los Angeles: University of California Press, 2006).

4. See Izuchi Kishū, *Left Alone: Jizoku suru nyūlefuto no "68-nen kakumei"* (Left Alone: The continuing new left's "1968 revolution") (Tokyo: Akashi shoten, 2005), and Suga Hidemi, *Kakumeitekina, amari ni kakumeitekina: "1968-nen no kakumei" shiron* (Revolutionary, all too revolutionary: On the "1968 revolution") (Tokyo: Sakuhinsha, 2004).

5. Ibid., 31.

6. Chika Kinoshita reminded me of this point, and of Ikeda's political affiliation.

7. René Wellek, "The Concept of Baroque in Literary Scholarship," *Journal of Aesthetics and Art Criticism* 5 no. 2, (1946): 77.

8. Heinrich Wöfflin, *Renaissance und Barock: Eine Untersuchung überr Wesen und Entstehung des Barockstils in Italien* (Renaissance and Baroque: An examination of the nature and genesis of the baroque style in Italy) (Munich: T. Ackermann, 1888), and *Kunstgeschichtliche Grundbegriffe: Das Problem der Stilentwicklung in der Neueren Kunst* (Principles of art history: The problem of stylistic development in later art). (Munich: F. Bruckmann, 1915).

9. Angela Ndalianis, *Neo-Baroque Aesthetics and Contemporary Entertainment.* (Cambridge, Mass.: MIT Press, 2004), 7.

10. Ken Gelder, *The Subcultures Reader,* 2nd ed. (London: Routledge, 2005), 19.

11. Dick Hebdige, *Subculture, the Meaning of Style* (London: Methuen, 1979), 17.

Many of the CCSC works, in particular, had a focus on gender that was, in fact, very compatible with how subculture emerged in Japan. See Angela McRobbie, *Feminism and Youth Culture: From "Jackie" to "Just Seventeen"* (Houndmills, Basingstoke, Hampshire: Macmillan, 1991), and Paul E. Willis, *Learning to Labour: How Working Class Kids Get Working Class Jobs* (Farnborough, U.K.: Saxon House, 1977).

12. Etō Jun: *Tozasareta gengo kūkan: senryō-gun no ken'etsu to sengo nihon* (Closed linguistic space: Occupation censorship and postwar Japan) (Tokyo: Bungei shunjū, 1989).

13. Ōtsuka Eiji, *Sabukaruchaa bungakuron (On literature and/as subculture)* (Tokyo: Asahi shinbunsha, 2004), 12.

14. Etō, an extremely sophisticated, learned, textually sensitive and nationalist literary critic and public intellectual, published a 1989 a book on censorship following a stay at Princeton and a second stint in the United States in 1979–80.

15. Ōtsuka Eiji. *Kanojotachi no rengō sekigun: sabukaruchaa to sengo minshūshugi* (Their Red Army: Subculture and postwar democracy) (Tokyo: Bungei shunjū, 1996), 236.

16. Mabuchi Kōsuke, *"Zoku"tachi no sengoshi. Toshi no jānarizumu* (A postwar history of "zoku" subculture. Series Journalism of the city) (Tokyo: Sanseidō, 1989), 13.

17. Ueno Toshiya, "Unlearning to Rave: Techno-Party as the Contact Zone in Trans-Local Formations," in *The Post-Subcultures Reader,* eds. David Muggleton and Rupert Weinzierl (Oxford: Berg, 2003), 104.

18. Quoted in Wolfgang Stechow, "Definitions of the Baroque in the Visual Arts," *Journal of Aesthetics and Art Criticism* 5, no. 2 (1946): 110.

19. Suzuki Sadami, *The Concept of "Literature" in Japan,* trans. Royall Tyler (Kyoto, Japan: International Research Center for Japanese Studies, 2006).

20. Sharon Kinsella, *Adult Manga: Culture and Power in Contemporary Japanese Society* (Honolulu: University of Hawai'i Press, 2000), 106.

21. Stefan Zweig, *Marie Antoinette, the Portrait of an Average Woman,* trans. Eden and Cedar Paul (New York: The Viking Press, 1933), xi.

22. Ibid., xiv.

23. See Katherine Binhammer, "Marie Antoinette Was 'One of Us': British Accounts of the Martyred Wicked Queen," *Eighteenth Century: Theory and Interpretation* 44, no. 2–3 (2003): 233–55; and Regina Schulte, "The Queen—a Middle-Class Tragedy: The Writing of History and Creation of Myths in Nineteenth-Century France and Germany," *Gender and History* 14, no. 2 (2002): 266–93.

24. Thierry Groensteen, *The System of Comics,* trans. Bart Beaty and Nick Nguyen (Jackson: University Press of Mississippi, 2007), 17.

25. Zweig, *Marie Antoinette,* 226.

26. See Caroline Weber, *Queen of Fashion: What Marie Antoinette Wore to the Revolution,* 1st ed. (New York: H. Holt, 2006); and Daniel Roche, *La culture des apparences: une histoire du vêtement (xviie–xviiie siècles)* (Paris: Fayard, 1989); translated into English as *The Culture of Clothing: Dress and Fashion in the "Ancien Régime"* (Cambridge: Cambridge University Press, 1994).

27. Takemoto, *Kamikaze Girls,* 176.

28. Ibid., 138.

29. Ibid., 43.

30. Ibid., 168.

GERALD FIGAL

• • •

Monstrous Media and Delusional Consumption in Kon Satoshi's *Paranoia Agent*

THE OTAKU MANQUÉ

Kon Satoshi's 2004 thirteen-episode TV anime series *Mōsō dairinin*[1] (translated as *Paranoia Agent*, although *mōsō* is more akin to "delusion") presents a twist on the usual Tokyo-destroying monster. The monster that lays waste to the city springs not from an atomic mutation or alien planet or from a supernatural realm or robots run amok but apparently from the stressed-out psyches of the people themselves: when feeling cornered and under pressure, a mysterious inline-skating, bat-wielding boy (dubbed "Shōnen Batto," literally "Bat Boy" but translated in the English version as "L'il Slugger") appears and whacks them, sometimes fatally, thus releasing them from their anxieties. As the series progresses, Shōnen Batto transforms into an increasingly monstrous shape, first through rumors and media hype and then in "reality" by feeding on people's anxieties and desires for escape. By the climax of the story, he is an amorphous black ooze flooding violently through the urban landscape, absorbing everyone. While the origin of Shōnen Batto is revealed to have been a young girl's inability to take responsibility for her actions out of embarrassment and fear of punishment, the social conditions under

which her present actions trigger Shōnen Batto's assaults and metamorphosis point to the monster as something beyond a mere mass-psychological projection of stress made manifest. Media itself attains monstrous proportions, feeding and fed by a hollow hyperconsumerism, a consumerism for the sake of consuming.

I'd like to read *Paranoia Agent* as working through the unexpected and monstrous transformations that mass-mediated consumer capitalism effects on social relations and individual agency, turning consumers into what we might call *otaku manqué*—obsessive "fans" of media products without the attendant specialized knowledge of them or active engagement in them. In this context, the "fans" are all those who passively participate in and sustain this consumption, not the archetypal otaku, although the figure of the otaku occupies a key position in the critique I think Kon is offering as overseer of the series (the thirteen episodes have several different directors). Here the classic otaku figure becomes the active, overt, and concentrated instance of the passive "soft fandom" that progressively congeals, hardens, and materializes among the Tokyoites depicted in the series. In their hypermediated daily lives and in their mania over a media consumable, they become unwitting and incomplete otaku without even knowing it. Not that being a complete otaku fares much better. This vision of a kind of otakuization of society through media and consumption differs from the usual emphasis on the obsessive otaku inhabiting semiautonomous "islands in space" carved out by self-consciously attained media-based knowledge of specialized subjects.[2] Rather, these consumer-fans, by dint of their unreflective and generalized but no less obsessive—in a word, delusional—relationship to media and media consumables, drown in an undifferentiated mass (culture).

For this analysis, Marshall McLuhan's famous but often misunderstood dictum "the medium is the message" provides a useful springboard. For McLuhan, a "medium" is "any extension of ourselves" (a tool, a technology, a system of signs). A "message" comprises the often-unnoticed structural changes (of "scale" or "pace" or "pattern") that a new innovation brings into society.[3] In *Paranoia Agent,* the medium is the monster, where the medium comprises the electronic media technologies that have become part and parcel of mass—I would say mass-delusional—consumption. The monster—the structural transformation or, in this instance, structural deformation—lies in the figure of comfort-providing character goods: the soft plush toy, the childish accessory, the cute "superdeformed" anime figure. The overtly monstrous figure of Shōnen Batto is wedded to the covertly monstrous figure of Maromi, the "sleepy-eyed dog" character at the psychic heart of the series.

Both absorb virtually all the public's attention to become potential objects of otaku knowledge and desire that remain unfulfilled. This relationship between the threatening Shōnen Batto and the *kawaii* Maromi comes across in one promotional still for the series where the former appears as a shadow on the latter. The real threat is thus not the personal anxiety that conjures up Shōnen Batto but rather what might be called the social narcolepsy and narcissism that media-driven mass consumerism produces in contemporary Japan, according to the critique Kon seems to be staging (ironically) in this anime. In this respect, Kon's commentary bears relation to Murakami Takashi's Superflat project, which he styles as a "Monster Manifesto" (*kaibutsu sengen*) for the "deformed monsters" that are postwar Japanese and their popular art. Murakami, however, embraces this "art, the work of monsters," and its iconic figure, the otaku, while Kon displays their self-destructive logic.[4] If otaku are viewed (positively or negatively) as social monsters living on islands of self-absorption apart from society, consumers as otaku manqué are social monsters living on islands of self-absorption within society, which comes across in *Paranoia Agent* as a much more dangerous threat.

TAKE A REST

For the heart of Kon's critique, we must dive first into episode 10, "Maromi Madoromi" (officially translated as "Mellow Maromi" where "madoromi" suggests "dozing off"). The most self-reflexive of the series, this episode concerns the production of an anime series, called *Maromi Madoromi* and based on the hit character Maromi, created by character designer Sagi Tsukiko. We later learn that as a twelve-year-old Sagi accidentally let her puppy, also named Maromi, get hit by a car when she doubled over—apparently from her first menstrual cramps—and lost hold of the puppy's leash.[5] She is the first victim of Shōnen Batto, whom we also later learn she fabricated at the time of the puppy incident to cast herself as victim, thus excusing herself from the real explanation for the accident. (Following the series' motif of naming characters in relation to various animals, her name "Sagi" is a homonym for a type of heron but also for the word for "fraud" or "deception.") By the end of the "Mellow Maromi" episode the entire production crew, under stress to make a deadline exacerbated by a bungling production manager, one-by-one falls fatal victim to Shōnen Batto. The commentary on the notoriously difficult work conditions of TV anime is clear, but my attention is drawn to the identification of Maromi as monster, which begins explicitly from this episode

and subsequently leads to a string of connections and revelations that propel the story through its climax and denouement during the final three episodes. That this occurs in an anime in production within an anime throws into relief the issue of the anime medium itself and its complicity in the production and dissemination of the soporific effect of character goods like Maromi and the delusional (*mōsō*) consumerism for which it is a representative, an agent (*dairinin*).

Episode 10 opens with what immediately strikes the viewer as a low-budget TV anime done in a simple, flat, cute style coded as "kids' cartoon" that is very different from the more sophisticated look of the rest of the series. The camera pans down from a blue-yellow sky through the horizon of a suburban neighborhood, cutting to a pair of small feet in baseball cleats and socks stepping along with a noonday shadow conspicuously cast as a fluctuating black ellipsis below. We then look down, as if from the roof of a three- or four-story building, at a little leaguer in his ball uniform, walking spiritlessly through town with a bat on his shoulder. A cut a few seconds later of the boy's upper torso is timed with his heavy sigh, at which point the camera shifts on cue to eye level for a medium shot of the boy passing a toy store that has a bin full of stuffed animals for sale on the sidewalk. In one window, a robot and Godzilla-like monster hover over his head (Figure 1). Just as he exits the frame, a Maromi doll comes alive from the bin of stuffed animals to follow the boy to a riverbank, where, in frustration, the boy has flashbacks of striking out in a game and berates himself, exclaiming "I'm a nothing" (*dōse boku nan ka* . . .). Just as he is about to heave his bat into the river, Maromi pokes him from behind, startling the boy, who drops the bat that then rolls into the river. This action sends the scene for a few seconds into the sketches on which the completed scene was based. This sudden shift to an even more primitive state of the animation works well to convey the boy's surprise—it is as if the color is knocked out of him as the background is pulled away, isolating the emotion on the isolated characters. But it also works to underscore the self-reflexive nature of this episode.

This play between the completed animation and the sketches continues during Maromi's attempts to cheer up the boy by assuring him that he isn't worthless; instead, he is only "tired" and should simply "take a rest." As Maromi repeats several times the hypnotic mantra *"yasuminayō"* ("take a rest"), the details of the sketches degrade further and then the camera zooms out to reveal that we have been watching the production of the cartoon on a monitor in an anime studio (Figure 2).

Besides this self-referential framing, the first thing of note about this

FIGURE 1. Anime within anime: scene from episode 1 of the TV series *Maromi Madoromi* in episode 10—"Maromi Madoromi" ("Mellow Maromi")—of the TV series *Paranoia Agent.*

sequence is the soundtrack. The music is the end theme of the series itself, "White Hill: Maromi's Theme," which normally plays through the credits of each episode while the camera pans around images of the main characters in a death-like sleep in a circle around a huge plush toy—Maromi—that appears as the camera zooms out. Played during the opening of episode 10, it invokes the drowsiness that Maromi induces and presides over. Indeed, the scene ends with Maromi easing the boy's frustrations and disappointment not by suggesting he practice harder but rather by coaxing him to take a rest, to escape waking reality through sleep. Maromi's function here, as it is throughout the series, is that of a narcotic that relieves stress by encouraging the avoidance of the hard work of adult reality and by providing excuses to evade responsibility. In this episode, the blundering staff production manager Saruta ("Monkey")—nothing but a bundle of excuses—is frequently framed by images of Maromi in the form of promotional posters and various character goods. At one point, echoing the opening sequence's shift to sketches, he begins to dissolve into an anime sketch of himself as he verbally denies responsibility for foul-ups that have plagued the production of *Mellow Maromi*. In other words, his escape from responsibility is paralleled by a fall from his "real" anime world into a second-degree, cartoon-sketch world. In both instances, the anime within the anime is associated with escape from

FIGURE 2. Framing the site of production of the anime within the anime. From *Paranoia Agent*, episode 10, "Maromi Madoromi."

the burdens of reality facilitated by the "sleepy-eyed" Maromi, itself a narcotic in all its manifestations: plush toy, hallucination, anime. The analogy to our (real human) relationship to the consumption of "first-order" anime is apparent.

The second thing of note in the opening sequence is the suggestion that Maromi and Shōnen Batto are connected. It is no coincidence that the little leaguer, a kind of superdeformed anime version of Shōnen Batto himself, calls Maromi a *bakemono* (monster). The same language is applied to Shōnen Batto in the following episodes, wherein the identification of Maromi with Shōnen Batto is made explicit. One might also read the "M" on the boy's ball cap as signifying Maromi, covering—and controlling—the head of the boy.

The rest of this episode is about the making of this inaugural episode of *Mellow Maromi,* interspersed with several nondiagetic insets hosted by a mini-Maromi who teaches us about the various staff roles as staff members are successively knocked off by Shōnen Batto. Unlike earlier attacks, however, the crewmembers are never shown actually being assaulted by Shōnen Batto. Each is simply shown with his or her head in pool of blood. What we do see is the ubiquitous image of Maromi ("The Healer Dog" as the promotional posters say) dominating the office space and Saruta burying his head into his Maromi *dakimakura* (huggable pillow) in a posture similar to his colleagues who have been whacked at their desks. In other words, Maromi—not the phantom Shōnen Batto—is what killed them.

> THE ANIME WITHIN THE ANIME IS ASSOCIATED WITH ESCAPE FROM THE BURDENS OF REALITY FACILITATED BY THE "SLEEPY-EYED" MAROMI, ITSELF A NARCOTIC IN ALL ITS MANIFESTATIONS: PLUSH TOY, HALLUCINATION, ANIME.

Episode 10 ends on an explicit staging of the issue of representation through media such as anime. After most of the staff is dead, the enraged and panicked Saruta kills the series production manager in the manner of Shōnen Batto and then gets whacked himself, apparently by Shōnen Batto, who, in time-shifted scenes that have been interleaved throughout the main narrative, has been pursuing Saruta's car as Saruta desperately tries—and fails—to deliver the *Mellow Maromi* tape to the studio on time. The all-important tape, however, survives. In an overhead shot in the night rain, we see Saruta splayed out on his back, (consuming) eyes and (consuming) mouth wide open and blood pooling around his head, hand still grasping the videotaped episode 1 of *Mellow Maromi.* A worried male voice out of the frame asks: "Is it OK?"—"Yes, it's okay!" replies a frantic female voice as the camera zooms in on the tape

that the woman takes from Saruta's dead hand. The tape is labeled in Japanese *Maromi Madoromi #1,* but it also has a number "10" on it, self-referencing episode 10 of *Paranoia Agent* that we are watching. As we watch the tape taken from Saruta's hand, the dialogue between the boy and Maromi from the opening of the episode continues before we cut to the two of them in the completed cartoon scene that was in the sketches of the opening:

BOY: "I have no talents" (*Boku ni wa sainō ga nai n da*)
MAROMI: "That's not true! I think you're just tired. Yeah, that's it! You
should take a rest. OK?" (*Sonna koto nai yo. Kitto kimi ga tsukarete irun da yo.
Kitto sō da yo. Yasunda hō ga ii yo. Ne?*)

Maromi then begins the same soporific chant, "Take a rest, take a rest, take a rest . . .," while climbing around the body and over the head of the boy. After the fourth iteration the camera zooms out as in the opening sequence, but this time to reveal the scene running on a laptop next to a Maromi *dakimakura* in a darkened workroom without workers—two desks have vases with a cut flower, apparently commemorating the deaths of their previous occupants. There's a quick cut to a box overflowing with extra Maromi pillows and then a close-up of a half-filled Maromi coffee cup between a pencil and part of an instruction sheet of scene retakes for *Maromi Madoromi #1* dated 19 April 2004, the original airdate for this episode of *Paranoia Agent.* All the while Maromi is chanting "*yasuminayō, yasuminayō, yasuminayō . . .*" The camera then moves to a ceiling position over the workroom before the scene suddenly switches off like a traditional CRT screen, nesting yet another visual frame of reference in a fashion that has become a trademark in Kon Satoshi's work (Figure 3).

This switch-off of the screen at the end of this episode—a simulation of our own switching off of the television or perhaps of a surveillance camera mounted on a wall near the ceiling of the workroom—makes all the difference in this repetition of the opening sequence. Whereas the zoom out in the opening places us in the site of production (the studio), the switch-off calls attention to the viewer-consumer/fan and the site of consumption (wherever we are watching this) and could be interpreted as a call to take a rest from anime (and consumption) itself—just turn it off because Mellow Maromi and its narcotic effect are dangerous. This paradoxical critique of anime within an anime is reinforced by the usual end theme and image immediately following. The multiple screens and framing in this episode emphasize that we live (and die) through layers of media and mediation that are complicit with networks

FIGURE 3. Framing the site of consumption and the fan's gaze. From episode 10, "Maromi Madoromi."

of consumption. The commentary that Kon develops crystallizes in the media figure of Maromi as monster, associated and on par with Shōnen Batto.

ALL-CONSUMING MEDIA

This identification of Maromi as a monster in league with Shōnen Batto is furthered in the next episode, "No Entry" ("*Shin'nyū kinshi*"), which begins with a TV program promoting the *Mellow Maromi* anime series, followed by rumors that Shōnen Batto has transformed, in the words of one character, into a true *bakemono*. In response to this anxiety, the entire population—save for a couple clear-headed observers—turns to the escapist comfort Maromi brings. As a result, by the following episode, Maromi has quickly saturated the media, markets, and minds of Tokyo, creating a fanaticism that is displayed in a series of quick cuts of TV reports, with us in the position of viewers of the various TV screens. One such scene is outside a record store where fans of the *Mellow Maromi* TV show, adorned with Maromi character-goods, are queued up to buy the CD of the series' hit song "Oyasumi" ("Goodnight"). In another, a mother, holding her son who is sporting a Maromi t-shirt and holding a Maromi plush toy, explains to the interviewer that "It's his favorite, our house has become full of Maromi" The composition, movement, and lines of sight in this four-second scene are revealing (Figure 4). The dark, disembodied microphone in the interviewer's hand anchors the center of the shot while the mother's opening and closing mouth moves into the frame as the camera pans up slowly at a slight angle from lower left to upper right. Besides the slow pan, her mouth is the only movement in the scene and is visually as well as functionally linked to the microphone. The scene cuts to the next news clip just before the pan reaches her eyes, reducing her to a moving mouth that seems eager to consume the microphone, the metonymy for the media in this scene. The eyes that we do see are those of her son, staring past the microphone and, we presume, up at the interviewer. At the same time, mouthless Maromi's oversized eyes are fixed squarely—and unnervingly—on the viewer, who is in a position not quite aligned with that of the interviewer. Their size and shape tie in visually with the microphone, underscoring the relationship already established between the media, Maromi as metaphor for consumption gone mad, the consumer-fans of Maromi, and we viewers as consumer-fans of this anime. It is a relationship of mutually reinforcing complicity that defines a world of media-driven consumer capitalism that, short of total catastrophic breakdown, appears difficult to extricate

FIGURE 4. The birth of a fan among mother, media, and character goods. From *Paranoia Agent*, episode 11, "Shinnyō Kinshi" ("No Entry").

oneself from once ensnared. The boy in this scene, literally wedged between the nurturing and overindulgent mother and his other object of comfort and desire, Maromi, is depicted as bewildered at the formative moment of entering this world as a full-fledged "citizen," born, if you will, between the mother and Maromi. Lost is the innocence of the favorite bedtime cuddle friend once that same figure transforms into a media monster and is experienced as such, worn as a t-shirt over the heart of the child whose mother is unwittingly and yet willingly giving him over to this world.

This rapid series of news clips occurs just as the identification of Maromi with Shōnen Batto is made explicit when the wife of Chief Detective Ikari—who was investigating the series of assaults, until forced to quit—tells her husband's partner, Detective Maniwa, about her confrontation with Shōnen Batto. In that conversation, Ikari's sickly wife explains that she was able to stand down the monstrous Shōnen Batto by telling him that: "he was the same as that sleepy-eyed dog." We learn through Maniwa's sleuthing that ten years ago, at the moment of entering pubescence, Tsukiko made up a story of a bat-wielding assailant to mask that her momentary inattention led to her puppy Maromi being killed. She has essentially recreated that childhood incident in an adult context when under job-related stress. When Detective Maniwa, in the persona of "Radar Man," calls Tsukiko and confronts her

with this truth, monsters of the past and present appear. Visibly disturbed, Tsukiko is "saved" from the trauma of the news by her Maromi doll, who cuts the telephone line and tells her not to think. But it is too late—the demon-like Shōnen Batto beats down the door and chases her. Just as he is about to strike her with his golden bat, Maniwa intervenes and transforms into a caped superhero with a magical sword to stave off the monster long enough for Maromi to lead Tsukiko through a pink (i.e., Maromi-colored) door floating in isolation in the middle of the room.

The door that Maromi takes Tsukiko through leads to an imaginary nostalgic Japan made of two-dimensional (superflat) paper cutouts, where the now down-and-out Ikari, having picked up a Maromi key fob, has been tempted to find solace. This is a place, says one of the cutout characters, where "Shōnen Batto never comes." At the beginning of the final episode—called "The Final Episode" ("*Saishūkai*")—Tsukiko and Maromi meet him there, again with the drowsy "Maromi's Theme" playing in the background (Figure 5).

In the meantime, in the real world, the sudden disappearance of Maromi items creates a panic as people are swept up by a black ooze now destroying Tokyo and Japan at large. The Shōnen Batto–turned-black-ooze physically and metaphorically envelopes and consumes media and consumers. Frustrated shoppers scream "We want Maromi"; pedestrians and train passengers are passively absorbed in their cell phones (a ubiquitous media device throughout the entire series); news media is a talking head in mid-broadcast; and—to drive the point home—a gangster changes the channel on the television set—where the medium literally spews forth the monster (Figure 6).

Tellingly, the first victim of the black ooze shown, in a scene near the end of the previous episode, is actually a cartoon doll–obsessed otaku, which enacts the narcissism at the core of the media-consumerism nexus Kon explores. The otaku has just completed his masterpiece: a toy figure of himself wearing a Maromi t-shirt. When he looks down at himself, however, he is shocked to see that the Maromi logo of his real t-shirt has transformed into what looks like a representation of his own bare chest. At that moment, the Maromi logo on the doll turns black, prefiguring the onslaught of the black ooze. In a panic, he stumbles onto the street where he is promptly struck with a wave of black ooze. The sequence brilliantly suggests the negative self-absorption that that shallow consumer culture can create (Figure 7).

When Maniwa radios Chief Ikari with his theory of the Maromi–Shōnen Batto connection, he appears to Ikari on a black-and-white TV screen in the nostalgic cutout world where Ikari and Tsukiko are still willingly trapped. He explains that emotional dependence on Maromi allowed the monstrous

FIGURE 5. The flatness of the nostalgic past. From *Paranoia Agent*, episode 13, "Saishūkai" ("Final Episode").

growth of Shōnen Batto and that only Tsukiko can put an end to the catastrophe. Ikari, rejecting Maniwa's plea to send Tsukiko back, destroys the TV set to spare his and Tsukiko's conscience of Shōnen Batto and the pain of the real world. The cutout people rejoice and Ikari is almost convinced to escape permanently in this imaginary world, until his ill wife (who has always been weak and just had a heart attack) appears there to remind him of their mutual devotion and the value of accepting the real world while working through its trials and tribulations together. With the memory of his words to her at a time of despair—"a makeshift salvation is nothing but deception"—and of the love they have shared together in life, he, when confronted with her dying, has his epiphany and, with a baseball bat, smashes the 2D set of the cutout world, thus escaping the escape. As the cutouts smash to pieces, they turn into multiple Maromi dolls. He has seen through the delusion that was society's own collective making.

TAKE TWO

In the climax of the series, the black ooze goes berserk, chasing down Ikari and Tsukiko as they flee. A giant Maromi temporarily obstructs the ooze from

ニュース速報

FIGURE 6. The medium is the monster. From episode 13, "Saishūkai."

FIGURE 7. Otaku consumed as his own object of desire. From episode 13, "Saishūkai."

reaching them, but then is filled to bursting by it and completes a blending with it, thus visualizing the union of Shōnen Batto and Maromi. Not until Tsukiko gives up the lie (she drops her Maromi plush toy, which transforms into her puppy) and takes responsibility for her puppy's death through an apology while enveloped in the ooze does it stop laying waste to the city. Ikari then emerges from the wreckage and says provocatively as he surveys the damage: "This is just like right after the war," suddenly raising the issues of Japan's war responsibility and victim consciousness, as well as suggesting the role of postwar consumerism in occluding an honest recognition of the past upon which present affluence has grown. Japan's postwar rebuilding of an affluent consumer society is alluded to in the final sequence, which points to a new beginning—take two—of the same cycle we just witnessed throughout the series. A TV broadcast announces the end of a two-year reconstruction of Tokyo, followed by a repeat of the opening scene of episode 1: people on cell phones, music players plugged into their ears, faces in newspapers, and eyes closed on trains. These images are accompanied by a montage of conversation fragments expressing various excuses and complaints, including a close-up of a text message that implies an ironic critique of the medium we are watching: "What? That's an anime, right? Can't we see something more like a normal movie?"

The apparent answer is no, as this sequence cuts to an animation on a jumbo screen: a cat yawning and waking up as pedestrians pass underneath. Tsukiko, in what looks like a school uniform despite her being twenty-two years old, stops to look up at it and then continues on. We see Ikari back as a construction traffic guard and the unsavory hack journalist, Kawazu, on a cell phone trying to hawk a story as usual. Our screen fades to white and then fades into what looks like the same mysterious old man who appears throughout the series writing characters and symbols in some kind of equation on the sidewalk. As in his first such appearance, the equation ends suspended with what could be construed as katakana for "a" and "ni," perhaps to end with "me." We then see that it is not the usual old man but Detective Maniwa, whose now-white hair, widening eyes, and perspiring face show shock and fear. Then it's cut to black and "Maromi's Theme." After the end credits the white-haired Maniwa appears for the usual interepisode "Prophetic Vision" in place of the old man from previous episodes. He stands on the moon with the Earth in the background, with his final words suggesting that it is all going to begin again.

I have suggested, in a twist on Marshall McLuhan's formulation of the relationship between "the medium" and "the message," that in *Paranoia Agent* the medium is the monster. That is, mediated extensions of self—depicted

conspicuously throughout the series by ubiquitous screens, phones, character goods, and anime itself—bring about unsuspected and unnoticed (until too late) transformations in society and among individuals (McLuhan's notion of the "message"). Media- and consumption-driven relations and identities as depicted in *Paranoia Agent,* induce self-absorption, delusions, and a misrecognition and devaluation—a flattening—of "real life." By the catastrophic climax of the series, the initial threat, a bat-wielding boy on inline skates striking desperate and pressured people, has metastasized through media networks into a full-blown monster who feeds on their unreflective consumption of the media that permeates them. Media that once provided individuals with leisure, information, and social connections become the source of discomfort and disconnection, feeding in turn a desire for immediate comfort-through-escape that is made manifest in the mania for the character Maromi. Shōnen Batto as monster, and Maromi as monster, are thus in a circular complementary relationship with the consumer-fan caught in its self-perpetuating vortex. The Maromi–Shōnen Batto monster encourages "sleep" (or unconsciousness or even death), where "sleep" is a figure of disengagement from the reality of adult society and the responsibilities that it entails. The result is a narcoleptic state where one falls down or is beaten down asleep. As the ending of *Paranoia Agent* suggests, this mass-produced monster deforms self and societal development, producing and reproducing another monster that can be seen as the spawn of Shōnen Batto (monstrous media) and Maromi (delusional consumption)—a society of otaku manqué, the result of the mass production of otaku but lacking the aura of the original.

..

Notes

1. *Mōsō dairinin,* dir. Kon Satoshi, TV series, 13 episodes (2004); translated as *Paranoia Agent: Complete Collection,* 4-DVD box set (Geneon, 2005).

2. Miyadai Shinji, *Seifuku shōjo tachi no sentaku* (The choice of the uniformed schoolgirls) (Tokyo: Kōdansha, 1994), 231–74.

3. Marshall McLuhan, *Understanding Media: The Extensions of Man* (Cambridge, Mass.: The MIT Press, 1994), 7.

4. Murakami Takashi, "Superflat Trilogy: Greetings, You Are Alive," in *Little Boy: The Arts of Japan's Exploding Subculture,* ed. Murakami Takashi (New Haven, Conn.: Yale University Press, 2005), 161.

5. That the onset of Tsukiko's first period is, in a sense, at the source of the problem deserves further questioning: What does it mean to have this gendered and rather charged incident—trauma—surround the original deception and genesis of Shōnen Batto? Does Tokyo deserve to be destroyed because of a girl's natural reaction to a menstrual cramp?

KERIN OGG

• • •

Lucid Dreams, False Awakenings: Figures of the Fan in Kon Satoshi

FATAL BUT NOT SERIOUS

"*Rear Window, Strangers on a Train, Psycho*—they're all wonderful films, sir, but when in the world are you going to get serious and do something animated?"

Entertaining as the reply surely would have been, it is hard to imagine an interviewer posing that question to Hitchcock. More's the pity: a director with a reputation for storyboarding and controlling his films down to the last detail might have found a natural home in what Howard Beckerman characterizes as "the least spontaneous of the arts."[1] What we are far more likely to see is the opposite question, one frequently put to anime director Kon Satoshi, here paraphrased: "You are a critical and commercial hit in Japan and abroad, you have world-class production capabilities and resources at hand with Madhouse studio, and you do things with animation that challenge long-held assumptions about the uses to which animation can and should be put. So you're going to start putting real people in front of the camera soon, right?"

As much as this attitude raises hackles among animation fans, it is understandable given lingering prejudices against animation as a serious art form, especially in the West. There is also the unavoidable fact that most of Kon's

157

films have a markedly "realistic" look: the action takes place against photorealistic backgrounds, movement is weighty and credible even when not perfectly fluid, and characters as a rule have normally proportioned bodies and faces. Kon sometimes underscores the contrast between his style and the "industry standard," most famously in the video store scene in *Perfect Blue* (1997) that juxtaposes Kirigoe Mima's fans with the Technicolor-haired, big-eyed anime girls seen on posters and cassette boxes.[2] While it is difficult to imagine Kon's outstanding use of trompe l'oeil effects being as persuasive in live action, it is not inconceivable, particularly given the state of modern CGI.

There may be another factor at work here, one not much remarked on but important: the obvious interest in and fondness for live-action cinema pervading Kon's entire body of work. Even when film is not Kon's main subject, his films are intimately engaged with the medium, often depicting the filmmaking process or commenting on our relationship to the movies as both individual viewers and participants in movie culture. Most famously, *Millennium Actress* (2001, *Sennen joyū*) celebrates and reflexively critiques the golden age of Japanese filmmaking, full of tributes to popular genres like *jidaigeki*, family drama, and giant-monster films, all framed by the making of a documentary that literally and figuratively depicts actress Fujiwara Chiyoko's "life in the movies."[3] On a smaller scale, Kon's debut work, *Perfect Blue,* uses the filming of a television serial as the vehicle for Mima's transformation from idol to actress, and even the relatively straightforward *Tokyo Godfathers* (2003) has Gin's repeated refrain that he, Hana and Miyuki are "homeless bums, not action movie heroes."[4] Most recently, *Paprika* (2006) opens with unambiguous nods to *Roman Holiday* (1953), *From Russia with Love* (1963), the Tarzan series, and DeMille's *The Greatest Show on Earth* (1952), all found in the unconscious mind of would-be filmmaker turned police detective Konakawa Toshimi.[5]

While these references serve a higher purpose in the film than mere winking in-jokes, it does not change the fact that they *are* winking in-jokes, little love letters to all the avid movie watchers in the audience that yield a pleasant frisson of recognition when we spot the reference. Kon has confirmed his cinephilia in multiple interviews, describing Western films as especially influential (perhaps not surprisingly, he commonly cites Kurosawa Akira as a favorite director).[6] Tellingly, Kon describes his collaborative process with his first screenwriting partner, Murai Sadayuki, as centered around film viewing: "It was fun, and we ended up watching a lot of movies together, with movie scenes and shots becoming our mutual language."[7]

Given all that, it is not surprising that Kon gets asked when he will leave the ink-and-paint ghetto and move into "real" moviemaking. But even those

FIGURE 1. Three of Kon's "biggest fans": movie lover Paprika, anime/manga otaku Kamei, and detective-turned-paranoia-phile Maniwa. *Top: Paprika,* directed by Kon Satoshi (Sony Pictures, 2007). *Center and bottom: Paranoia Agent,* directed by Kon Satoshi (Geneon Entertainment [USA], 2004–2005).

of us who pride ourselves on "knowing better" might start to wonder about that, if we consider how animation and animation fandom are portrayed in Kon's films. The references to his chosen medium are few and almost universally negative. Among the cast of the TV series *Paranoia Agent* (2004, *Mōsō dairinin*), for instance, is the stereotypically overweight, bespectacled otaku Kamei Masashi, whose apartment is as crammed full of *bishōjo* figures as his front porch is littered with trash bags.[8] Kamei's t-shirt pegs him as a fan of the heavily merchandised mascot character Maromi, an analogue to Tarepanda—in other words, another droopy little creature.[9] Viewers familiar with mainstream anime of the last decade will find direct references to *Love Hina* (2000), *To Heart* (1999), *Battle Athletes* (1997–1998, *Battle asuriitesu daiundōkai*), *Gate Keepers* (2000), and *Hand Maid May* (2000) among his figure collection, while nearly every poster seen depicts the *Di Gi Charat* (1998–present, *De Ji Kyaratto*) characters created by Koge-Donbo, adopted as the heavily merchandised mascots for the Gamers chain of anime and manga stores.

If the references in *Paprika* were love letters, the references in *Paranoia Agent* are letter bombs, any thrill of recognition quickly short-circuited by Kamei's disturbing behavior. In one of his first appearances, the otaku ignores the prostitute in his bed postorgasm to congratulate *his figure collection* on helping him get off. Late in the series, he appears so absorbed in making a new model that he fails to notice he has a visitor, while his suddenly animate figures complain that Kamei is "just a doll" who can do nothing unless they are watching him. Further, while aware of an approaching catastrophe, these PVC princesses are powerless to intervene because "look who we have for a master." In a testimony to Kamei's narcissism, the last figure he finishes before being swept up in the series' apocalyptic finale is of *himself*. Taken together, it is among the most damning and direct criticism Kon and screenwriter Minakami Seishi level in the series, only slightly removed from Dr. Chiba Atsuko's angry denunciation of a similarly obsessive colleague in *Paprika*, delivered almost straight into the camera:

> You get preoccupied with what you want to do, and ignore what you have to do. Don't you understand that your irresponsibility cost lives? Of course not. Nothing can get through all that fat. . . . If you want to be the king of geeks (*otaku no ōsama*) with your bloated ego, then just keep up all this and indulge in your freakish masturbation!

Animation production does not come off any better. To be sure, episode 10 of *Paranoia Agent* depicts the staff working on the diegetic *Mellow Maromi*

(*Maromi madoromi*) television series in a knowing and sympathetic way, gently ribbing the personnel while communicating their general competence and professionalism. The process, on the other hand, is depicted in a fashion as far removed from the paeans to filmmaking in Kon's other works as could be imagined. Here, animation production is essentially an assembly line process, impersonal work rather than an opportunity for artistic endeavor. (The only

> IF THE REFERENCES IN *PAPRIKA* WERE LOVE LETTERS, THE REFERENCES IN *PARANOIA AGENT* ARE LETTER BOMBS, ANY THRILL OF RECOGNITION QUICKLY SHORT-CIRCUITED BY KAMEI'S DISTURBING BEHAVIOR.

thing the staff seems passionate about is their mutual hatred for a particularly incompetent production manager.) The studio literally kills itself to get the show on air, each staff member just finishing their task before their visit from *Paranoia Agent*'s deadly stress reliever, Shōnen Bat ("Shōnen Batto" in Japanese, known as "Lil' Slugger" in the English dub). Throughout the episode Maromi offers helpful but bleak assessments of the various positions, putting emphasis on stresses and ailments peculiar to each: the producer "seems to suffer from constant stomachaches," while the episode director is "the most likely to end up with beard stubble." These asides suggest that, while the bloodbath we see is unique to the *Mellow Maromi* project, the hellish working conditions are actually close to the norm.[10]

Anime fans might at least take solace in the fact that they are not alone: virtually no hobby or area of interest apart from film going seems to get Kon's implied stamp of approval. With few exceptions, characters whose backgrounds include fannish pursuits are portrayed as deluded, childish, isolated, irresponsible, sometimes violent, and often monstrous in appearance. Even the Greek choruses in *Perfect Blue* and *Paranoia Agent* that critique the viewing/consumption habits of others pointedly refrain from examining their own,[11] which, as Susan Napier points out, have the very same disturbing implications.[12] It may be some cold comfort that these fan characters are more often victims than villains (although the special quality of victimization in *Paranoia Agent* problematizes this).

During a recent Q&A session at New York's Lincoln Center, Kon commented[13] that he would have been considered an otaku himself during his high school days,[14] and added that he is far less critical of his modern-day counterparts than his films might suggest.[15] When we explore the apparent contradiction that emerges in Kon's works between the all-but-unquestioned good of live-action cinephilia and the wretched excesses of any other form of otakudom, we find a number of surprising things, chiefly a tendency to

flatten expected hierarchies of artistic value rather than support them and a critique of hardcore fans that forces us to ask what function such negative portrayals of otaku might ultimately serve.

RESISTANCE IS FUTILE:
WE ALL DREAM IN PANFOCUS

While Konakawa's journey from cinephobe to cinephile frames *Paprika,* it is the titular heroine who appears the true film fanatic, her characteristic sly-ness giving way to unabashed enthusiasm whenever the subject of movies comes up. A more flattering (self-)portrait of the cinephile would be hard to imagine: clever, vivacious, physically attractive, and charming, Paprika is also the film's central and most powerful character. If she seems to have neither an encyclopedic knowledge of film history à la *Millennium Actress*'s Tachibana Gen'ya or Konakawa's (disavowed) knowledge of filmmaking technique, her love of the movies is presented as unpretentious and sincere.

Despite the repeated stress on Paprika as movie lover, her ability to change into fictional characters and archetypes is hardly limited to film. In fact, she makes use of specifically cinematic tropes only in connection with Konakawa.[16] At other times, she draws on a range of sources including West-ern fairy tales (her turns as Pinocchio and the Little Mermaid), Eastern legends (Son Gokū), and classical Greek drama (the Oedipal Sphinx). Con-sider, too, *Paprika*'s bravura title sequence, which has the heroine moving merrily not through films, myths, or literary classics but through *advertise-ments and logos*: the graphic on the side of a truck, billboards, the design on a boy's t-shirt, and so on. Later in the film, Paprika uses ads to navigate the dream-besieged Tokyo. Whether leaping headlong into an actual illustration or rendering a nonvisual source physically upon her person (as costume or metamorphosis), Paprika engages with all media as *images,* with no image off limits to her inventive repurposing. A similar point could be made apropos of *Millennium Actress*: fragments of Chiyoko's movies appear according to their ability to illustrate a moment in Chiyoko's narrative of her life, with personal relevance the chief determinant of their place in her reconstruction.[17] Kon and Murai never allude to these films-within-the-film's relative artistic merit or public reception.[18]

Millennium Actress leaves ambiguous how much of what we see is Chi-yoko's metaphorized personal history and how much the plots of her films. By contrast, the very iconicity of the "clips" in Konakawa's dream makes it

difficult for the viewer to mistake them for actual events—*although that's exactly what the detective's unconscious mind appears to have done*. More precisely, it draws no distinction between memories of real life and memories of film as suitable raw material for dream production. In this way *Paprika* crystallizes an idea that runs through all of Kon's work: modern man is saturated by and exists through media; his mental landscape is a pastiche of movies, ancient myths, literature, television programs, memes, and images. Not merely an adjunct to human existence that we consume, stories also consume us, populating the mind and structuring our very interface with memory and reality.

Paranoia Agent explores the idea thoroughly, across multiple characters and episodes, but with a decidedly negative bent. Kamei is a relatively minor example; more salient cases include Shōnen Bat–wannabe Kozuka Makoto, a junior high school videogame freak who seems to perceive his violent assaults as one more level in his favorite game, and crooked cop Hirukawa Masumi, whose dealings with the mob, extortion schemes, and theft are juxtaposed ironically with the clichéd "code of honor" on display in the *seinen* (adult men's) manga he reads.

And then there's Shōnen Bat, in part an urban legend come to life. The phantom assailant made up by character designer Sagi Tsukiko gets picked up and spread by sensationalist media, then eagerly swallowed up by a public desperate for distraction from the pressures, mundanity, and anxieties of everyday life. From a slightly different perspective, one alluded to by their constant visual linkage, Shōnen Bat is also the new character Sagi's boss pressures her to create as a follow-up to Maromi. His genesis in the first episode subtly parodies the birth of such a character: Sagi generates an initial concept during her interrogation by the police, brainstorming Shōnen Bat's basic appearance as she sketches (Figure 2). The mass media promote and market her general description, and the public consumes and spreads the product. As if testifying to Sagi's skill in character creation, Shōnen Bat is soon as wildly successful as Maromi, with fan-victims piling all over Tokyo until the city—if not the world—is in jeopardy.

Curiously, though, Kon presents Shōnen Bat's creation in two parts. In the first, he has Sagi give only a rough outline of Shōnen Bat's appearance. Her sketch is a faceless silhouette, and she provides just a few details to the detectives: the assailant is a grade-schooler, he carries a metal bat and wears golden inline skates, and so on. In the second part, other key visual qualities like Shōnen Bat's dress, strange smile, and the bend in his bat are added—but not by Sagi. Instead, the figure's evolution from dark, featureless form to the finalized Shōnen Bat juxtaposes each new detail with an ordinary,

anonymous person saying they "heard that" Sagi's assailant looked like X or does Y (Figure 3). Significantly, it is only after this scene that the viewing audience sees Shōnen Bat within the episode itself (that is, outside the opening credits). The implication is that the public at large, the diegetic audience within *Paranoia Agent,* is directly complicit in Shōnen Bat's creation, reinforcing the received narrative if not actively embellishing it. Where they have *complete* responsibility is in transforming Sagi's ordinary (imaginary) criminal into a quasi-supernatural presence that can appear to anyone, anywhere, at their time of greatest stress and provide relief (of a sort).

Far from being passive consumers, then, the public actively shapes and refines the very notion of Shōnen Bat, completely repurposing the figure to fit their needs. While there's little formal difference between this appropriation process and the one carried out by the leads of *Millennium Actress* and *Paprika,* here it has apocalyptic consequences. Once again the split between positive and negative portrayal seems to break down along film/nonfilm lines; it also suggests the divide between Ōtsuka Eiji and Azuma Hiroki's models of media consumption in the postmodern age.[19] To really get a sense of what distinguishes one kind of fan from the other, though, let us turn to the one

FIGURE 2. The creation process, part one: Sagi's original sketch of her assailant. From *Paranoia Agent.*

character who during the course of *Paranoia Agent* effectively represents both poles: the tragicomic figure of Detective Maniwa Mitsuhiro.

I REJECT YOUR REALITY AND SUBSTITUTE MY OWN: THE RISE AND FALL OF RADAR MAN

When *Paranoia Agent* begins, Maniwa is not notably eccentric or obsessive about anything, although his style of investigation is markedly odd when compared to that of grizzled veteran Ikari Keiichi. The difference emerges readily in the Kozuka interrogation: Ikari grows frustrated with the teen blithely going on about his favorite video game and orders him to get to the facts, while Maniwa encourages the boy to continue, consults the game's strategy guide, and even assumes the guise of "Maniston the Wandering Minstrel" to assist Kozuka in his storytelling. The rightness of this approach is immediately apparent to viewers, since the game characters that appear

FIGURE 3. The creation process, part two: the public embellishes/appropriates Shōnen Bat. From *Paranoia Agent.*

onscreen are thinly disguised versions of other *Paranoia Agent* characters. At the end of the interrogation, Maniwa follows up on "Holy Warrior" Kozuka's insistence that "an old woman of the Mi Jot tribe" knows the true form of game villain "Gōma," leading the detectives straight to the only person who witnessed Sagi's attack and can corroborate Shōnen Bat's appearance.[20]

This openness is typical of Maniwa's method throughout the series, its key feature a radical receptiveness to any and all potential sources of information, however tangential or even nonsensical they may at first seem. At various times Maniwa participates in online forums and short-wave radio networks where Shōnen Bat is a frequent topic of conversation, drawing on and contributing to the pool of collective knowl-

> GOING BEYOND HIS INITIAL DETACHED PROFESSIONAL INTEREST, THE DETECTIVE BECOMES AN OFF-HOURS HOBBYIST STUDYING ALL ASPECTS OF THE SHŌNEN BAT PHENOMENON, WHICH TURNS TO ALL-CONSUMING OBSESSION AFTER HIS AND IKARI'S OUSTER FROM THE FORCE.

edge. He comes to rely heavily on visions and dreams he experiences, where the words and actions of a mysterious white-haired old man (the "Ancient Master") seem to hint at cosmic-scale enigmas connected to Sagi's assailant. In the penultimate episode, following one of the Ancient Master's typically elliptical clues, Maniwa thinks nothing of chasing after one of Kamei's bunny girl figures when she appears before him in a shop window. All this is more than a little reminiscent of *Twin Peaks'* unconventional investigator Dale Cooper, and of the tendency of both that agent and that series to engage in what Angela Hague calls "infinite play": the dissolving of boundaries and rules within a game to expand the field of play and continue the game into perpetuity.[21]

It is also an approach that seems to anticipate *Paprika*, herself more of a "dream detective" than the "dream movie star" Konakawa suggests.[22] Although his repertoire is extremely limited by comparison, Maniwa can likewise assume costumed personas representing certain media tropes to aid in his investigation. In addition to the aforementioned "Maniston," he adopts the crimson mantle of "Radar Man," a caped superhero whose preternatural abilities allow him to hold his own in battle with increasingly monstrous manifestations of Shōnen Bat. In their final confrontation, Radar Man wields a literal "sword of truth" against the beast—to no avail, since Shōnen Bat swats him aside as if he were a gnat. It is an unceremonious kibosh on what had been the detective's moment of triumph, when he announced

to a stunned Ikari and Sagi that Shōnen Bat and Maromi are two separate manifestations of Sagi's disavowed and repressed guilt over a long-forgotten childhood accident for which she refused to accept responsibility. (Phew!)

The finale of *Paranoia Agent* backs up Maniwa's conclusions, so why does his attack fail so spectacularly? Consider the structural similarity of this scene to *Perfect Blue*'s climax: in both cases the mystery is ostensibly solved, yet the phantasm that has been menacing the main character remains and continues its ruthless pursuit. This refusal to give up the ghost—or rather, for the ghost to give up—at the proper time points to the inability of mere factual truth to resolve the heroines' psychological instabilities, e.g., simply identifying the ringleader(s) of the real-life harassment campaign against Mima fails to address her interior struggle to maintain her identity.[23] Sagi's case is slightly different: here, the "official solution" directly addresses her neuroses and could therefore be effective, but success depends on her internalizing and accepting it as true.

Given that he all but uses the phrase "return of the repressed" to describe the Sagi/Shōnen Bat/Maromi connection, that kind of layman's psychology should be well within Maniwa's grasp. It should be obvious to him that neither shouting the truth at Sagi nor charging the monster with a "sword of truth" will work. The question is therefore not why the attack fails but why Radar Man turns and attacks in the first place. The answer is as simple as it is counterintuitive: *this the only way he can prolong the existence of Shōnen Bat*. For Maniwa is himself an otaku, identified by a computer network address as "otaku.mousou.para," which we might render in any number of ways: "otaku.delusion.paranoia," "hardcore fan of delusion and paranoia," and so on. Going beyond his initial detached professional interest, the detective becomes an off-hours hobbyist studying all aspects of the Shōnen Bat phenomenon, which turns to all-consuming obsession after his and Ikari's ouster from the force.

The monster's appearance before him in the final episode is therefore the culmination of all Maniwa's activity. His entire existence has collapsed down to this single point; therefore, to tackle the problem in any truly effective way would dismantle his entire world. Notice how the fear and anxiety on exhibit during his solitary investigations immediately give way to the smug and cocksure Maniwa of the early episodes once he finally has a chance to reveal the fruit of his labors to an audience. In this light, even his purpose in revealing Shōnen Bat's origin becomes ambiguous: is this a policeman following his duty through to the end, or simply a show of mastery, of knowledge? The second half of the series sees the increasingly unkempt Maniwa

wandering the streets with a blanket tied around his neck, the real face of "Radar Man" and an indication of just how much the detective's self-image depends on the existence of Shōnen Bat (Figure 4). What guarantees his perception of himself as clever, authoritative, and powerful is the very monster he seeks to destroy.

Faced with the possibility of losing the object of his obsession and the very lynchpin of his identity, Maniwa opts to leave reality behind and live the fantasy. It is no accident that the monster does not merely absorb him, as it does everyone else in Tokyo, but *strikes* him, making Maniwa Shōnen Bat's final victim. In *Paranoia Agent*'s concluding scene, a near mirror of the series opener, Maniwa takes the place of his now-deceased Ancient Master in the mysteries surrounding the self-reinforcing feedback loop of anxiety and avoidance that culminates in the violent appearance of Shōnen Bat. The detective has all but disappeared; this newly white-haired Maniwa stares the same blank-eyed stare as the old man and uses only slightly less elliptical language. By the (dummy) preview of the next episode he is barely recognizable as himself, a pathetic figure made doubly so by his promise of endless mysteries in episodes yet to come *when there are no more episodes left*. The

FIGURE 4. Four faces of Maniwa: detective, otaku, Radar Man, and the new "Ancient Master." From *Paranoia Agent*.

result of collapsing all distance between himself and his obsession is self-annihilation.[24] Radar Man's leap is a suicidal plunge (Figure 4).

WHY DO YOU SEE THE *MOE* IN YOUR BROTHER'S EYE BUT FAIL TO NOTICE THE BEAM SABER IN YOUR OWN?

One other rendering of "otaku.delusion.paranoia" to consider might be the "hardcore fan of *Paranoia Agent*"—not much of a stretch given the almost metafictional character of Maniwa's investigation. Viewers familiar with Kon come to the series expecting that it too will unfold in the genre of the fantastic[25]—that is, the strange goings on will never be accounted for by exclusively natural (uncanny) or supernatural (marvelous) explanations.[26] Consequently, we identify Maniwa's frenzied pursuit of both courses at once as the correct approach, even as or perhaps *because* he appears increasingly unhinged. (That just means he is getting close!) We share his skepticism of Ikari's skepticism, since Kon would *never* go for a purely mundane solution. "Following each stepping stone and connecting the dots, you will find an eternally recurring phantasmal castle"—Maniwa's final remarks, delivered straight into the camera, acknowledge our identification with the detective, which by this point is obviously somewhat uncomfortable.[27]

Still, he was *right*. Significantly, it is only after Maniwa's revelations that Sagi's characteristically blank expression begins to crack, the first sure sign of her breakthrough. This is hardly a unique case: contrary to the stereotype of the geek possessing stores of useless trivia, Kon's fan characters often provide the key information, insights, and eye-opening new perspectives needed to resolve the plot. We could point to the gossiping housewives of *Tokyo Godfathers* and *Paranoia Agent,* or *Paprika*'s Dr. Tokita (he of the "freakish masturbation"). Who is it but Chiyoko's biggest fan who presents her with the literal key to unlock her memories?

But mobilizing those kinds of insights in other contexts requires, obviously, awareness that there *are* other contexts. On the surface, *Paranoia Agent* would seem to suggest that what divides "good" fans from "bad" in Kon's universe is not what a person is, what he/she is a fan of, but whether or not they remain connected to reality at large. The common thread among fans portrayed negatively is that they use entertainment and hobbies as a way of escaping real-world problems; they shirk their responsibilities and drop out of the community. By contrast, Kon's cinephiles never (or rarely) let the real

world sink below the horizon of their interests. Paprika is emblematic: her real "superpower" is not that she can move through dreams but that *she is always aware of being in one*. She maintains a distance between her identity and the poses she strikes, and that allows her to utilize a seemingly infinite collection of myths, legends, and media tropes according to the needs of the moment. Characters like Tachibana and (eventually) Konakawa demonstrate that it is possible to pursue one's fannish interests, be a fully engaged participant in society, and stay healthy. The ideal position therefore seems be a kind of "distanced fanning": given that you are already saturated through and through with fictions of all stripes, and that even the lowest of low art may yield something useful beyond its sheer entertainment value, feel free to follow your passions—just do not lose yourself, and do not shut out the real world.

If "everything in moderation" sounds like a suspect moral from a director so given to collapsing the reality/fantasy barrier in ever more spectacular and bombastic ways, it should. While Kon's cinephiles appear uniquely able to strike a responsible balance between their hobby and "real life," they are also uniquely prone to small gestures of shame and embarrassment when they're "found out" as film fans. They only appear completely at ease with that side of themselves when they have symbolically withdrawn from the public sphere. It is as if acknowledging that they really ought to be ashamed of their deep interest in film is the price for not being lumped in with the likes of Kamei—and that possibility is not far off. If guilt-free access to enjoyment in general is the price of admission to "reality"—that is, socially constructed reality, the intersubjective network in which we exist, Lacan's "symbolic order"/"big Other"—then the ability to "fan freely" is likewise sacrificed. The seeming exception to the rule, Paprika, only bolsters it further: her near-confinement to dreams and nonidentical relationship to her waking-world counterpart Atsuko (a split subject if there ever was one) all but confirms her brand of unashamed, blissful immersion in her pursuits is impossible in the real world.

Perhaps this is why Atsuko claims she herself is unable to dream: Paprika's infinite pleasure comes at the other woman's expense. In Kon's films and elsewhere, the hardcore otaku functions a kind of "other of the Other," one who finds complete fulfillment precisely by draining us of our rightful pleasure. Refusing to abide by the un/written rules the rest of us live by, this figure also causes all manner of social ills. If this all sounds like a roundabout way of saying "the otaku is a scapegoat," that is because it is: the other of the Other conceals the flaws and structural deadlocks inherent in the system that

actually frustrate our desires. Rather than a real impediment to a smoothly functioning social order, it is a *structurally necessary fantasy* without which this "reality" would collapse.[28]

The tendency of Kon's plots to hinge on knowledge only otaku could produce/synthesize might therefore be understood as indicating these blind spots in the social edifice, mirroring Azuma's point that, while otaku may not be more self-consciously *aware* of shifts and changes in the zeitgeist, they do "most sensitively [register]" them.[29] Moreover, Kon deploys the straw-otaku in such a way that every pathology attributed to the stereotype is ultimately revealed as commonplace. By not rehabilitating or fully humanizing the otaku, the director all the more effectively dismantles the last defense of the nonfanboy audience against critical analyses of their own position (namely, "but I'm still not as bad as those [insert stereotypical trait] otaku . . ."). And given Kon's basic premise that our minds are always already saturated by fictions of all stripes, and that every one of us consciously and unconsciously uses those memes and tropes, it is hard *not* to see the danger of such an unreflective spectatorship.

> IF "EVERYTHING IN MODERATION" SOUNDS LIKE A SUSPECT MORAL FROM A DIRECTOR SO GIVEN TO COLLAPSING THE REALITY/FANTASY BARRIER IN EVER MORE SPECTACULAR AND BOMBASTIC WAYS, IT SHOULD.

WE HAVE MET THE ENEMY, AND HE IS ~~OTAKU~~ US

If there is a more pathetic sight than the underlying reality of Radar Man, it is the helplessness of the ordinary Tokyoites swallowed up by the Shōnen Bat monster—that is, by their own creation. Repeating *Paranoia Agent*'s opening scene at the end of the series underscores who's really responsible for bringing the apocalypse down on everyone's heads . . . and their continued obliviousness to it. Kon shows the world post–Shōnen Bat to be virtually unchanged: people still run from responsibility, find ways to isolate themselves even in overcrowded railcars, and distract themselves with the Maromi-like Konya the cat. As an assessment of society as a whole, it is bleak, but for that very reason animation fans may find something to grin about as a girl taps out a text message reading "What? That's an animation, right? Can't we see something more like a normal movie?" It is a rare vindication of the medium from Kon, a small encouragement for otaku, and perhaps a sign that those who take their entertainment more seriously than most have a leg up.

Notes

1. Howard Beckerman, *Animation: The Whole Story,* 2nd ed. (New York: Allworth, 2003), 152.

2. *Perfect Blue,* dir. Kon Satoshi (1998); subtitled DVD (Manga Entertainment, 2000).

3. *Sennen joyū,* dir. Kon Satoshi (2001); translated as *Millennium Actress,* subtitled DVD (DreamWorks Video, 2003).

4. *Tokyo Godfathers,* dir. Kon Satoshi (2003); subtitled DVD (Sony Pictures, 2004).

5. *Paprika,* dir. Kon Satoshi (2006); subtitled DVD (Sony Pictures, 2007).

6. Kon Satoshi, "Comments from Interview with DreamWorks DVD Producer," *Millennium Actress* (official Web site), http://www.millenniumactress-themovie.com (accessed April 18, 2005). The site is no longer available, but this and other press kit materials are widely available online. See http://www.dvdvisionjapan.com/actress2.html (accessed 5 January 2009).

7. Kon Satoshi, "Interview with Kon Satoshi, Director of *Perfect Blue,*" *Perfect Blue* (official Web site), http://www.perfectblue.com/interview.html, September 4, 1998 (accessed April 18, 2005).

8. *Mōsō dairinin,* dir. Kon Satoshi (2004); translated as *Paranoia Agent,* four subtitled DVDs (Geneon Entertainment [USA], 2004–2005).

9. Tarepanda is a character created by Suemasa Hikaru and licensed by San-X. As the name implies, Tarepanda is "lazy," "droopy," or "slouched" in appearance. The character's incredible popularity on its introduction in 1995 has been linked to anxieties over the Asian financial crisis of 1997. In the words of Sone Kenji of San-X, "Many office workers felt exhausted thinking about the dark cloud hanging over the economy, which had grown unhindered until that time. I guess they saw a little bit of themselves in the worn-out panda character, so they were sympathetic toward it." See Hamashima Takuya, "Stressed out? You Need 'Virtual Healing'!" *Yomiuri Shimbun,* November 27, 1999, 7.

10. For a sense of the actual working conditions on *Paranoia Agent,* see the "Paranoia Radio" roundtable discussion between Kon, Minakami, and Toyoda Satoki on *Paranoia Agent* DVD, volume 4.

11. A group of schoolboys in *Paranoia Agent,* for instance, seem perceptive enough to grasp that the hand-wringing over violent video games is overblown and mock anyone who can't distinguish between games and reality as a "loser." Within the same episode, however, the trio eagerly trade the latest rumors about Shōnen Bat, helping to spread the phenomenon.

12. Susan Napier, "'Excuse Me, Who Are You?' Performance, the Gaze, and the Female in the Works of Kon Satoshi," in *Cinema Anime,* ed. Steven T. Brown (New York: Palgrave Macmillan, 2006), 32.

13. Kon Satoshi, "Conversation with Satoshi Kon" (discussion with Q&A, Film Society of Lincoln Center, New York, June 27, 2008). From notes taken by author (no transcript available).

14. In his profile for the Japan Media Arts Plaza, Kon mentions a particular fondness at the time for manga by Katsuhiro Otomo, the "comic new wave" and girls' (*shōjo*) manga. He claims to have been reading the latter "all the time," adding, "I devoured everything

from Sh[ū]eisha and any other publishers." Kon Satoshi, "2001 Japan Media Arts Festival Animation Division Grand Prize Millenial [sic] Actress," Japan Media Arts Plaza, http://plaza.bunka.go.jp/english/festival/2001/animation/000372/ (accessed April 18, 2005).

15. In another interview, the director cites film, animation, and video games as legitimate ways of dealing with pent-up frustrations, adding, "To say sports are the only healthy way to release stress is a form of discrimination." Kon Satoshi, "Interview with Satoshi Kon," Gamestar, http://www.gamestar.com/11_04/pause/pause_disc_satoshikon.shtml, 2004 (accessed October 23, 2006).

16. This ought to give us pause. Like her waking-world double Dr. Chiba, Paprika is a psychoanalyst of sorts, and her current case involves a client who "dreams in pan-focus" but exhibits a visceral discomfort with movies. Having discovered this telling contradiction and resistance, is she exaggerating her fondness for film in an effort to unearth a repressed trauma? The film begins with Konakawa's cinematized dream, i.e., with Paprika's analysis already underway, and closes with the detective purchasing tickets to a movie, so there is no neutral point outside this arc when Paprika might declare a love of film and remove all doubt. Nothing in the film directly suggests she's being disingenuous, and I personally find it difficult to view it all as a cynical pose, but it's an interesting possibility.

17. Murai: "I wanted to intertwine fragments of Japanese history with the story of [Chiyoko's] life. In terms of craftsmanship, I wrote the screenplay underscoring the fact that she is the one telling the story. In other words, what she is telling is more significant than how the actual events took place." Kon Satoshi and Murai Sadayuki, "A Conversation with the Filmmakers," *Millennium Actress* (official Web site), http://www.millenniumactress-themovie.com (accessed April 18, 2005). This official site is no longer available, but this and other press kit materials are widely available online. See http://www.dvdvisionjapan.com/actress.html (accessed January 5, 2009).

18. The *Chiyoko: Millennial Actress Special Edition* guidebook is similarly mum about the artistic qualities of Chiyoko's films but does sometimes note commercial success. Madhouse, *Chiyoko: Millennial Actress Special Edition* (Tokyo: Kawade Shobo Shinsha, 2002).

19. Azuma succinctly describes both in "The Animalization of Otaku Culture," *Mechademia* 2 (2007): 175–87; see also Azuma's *Otaku: Japan's Database Animals,* (Minneapolis: University of Minnesota Press, 2009), particularly 29–54. The simultaneous spread of Maromi and Shōnen Bat is oddly similar to the proliferation of characters resembling Rei Ayanami post-*Evangelion* as described by Azuma in *Otaku,* (49–53), although it would be difficult to discern a shared "*moe*-element" between Kon's characters.

20. Perhaps not coincidentally, the first suggestion that the old woman may be a valuable witness comes from Kamei.

21. Angela Hague, "Infinite Games: The Derationalization of Detection," in *Full of Secrets: Critical Approaches to Twin Peaks,* ed. David Lavery (Detroit, Mich.: Wayne State University Press, 1995), 130.

22. Kon also depicts both Maniwa and Paprika falling headlong through a blue sky toward earth, the former in the *Paranoia Agent* opening and the latter when she enters Himuro's dream to rescue Tokita. The difference between Paprika's controlled descent and Maniwa laughing madly is telling, however . . .

23. In this way Kon thoroughly subverts the usual workings of the mystery genre, in which the "official solution" papers over the underlying libidinal economy connected to

the crime—hence perhaps the odd feeling at the end of *Perfect Blue* that Mima really has gotten away with murder. See Slavoj Žižek, *Looking Awry: An Introduction to Jacques Lacan through Popular Culture* (Cambridge, Mass.: MIT Press, 1991), 57–59. A case could easily be made, using Žižek's distinction between the two major genres of detective story, that *Perfect Blue* is more a hardboiled than a classical mystery.

24. See also Mima's stalker Uchida, who goes by the online handle "Me-Mania" and vaguely resembles Mima with his long hair; likewise Rumi, particularly at the end of the film.

25. And Kon is aware of his audience's expectations: "I think blurring the lines of reality and fantasy is an interesting technique. Since using it in my debut piece *Perfect Blue,* many fans seem to enjoy it, so now I deliberately choose to use it." "Interview with Satoshi Kon," Gamestar.

26. Diane Stevenson, "Family Romance, Family Violence, and the Fantastic in *Twin Peaks,*" in *Full of Secrets: Critical Approaches to Twin Peaks,* ed. David Lavery (Detroit, Mich.: Wayne State University Press, 1995), 70.

27. One final key direct address worth noting: every episode of *Paranoia Agent* ends with the image of an enormous Maromi staring straight at the viewer. The spot where Maromi sits is exactly where Shōnen Bat stands in the opening; the droopy dog is ringed by the bodies of the main cast, arranged in a question mark, with Maniwa as its tail and dot—and pointed straight at the viewer.

28. Žižek, *Looking Awry,* 18–19. Žižek often cites the figure of "the Jew" in pre–World War II Germany, or radical Islam in the United States post-9/11. In anime, there may be no more clear-cut example than *Revolutionary Girl Utena*'s (1997, *Shōjo kakumei Utena*) Hime-miya Anthy: as the Rose Bride/Witch, she obscures the contradictions and traps inherent in the figure of "the Prince" and bears all the anger and abuse that results from desires frustrated by traditional models of opposite-sex romance. (Meanwhile, Utena and Anthy's road race to freedom in the film version [*Shōjo kakumei Utena: Adōresensu mokushiroku,* 1999, *Revolutionary Girl Utena: Adolescence Apocalypse*] is as on-point an illustration of the Lacanian "act" as you're likely to find in animation.)

29. Azuma, "The Animalizaton of Otaku Culture," 184.

••• ERON RAUCH AND CHRISTOPHER BOLTON

A Cosplay
Photography
Sampler

"Making icons out of their icons."[1] This is how photographer Elena Dorfman describes her portraits of cosplayers, a characterization that suggests the layers of representation in cosplay photography and the ways these layers can be peeled apart (or collapsed together) to shed light on how fandom is viewed and displayed.

Cosplay itself probably needs little introduction here. Originally a Japanese abbreviation of "costume play," it refers to an international range of practices centered on dressing up, particularly but not exclusively fans' practice of constructing costumes based on anime and manga characters and donning them at conventions.[2] But the cosplayer is really only half the equation: the other half is the cameraman (or woman), and there is a strong sense that the photograph is the privileged end product of the entire enterprise.

Cosplay photography is a form of fanthropology in the sense that it documents fan activities. But it also accepts the challenge posed by the editors of this volume, the challenge to speak about fans in new ways. Fandom is not a foreign object to be regarded by academic specialists from the other side of a divide established by our own cultural or disciplinary expertise. Nor is it an esoteric community that only initiates—only fans themselves—can hope to

understand. Ideally it is a set of people, practices, and phenomena that challenge and expand not only our received knowledge but our very systems of knowledge.

One useful way to counter the sense of fandom as a closed object is to see the ways that fandom inevitably redraws the boundaries between producer and consumer, viewer and viewed. Like fan fiction and *dōjinshi* parodies, cosplay is part of the feedback loop that allows fans to enter into a text and transform it, turning readers into authors and blurring the distinction between fan and critic, as well as reader and text. Challenged by these practices, professional critics have lately learned to read more like fans—reinventing their own approaches in order to interpret the increasingly seamless space of *fan + text*.

By making icons from these icons, cosplay photography adds one more interesting layer. The photographers (in or out of costume themselves) range from interlopers, to fans, to fans of fans, and what their photos examine is precisely the construction and confusion of boundaries between fan and character, fan and critic, or observer and observed. Some photographers try to erase difference by creating photographs that reproduce the visual qualities of the animated frame or the manga page. Others intrude literally or figuratively into the frame, forcing us to consider the social contexts in which these images are produced and consumed. Some allow fans to emerge from underneath their costumes or try to pry them violently out of character, while many question the sometimes facile divisions and fraught power relationships these kinds of operations assume.

It is futile or contradictory to construct a canon of cosplay photography. Photo-sharing sites host millions of pictures by hundreds of thousands of photographers, making it impossible to give an overview of this genre, much less a who's who of photographers. But perhaps this ongoing documentary (constantly shot but never edited) gestures productively toward an anthropology of addition rather than reduction. In that spirit, we have assembled a purposely diverse sampling of work that hints at the range of approaches in this new genre.

EUROBEAT KING AND THE ARCHIVE OF FAN COSPLAY PHOTOGRAPHY

Several of the photographers discussed below approach cosplay productively from the outside, often with complex ideas about photography but limited

experience with the syntax and goals of the cosplay community. But here at the outset it is important to remember that all but a tiny fraction of cosplay images are made for and by the community, and come with their own very particular context that structures the images—a complex combination of conventions, history, geography, audience, and use values. Some of the photographers treated below (Elena Dorfman and Steve Schofield, for example) create images primarily for display and discussion within fine art galleries and for audiences of art buyers with no knowledge of anime. An image created by a cosplayer might have a very different but equally developed purpose—for example to showcase the sophisticated stitching on the inside of a garment for an online cosplay construction tutorial, or to serve as a memento of a convention.

Among fan photographers, there are certain insiders whose work clearly highlights some of the goals particular to the fan audience. An example is Eurobeat King, the screen name of one of the most prominent and prolific fan documentarians. He does not produce large gallery prints or strive for the single perfect image that looks like a photographic version of a *Newtype* magazine cover but instead responds to the cosplay community's insatiable need for documentation. His collection runs to over a quarter million images at this writing, housed almost exclusively on one of the main English-speaking cosplay Web sites, cosplay.com.[3] He travels extensively, trying to photograph as many of the cosplayers at as many conventions as he can. If it were possible to print all of his images in chronological order, one might tangibly see the evolution of the cosplay scene: the fans growing younger, the costumes becoming more varied, the quality increasing, the massive influx of female fans in the past five years, the ascendance of gothic Lolita styles, and the rise of "convention apparel" (using bits and accessories from costumes combined with street clothing).

Eurobeat King's online collection is the most elaborate example of one of the driving forces behind the rise of cosplay and cosplay photography: the increasing ease of image sharing, as digital cameras and digital storage get better and cheaper. Ten years ago a fan could spend twenty or thirty dollars just to develop a few roles of film at the grocery store and get a small stack of 4×6-inch prints to share with the local anime club. Today nearly every convention attendee interested in cosplay has some kind of networked digital image-making device (cell phone, camera, camcorder, and so on), and the growth of online forums, communities, networking services, and photo sharing has produced huge sites like cosplay.com as well as cosplay communities on image sharing sites like Flickr and deviantART. A decade ago, the highlight

of a convention might have been the panel by Anno Hideaki, but now the masquerade/cosplay contest garners by far the largest crowds and generates celebrities of its own.

It is most interesting and most useful to think of Eurobeat King's project and the online community's cosplay photographs not in terms of individual images but as an archive—for fans and of fans. To single out a given image here or even a certain style would be arbitrary. Each viewer traverses the archive according to his or her own criteria. A fine art photographer may look for "freaks" or formalism; a cosplayer might churn through nearly identical images searching for the one that shows his or her costume most precisely; a *hentai* lech may be looking for cute girls; friends might find images for their Web site to recall a particular convention, or browse uploads to scope out the cosplay at a convention they couldn't attend. The range of other uses is almost unlimited. The only constant principle is voracious inclusivity.

ALAIN CAMPORIVA AND THE LEGACY OF CURECOS

Alain Camporiva is an up-and-coming figure among the more technical and polished photographers working within the international cosplay community. Figures like Camporiva, Tony Quan, and Antonius Van den Brink (known as "hell-rider") work with cosplayers on carefully staged shoots, using commercial photography skills to create striking images. Their work is part of a style that was popularized by the Japanese cosplay Web site Cure-Cos and by feature shoots in the Japanese print magazine *Cosmode*. It is a style characterized by talented contributors, elaborate location shoots, heavy postprocessing, Dutch-angles, tropes borrowed from Asian science fiction and fantasy cinema, and highly attractive cosplayers in flawless costumes (Plates 1 and 2). These images became known outside Japan via forums on the image sharing site Chan.org, which had many posts that were picks of the best of CureCos.

Visually, the most striking thing about these images is that stylistically they are intentionally close to the primary sources that cosplayers use when researching their costumes. Images like Camporiva's resemble spreads in anime magazines like *Newtype, Animage,* and *Megami* sprung to life, with conventions such as tilted compositions, moody blue tints, high contrast, motion blur, selective focus, and ardent performances by the models, who have an intricate knowledge of the gestures and mannerisms favored by their characters. These are the kinds of images that inspire genuine passion among the fans.

> IMAGES LIKE CAMPORIVA'S RESEMBLE SPREADS IN ANIME MAGAZINES LIKE *NEWTYPE*, *ANIMAGE*, AND *MEGAMI* SPRUNG TO LIFE.

Neither portraits of the cosplayers nor documents of the costumes, Camporiva's images are attempted portraits of fictional characters, crafted using a visual vocabulary internal to the medium of anime. (Here is a battle-ready swordsman in an alley, there an angel who has just touched down in the city.) In many ways, images by Camporiva, Quan, and their ilk are more similar to fan fiction or *dōjinshi* than they are to documentary photography. Yet the genre of what might be termed "photo play" (or staged film still) has a lineage going back to some of the earliest photography, such as Julia Margaret Cameron's nineteenth-century stagings of historical and literary works.

Within the fan community, these images also function as celebratory monuments to the best of cosplay and as community standards of excellence. Meetings between skillful cosplayers and skillful photographers produce images that get passed around on forums, and people aspire to be a "better" Yuna or Naruto. Images such as Camporiva's thus become part of the currency by which the skill and fame of cosplayers are judged. But while it is fairly easy to identify the function and effect of images like these within the cosplay fan world, the broader status of these images in relation to art and mass media is more ambiguous.[4] As with *dōjinshi,* understanding their rigid aesthetic requires mastery of a particular and very precise vocabulary of popular culture, but they are more than mere artifacts of that culture, and ultimately their wide range of possible uses demands a careful and flexible approach from critics.

SUBCULTURE FASHION PHOTOGRAPHY

Cosplay photography clearly borrows some of its visual logic from high-fashion photography—both its formal features and its underlying assumption that the clothes exist to be photographed as much as to be worn. And subculture fashions like steampunk and Lolita may be influenced by the same fictional genres that inform cosplay (Plates 3 and 4). But a number of professional designers make strict distinctions between their own clothing lines and costumes.[5] Subculture fashion may involve role-playing or acting the part, but it is not about imitating a specific character at conventions or in other fan contexts; rather, it is about creating an individual look that becomes part of an everyday lifestyle and identity. Designer Samantha Rei cites

the broader cultural and historical origins of these styles to emphasize that the fashions exist before and apart from anime or manga characters that wear them: Ōtomo Katsuhiro's future primitive science fiction epic *Steamboy* borrows steampunk fashion, not the reverse. In other words, while cosplay participates in an existing literary narrative, subculture fashion enacts a social narrative of its own.

And yet fiction inevitably feeds back into fashion, and the line between the two can be a fine one. "If you lose the fake weapons and the little details that make it a bit too over the top," suggests designer Megan Maude McHugh, "you're left with an interesting outfit that people congratulate you on. Add the props back in, and people ask you if you're in a play or something." But the tipping point between the intriguingly original and the wildly theatrical can be difficult to locate—particularly in the dramatic world of runway shows and fashion photography—and it is always shifting.[6] Rei says her own work must continually raise the stakes: it must "be bigger and bolder to set itself apart since so many mainstream groups keep absorbing our aesthetics."

Finally one might say that cosplay and subculture fashion are both about an imagined ideal, but the latter holds out a stronger promise that we can refashion our everyday selves in that new image. The power of the model pictured in Plate 3, says Rei, is that whatever she wears, "she looks like she dresses that way on the weekends." What the designer, model, and photographer sell to the viewer is not only a certain fiction but the promise that the fiction might become real.

ERICH HOEBER

Of all of the photographs represented here, Erich Hoeber's are perhaps the least documentary. The images in his series "Cosplay: Transformation and Identity" are structured toward figuring psychological intensity, an intensity born from lack of familiarity, from implied narratives, fractured identities, and suspected secrets, particularly the secrets of young people in masks of their choosing (Plates 5 and 6).[7] In the southern gothic mode of photographers like Keith Carter, the subjects of Hoeber's work serve as arcane symbols in a pantheon of the photographer's own devising. They are like a Tarot—here the Fool, here Death. At times it can be difficult to read past the expressionist presentation, though, and one wonders what particular quality cosplayers have that makes them appropriate for filling Hoeber's pantheon.

In Hoeber's photographic technique, we find the beginning of an answer. Every decision he makes serves to reduce the materiality of the physical subject ("people in costumes at a convention"), and instead he insinuates a moody narrative of an inner journey that goes with the liminal state that is cosplay. Cosplay is turned into a metaphor as Hoeber strips the color away and applies a severe vignetting that turns even the midday California sky into a bleak shadow. He employs a highly regimented compositional structure that crops almost all of his subjects at the waist. And he shoots with archaic cameras, using focal shifts to blur large portions of the image and a wide-angle lens to distort facial features.

> THE SUBJECTS OF HOEBER'S WORK SERVE AS ARCANE SYMBOLS IN A PANTHEON OF THE PHOTOGRAPHER'S OWN DEVISING.

Bursting with symbols, Hoeber's work seems to embody a tension between cultural specificity and universality, reflected in these two statements about his work: "I made these photographs to show the people behind the costumes: their pride, their vulnerability, their beauty, and their bravery," but also, "For me, a great image is more than an image. It's a mysterious artifact with it's own special gravity."[8]

Hoeber is not interested in studying cosplay's signs on their own terms, but he is one of the rare photographers focused on cosplayers' internal worlds. Among the photographers in this sampler, he may provide the most focused visual interrogation of the simultaneous anxiety and euphoria of donning a fictional identity to fit into a group. If at times his work lapses a bit too far into psychological Romanticism, vague arcana, or visual Expressionism, it is courageous for its effort to address the nebulous question of "why"—why is the anime scene currently so obsessed with cosplay?

ZAN

Although cosplay is experienced largely though online photographs, very few cosplayers use the opportunity to stage and shoot their own images of themselves. An interesting exception is Zan, the screen name of an ardent Sailor Moon cosplayer who creates studio portraits of herself in costumes she has crafted, and sometimes augments the photographs with Photoshopped backgrounds and effects to produce fun, direct images that show an utter mastery of the Sailor Moon style (Plates 7 and 8).[9] Were they drawn, these images could easily be spreads in a shōjo anime or manga art book.

While Alain Camporiva's work has the same goal of seamlessly recreating the source material, he strives for a more action-oriented, cinematic feel—a male or shōnen counterpart to Zan's shōjo idiom. It is informative that in form, Zan's work is actually much closer to Erich Hoeber's closely cropped portraits of psychological inquiry, but she does not use photography to pry behind the costume, as Hoeber does. Instead, she uses the costume as an icon. As the quality of the clothing, the perfection of the symbolic gestures, and the slickness of the photography all reach a zenith, the images come to represent an almost perfect empathy with the characters, while at the same time armoring and concealing the portrait model. For example, in one of Zan's images, the models are backlit and shadowed to the point of total silhouette, concealing both their costumes and themselves in order to better enact the overall visual style of the series. This method is the inversion of Hoeber's: here the camera is used to investigate the character, not the model. On its beautiful surface, this is a photograph of and about Sailor Moon. No more, no less.

> THE IMAGES COME TO REPRESENT AN ALMOST PERFECT EMPATHY WITH THE CHARACTERS, WHILE AT THE SAME TIME ARMORING AND CONCEALING THE PORTRAIT MODEL.

Yet at another level, this work clearly embodies an act of communication between the model/photographer and fans—fans of the series as well as fans of Zan herself. In the sharp, clearly lit intimacy of these photos, the subject maintains direct eye contact with the camera, an invitation to the viewer to join her in exploring the nuances of the primary text. Empathy and narrative play allow her images to be additive, rather than authoritative. They do not attempt to replace or deconstruct the master texts or the social narrative from which they are spun. Instead they use identity and the body to create commentaries, expansions, adulations, and interpretations of the original texts to share with other fans.[10] In this sense, Zan's work illustrates Dean MacCannell's idea of cultural productions as communal rituals:

> They are rituals in the sense that they are based on formulae or models and in the sense that they carry individuals beyond themselves and the restrictions of everyday experience. Participation in a cultural production, even at the level of being influenced by it, can carry the individual to the frontiers of his [or her] being where his [or her] emotions enter into communion with the emotions of others "under the influence."[11]

STEVE SCHOFIELD

In his portrait series "Land of the Free," artist Steve Schofield photographs British fans wearing *Star Trek, Star Wars,* and Wild West costumes in their own homes.[12] In the process he highlights the migration of subcultural media and suggests the transformations and dislocations that are required for fan costuming to function across the Atlantic as well as the Pacific. How do subcultural forms travel? Do they have unique characteristics in different locations, or is Captain Picard the same across thousands of miles, just as he is in two neighboring homes in a subdivision? (And what does that say about suburban Britain and suburban America's similar or differing relationships with colonial power, as portrayed in *Star Trek* or the Wild West?)

While Elena Dorfman's work erases the traces of context and background to highlight the fans' awkward gestures and sometimes imperfect costumes, Schofield works with skilled costumers who have created slick, almost impenetrable surfaces.[13] Paradoxically, the costumes are clearly figured—whole, in focus, well exposed, and captured with wide lenses that set the spectator back far enough to see the whole view from the proverbial window. And yet vertigo still sets in—for example when we realize that one of the two Captain Picards we are staring at is a life-sized cardboard cutout posed next the costumed fan, both almost indistinguishable from the "original" and from one another.

As the fans merge visually with their characters, much of the psychological dimension is negated and the costumed figures begin to serve as negative spaces, compositionally and conceptually. The eye and the mind are deflected into the area all around these subjects, living rooms and front halls filled with other details that the camera voraciously records: props, figures, and other media related to the costume, but also everyday furniture, architecture, and the detritus of daily life. In a perversion of August Sander's "typologies" (but also in homage to them), Schofield plays media's slickness off itself, and the wealth of information in the periphery of the images reintroduces questions about the material and commercial social structures that serve as the set for these actors.

Staring at the smattering of items that lets us identify these kitchens, dens and bedrooms as the homes of fans (spaces identical to our own), we begin to wonder if the association between identity and costume is any more remarkable than the way identity is impressed and expressed by the rest of material and media culture we array around us—whether it is pin-up posters and model cars or print curtains and Berber carpet. If what is modulating identity is what's playing on the DVD player, it is equally what's on the walls

and shelves, things which are just as easy (and just as difficult) to change and rearrange. This final point draws our attention back to Schofield's own polished style and focuses these questions about material culture and identity formation back on the photographer, back on portrait photography itself.

ELENA DORFMAN

Elena Dorfman is an art photographer who turned her attention to cosplay in her 2007 book *Fandomania,* one of the first photography books in a genre dominated by online forums (Plate 9).[14] As this fact suggests, she approaches the genre and culture as a kind of outsider. The provocative quality of her work may trace to the way it forces the viewer into the same outsider position.

In their detail, lighting, and featureless deep black backgrounds, Dorfman's photos appropriate some of the vocabulary of glamour magazine photography, but her subjects—both the people and the costumes—are often unglamorous. In their neutral, even blank expressions and their isolation within the frame, Dorfman's subjects often convey a sense of ordinariness and even awkwardness that contrasts starkly with their heroic characters and the heroizing animeic styles that dominate fan-forum photography. This has provoked controversy among cosplayers: some feel it represents a healthy range of fans, while others feel it elides cosplay's sense of fun and empowerment.[15] Dorfman has said that her aim was to show the person beneath the outfit: "to find out who they were behind the pose, to see their costume and who they had chosen to be but not to get them entirely in their character."[16] In a way, this would be easier if the photos included some additional context—some intrusion of background, as in Steve Schofield's portraits. But the intriguing puzzle of Dorfman's work is that she uses this posed idiom and lack of context not to enhance the illusion but to strip away the layers of the costume and the role.

One could argue that Dorfman achieves this effect by refocusing attention on the gaze of the photographer and viewer. If the awkwardness or vulnerability of the subjects reveals a person behind their costume, it also highlights the manipulated quality of the shoot and the photograph itself—a sense that the models are aggressively posed (rather than posing) and that the image is tightly controlled. There can be an uncomfortable sense of power and even violation in these encounters, but the photos also remind us that we find ourselves on both sides of these cruel transactions every day. Dorfman's

photos are definitely not about the characters, and not primarily about the cosplayers; they are much more about the photographer and spectator. As we look at these pictures and feel the welling of our own desires and insecurities, our own sympathy, empathy, envy, and scorn, we are forced to consider our own place in the (sub)culture, our own power and vulnerability. There is some truth to Carlo McCormick's statement that "What is compelling, and to a certain degree disquieting, about Dorfman's cosplayers is how closely they approximate simultaneously the most innocent and the most perverse aspects of role-playing."[17] This may be why *Fandomania* has produced such strong reactions from viewers, all the more so because McCormick's "perversity" belongs to each viewer as much as to the image or to cosplay culture.

Contrast Dorfman's images with more benign portraits by Erich Hoeber, where the happy confidence of the subjects seems to trace partly to the fact that Hoeber has captured fan and character on the same plane. If one has the sense of seeing the fans more on their own terms in Hoeber's work, those terms still include a heavy dose of fantasy. In this way, the unsettling quality of Dorfman's work highlights the role of the photographer and the viewer in the cycle of judgment and consumption more trenchantly than most other photographers. While her notion of documentary is in some ways the antithesis of Eron Rauch's, they have that virtue in common. For the uninitiated looking for a glimpse into cosplay culture, Dorfman may paint an idiosyncratic picture. But for those who have some familiarity with the culture, her work shows it to us through new eyes.

ERON RAUCH

A professional artist who often works in documentary photography, Eron Rauch approaches the genre with an understanding of the history of documentary photography as well as long and deep experience as a fan organizing anime clubs, 'zines, and convention events. His work juxtaposes and bridges fandom and criticism (sometimes uneasily), with a viewpoint that is ironic and sympathetic by turns (Figures 1 and 2). His pictures often depict other photographers, or his own image reflected in a mirror, visual shorthand not just for his dual stance as recorder and participant but for the ways fan culture holds a glass up to its observers and fosters or forces self-reflection. "Making art with a critical relationship to your own context is an honest trauma," Rauch writes, "an act of increasing velocity that moves you . . . out of static, assumed relationships."[18]

FIGURES 1 AND 2. "Naruto Fan Group Meet-up and Photo Shoot" and "Near the Vending Machines," from Eron Rauch's series "Bridges of Desire." These photos were taken in 2004 at the Anime Central and Animagic conventions, respectively. Photographs copyright Eron Rauch. Used by permission.

HIS CANDID, EVEN SURREPTITIOUS
SHOTS SUGGEST BEAUTIFUL,
JOSTLED DOCUMENTARY
FOOTAGE FROM A HAND-HELD
MOTION-PICTURE CAMERA.

My comments here are based on Rauch's published work, culled in turn from an archive of thousands of photos taken at conventions over many years. Rauch's longitudinal visual study takes in cosplay but portrays convention culture broadly, rather than trying to document individual costumes. His black-and-white photos convey a sense of being in the mix—of recording fan culture from within. His candid, even surreptitious shots gracefully embrace awkward angles and dim hotel lighting. Arranged in series, they suggest beautiful, jostled documentary footage from a hand-held motion-picture camera that has penetrated the interstitial, personal spaces of the convention: hallways, bathrooms, backstage, hotel beds.

All this suggests the living energy and activity of a convention, but almost against the odds, a kind of flattening takes place as well. Rauch's black-and-white palette and the grain of the film, his frequent indifference to capturing faces, and the way he includes printed, painted, reflected, or projected images within the frame—all this compresses the visual gap between two-dimensional media and three-dimensional fans. Some of the cosplayers in his photos look like literal cartoons, and despite the sense of reality in these scenes, the figures seem on the verge of being sucked into the background or swallowed into the page. This artificiality (this confusion of real and artificial) calls our attention back to the art and artificiality of the photograph, the archive, the documentary. Rauch's work thus gives us some new perspectives on fan culture and a certain perspective on our own lack of perspective as well.

Notes

The sections on Eurobeat King, Alain Camporiva, Erich Hoeber, Zan, and Steve Schofield were authored principally by Eron Rauch. Christopher Bolton is the primary author of the sections on Rauch's work, on subculture fashion photography, and on Elena Dorfman. However, we would like emphasize that we have collaborated throughout. We would both like to thank Bennett Cousins and Jennifer Newman, who provided invaluable advice and information about the cosplay landscape.

1. Elena Dorfman, interview with The Independent Film Channel. See IFCNews, "'Fandomania' Photographer Elena Dorfman on Cosplay," video posting to YouTube, December 17, 2007, http://www.youtube.com/watch?v=0PWN_3aW05w (accessed May 11, 2009).

2. For readers who do want an introduction to cosplay in English, the following are